HISTORIC PHOTOS OF
NASHVILLE

TEXT AND CAPTIONS BY JAN DUKE

TURNER
PUBLISHING COMPANY

Union Station and the railroad yard, circa 1930. The eight-story building on the left held the offices of the N.C. & St.L. Railroad.

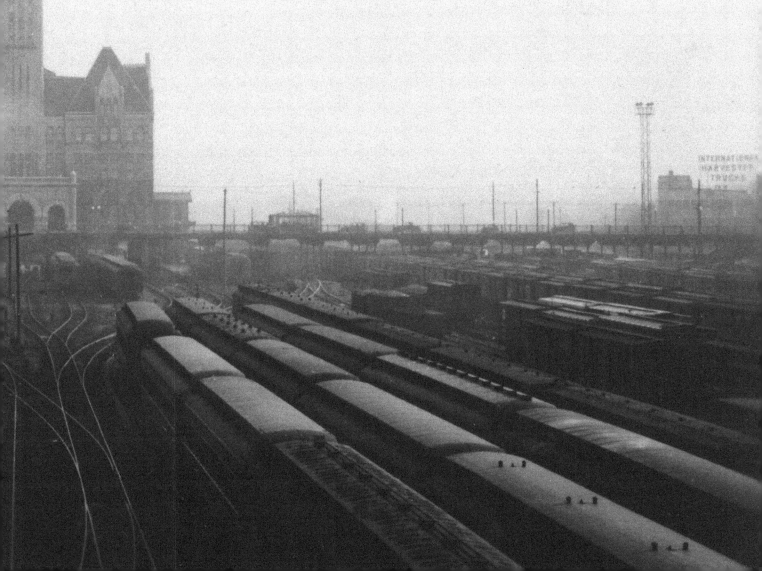

HISTORIC PHOTOS OF
NASHVILLE

Turner Publishing Company
www.turnerpublishing.com

Historic Photos of Nashville

Copyright © 2005 Turner Publishing Company

Library of Congress Control Number: 2005926683

ISBN-13: 978-1-59652-184-1
ISBN: 1-59652-184-8

ISBN 978-1-68336-908-0 (hc)

CONTENTS

This photograph captures shadows of the Parthenon columns.

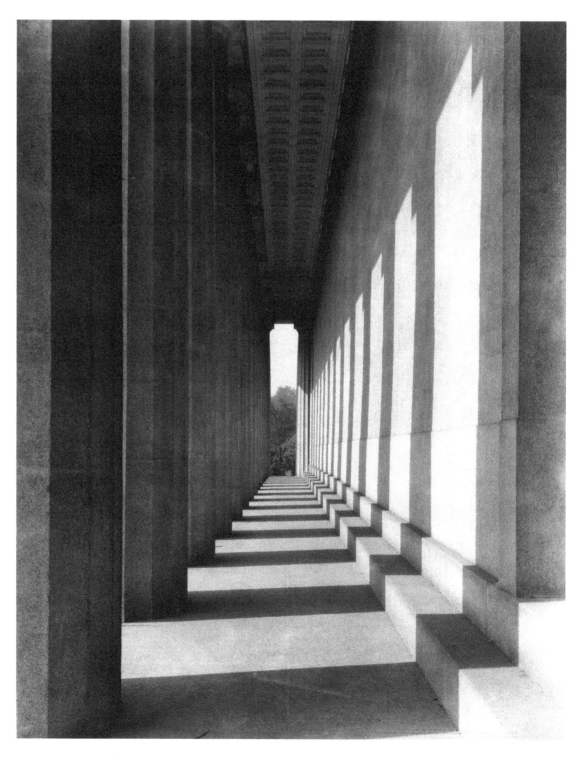

ACKNOWLEDGMENTS

This volume, *Historic Photos of Nashville,* is the result of the cooperation and efforts of many individuals, organizations, and corporations. It is with great thanks that we acknowledge the valuable contribution of the following for their generous support:

AmSouth Bank

First Tennessee

KraftCPAs PLLC

LBMC

Pinnacle Financial Partners

Tennessee State Library and Archives

US Bank

Bass, Berry & Sims

FirstBank

LifeWay

The Nashville Room—Nashville Public Library

Southern Baptist Historical Library and Archives

Tennessee Historical Society

Vanderbilt University Library and University Archives

We would also like to express our gratitude to Phil Duke for providing research, assisting the author, and contributing in all ways possible.

Finally, we would like to thank the following individuals for their valuable contribution and assistance in making this work possible:

Steven Gateley, Research Service Librarian, LifeWay

Susan Gordon, Archivist, Tennessee State Library and Archives

Lyle Lankford, Public Affairs Office, Vanderbilt University

Beth Odle, Special Collections Division, Nashville Public Library

Henry Shipman, Photographic Assistant, Vanderbilt University Library

Bill Sumners, Director, Southern Baptist Historical Library and Archives

Ridley Wills II, Historian

PREFACE

Nashville has thousands of historic photographs that reside in archives, both locally and nationally. This book began with the observation that, while those photographs are of great interest to many, they are not easily accessible. During a time when Nashville is looking ahead and evaluating its future course, many people are asking, How do we treat the past? These decisions affect every aspect of the city—architecture, public spaces, commerce, and infrastructure—and these, in turn, affect the way that people live their lives. This book seeks to provide easy access to a valuable, objective look into the history of Nashville.

The power of photographs is that they are less subjective than words in their treatment of history. Although the photographer can make subjective decisions regarding subject matter and how to capture and present it, photographs seldom interpret the past to the extent textual histories can. For this reason, photography is uniquely positioned to offer an original, untainted look at the past, allowing the viewer to learn for himself what the world was like a century or more ago.

This project represents countless hours of review and research. The researchers and writer have reviewed many hundreds of photographs in numerous archives. We greatly appreciate the generous assistance of the individuals and organizations listed in the acknowledgments of this work, without whom this project could not have been completed.

The goal in publishing this work is to provide broader access to this set of extraordinary photographs, as well as to inspire, provide perspective, and evoke insight that might assist citizens as they work to plan the city's future. In addition, the book seeks to preserve the past with adequate respect and reverence.

With the exception of touching up imperfections that have accrued with the passage of time and cropping where necessary, no changes have been made. The focus and clarity of many images is limited by the technology and the ability of the photographer at the time they were taken.

The work is divided into eras. Beginning with some of the earliest known photographs of Nashville, the first section records photographs from before the Civil War through the Centennial. The second section spans the beginning of the twentieth century to World War I. Section Three moves from WW I to World War II. And finally, Section Four covers from WWII to the late 1970s.

In each of these sections, we have made an effort to capture various aspects of life through our selection of photographs. People, commerce, transportation, infrastructure, religious institutions, and educational institutions have been included to provide a broad perspective.

We encourage readers to reflect as they walk in front of the State Capitol, along the riverfront, or through Centennial Park. Cannons were once positioned on the Capitol steps, steamboats once lined the banks of the Cumberland, and many buildings, long since demolished, surrounded the Parthenon in Centennial Park. It is the publisher's hope that in utilizing this work, longtime residents will learn something new and that new residents will gain a perspective on where Nashville has been, so that each can contribute to its future.

—Todd Bottorff, Publisher

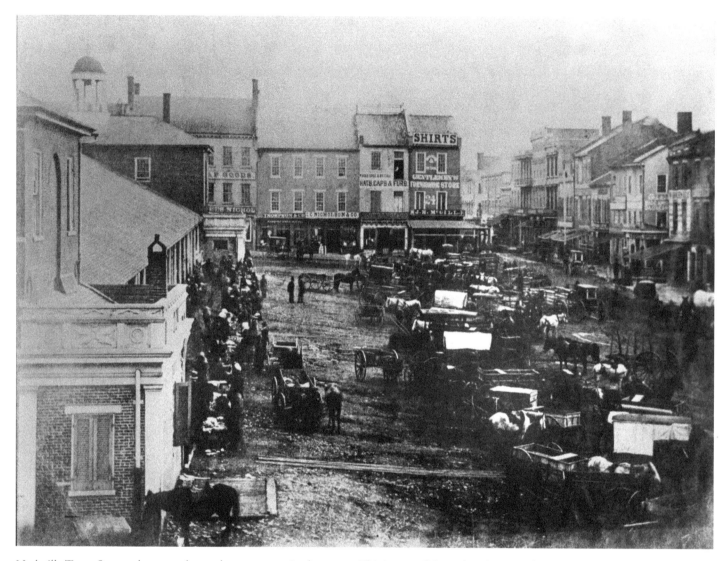

Nashville Town Square showcases horse-drawn wagons in the streets. This is one of the earliest known photographs of Nashville. The Davidson County Courthouse is on the left.

PRE-CIVIL WAR TO THE CENTENNIAL

1850–1899

By the 1850s, Nashville had earned the name "Athens of the South" by establishing the University of Nashville, Nashville Female Academy, and a promising public school system. By the end of the century, Nashville saw Fisk University, Montgomery Bell Academy, Meharry Medical College, Peabody Normal College, and Vanderbilt University open their doors.

At the time, Nashville was known to be one of the more refined and educated cities of the South. It had several theaters as well as many elegant accommodations. The city saw the completion of the majestic State Capitol in 1859. Nashville was a vibrant, expanding town, but that prosperity was interrupted with the beginning of the Civil War in 1861. That conflict devastated Nashville and its residents until its end in 1865.

Following the Civil War, Nashville began rebuilding and grew once again with the opening of Vanderbilt University in 1875, the completion of Jubilee Hall in 1876, General Hospital in 1890, the Union Gospel Tabernacle in 1892, a new state prison in 1898, and finally Union Station in 1900.

In the development of transportation, Nashville experienced the arrival of the first steam locomotive in 1850 and mule-drawn streetcars in 1865, only to replace them with electric trolleys in 1889. In 1896, the first automobile was driven in Nashville.

Nashville also witnessed its first professional baseball game at Athletic Field in 1885 and its first football game in 1890. The city received the world's first airmail by balloon in 1877, the same year telephones appeared. Three years later, in 1880, Nashville's first electric light was turned on. In the latter part of the nineteenth century, the city had two important celebrations: Nashville's Centennial in 1880, followed by the Tennessee Centennial Exposition in 1897.

The period during the second half of the nineteenth century was marked by early progress, interrupted by destruction, and closed with rebirth and new prosperity for the Athens of the South.

In 1859, men in suits pose for the camera at the storefront of the Benjamin T. Johnson & Company Confectionery.

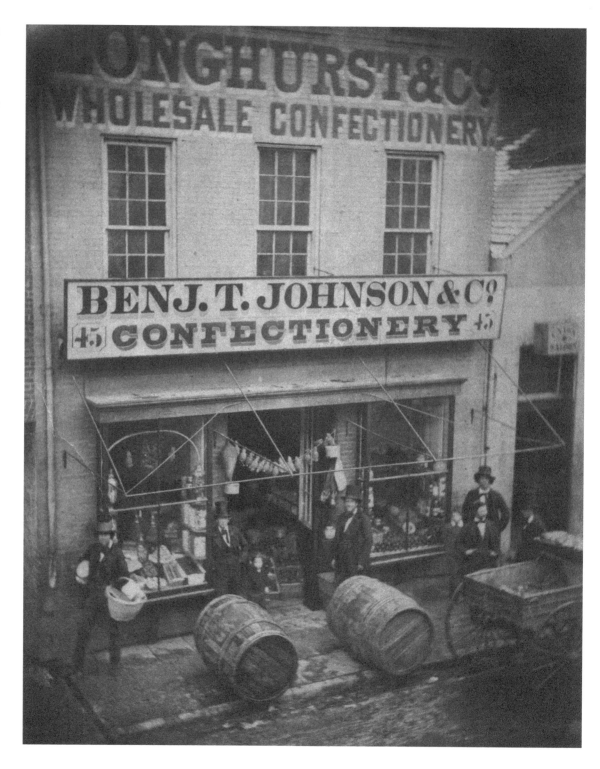

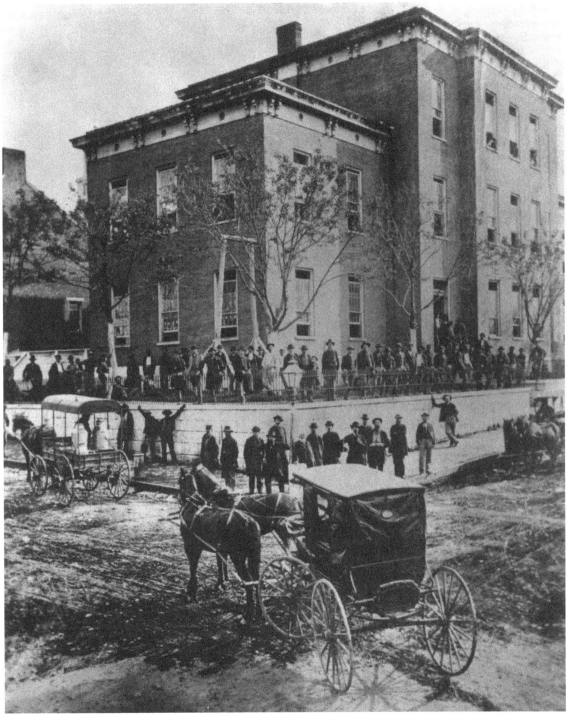

Hymes School, pictured here, was built in 1857 on the corner of Lime and Summer streets.

During the Battle of Nashville in 1864, men guard the fortified bridge over the Cumberland River. The battle lasted two days and ended in a major Union victory.

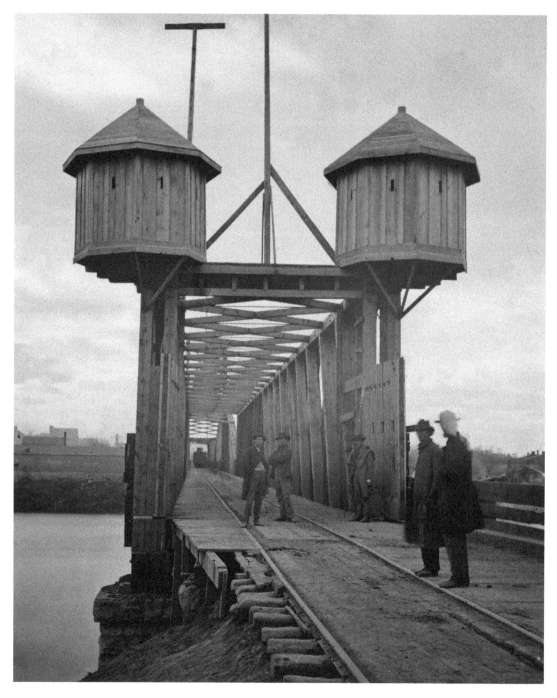

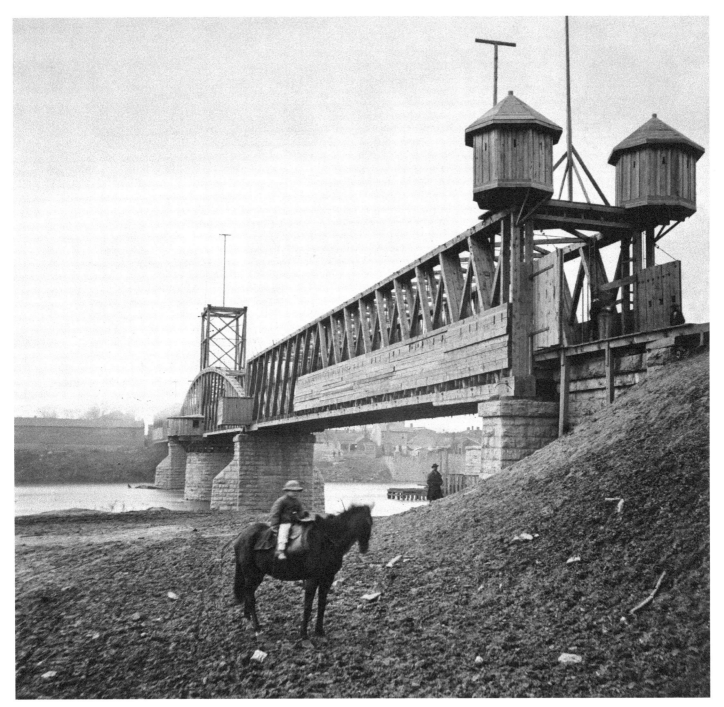

The Cumberland Railroad Bridge was fortified during the Civil War. Perhaps this youngster was supervising the fortification on his horse.

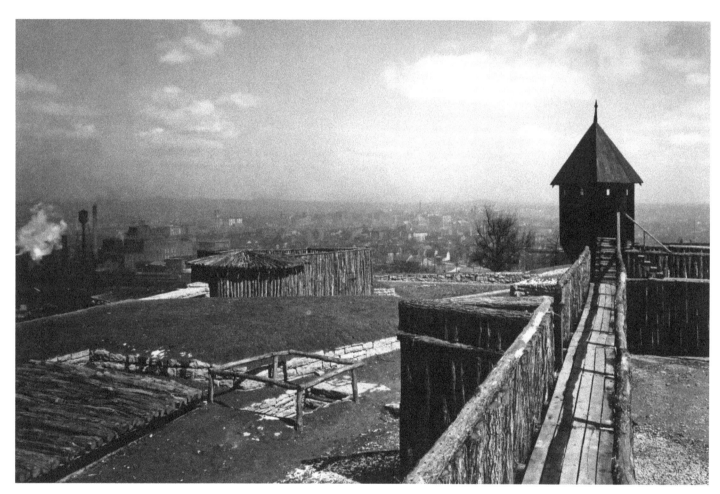

Ft. Negley was built in 1862 on St. Cloud Hill and was occupied by the Federal forces in Nashville. This picture shows the reconstructed fort built by the WPA in the 1930s.

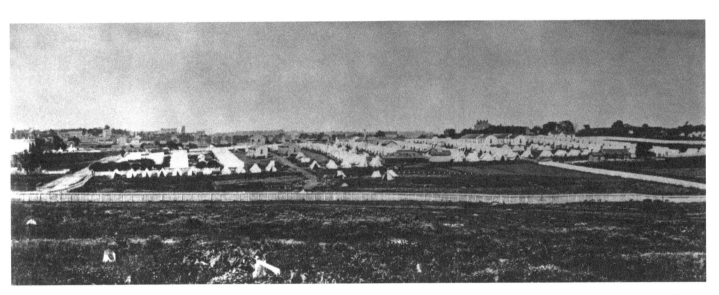

Pictured here around 1862-64 is the Federal Army field hospital on the western outskirts of Nashville. The dirt road on the left is Spring Street leading into town toward the Masonic Hall and the First Presbyterian Church, one tower of which is visible on the horizon.

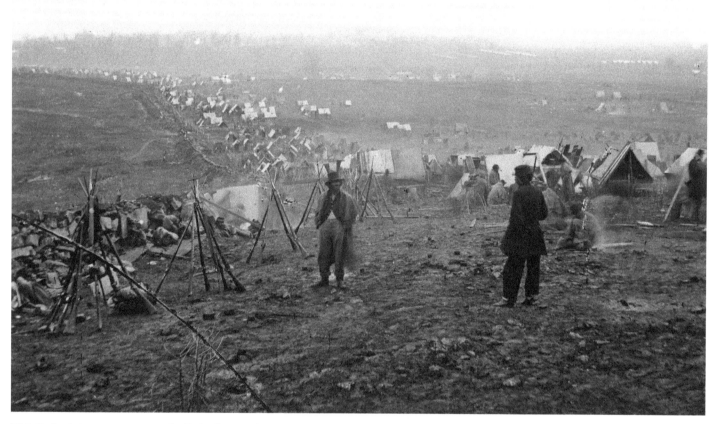

This Federal Army camp in Nashville looks west from near Fort Negley in 1864.

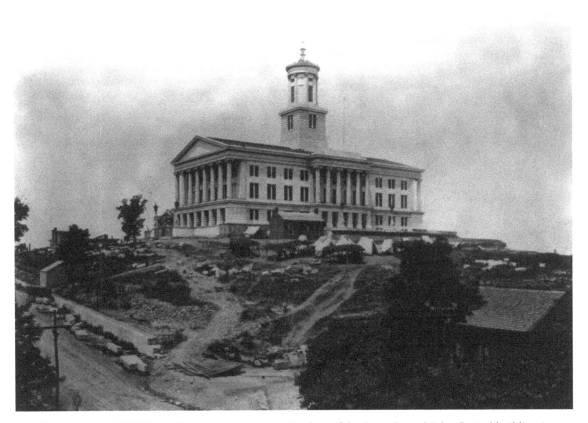

Shown here in 1863 is a military encampment at the foot of the State Capitol. The Capitol building is seen under construction.

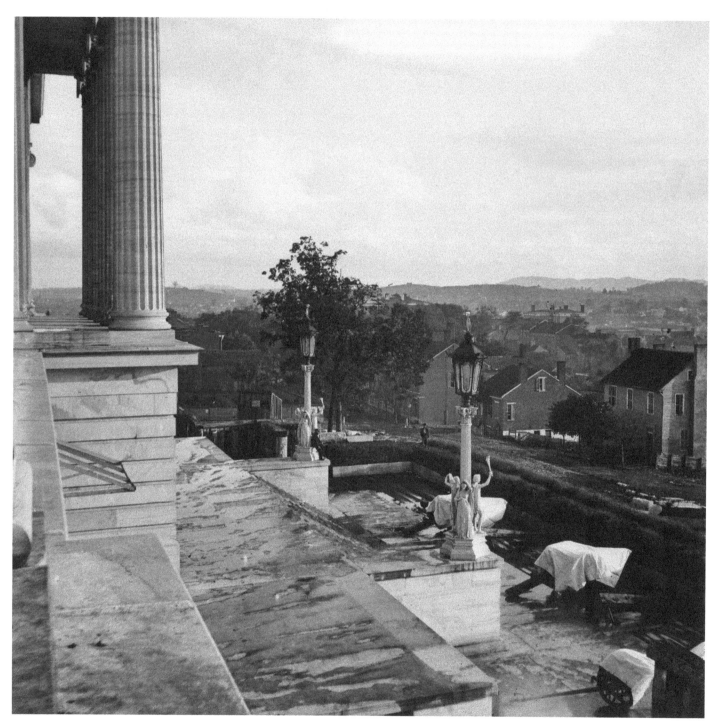

Covered artillery looks down from the steps of the armed Capitol around 1864.

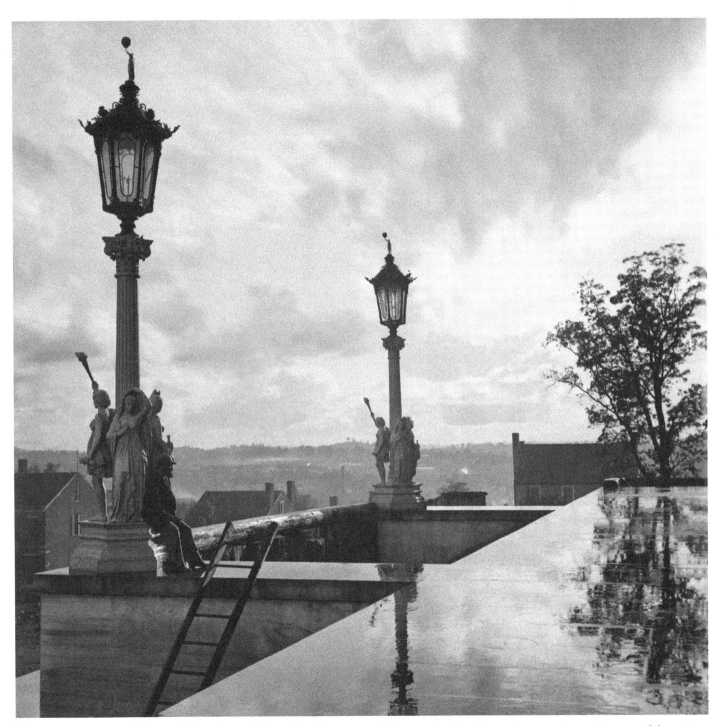

This 1864 view from the State Capitol was recorded on a rainy day. A man is seen resting against one of the statues.

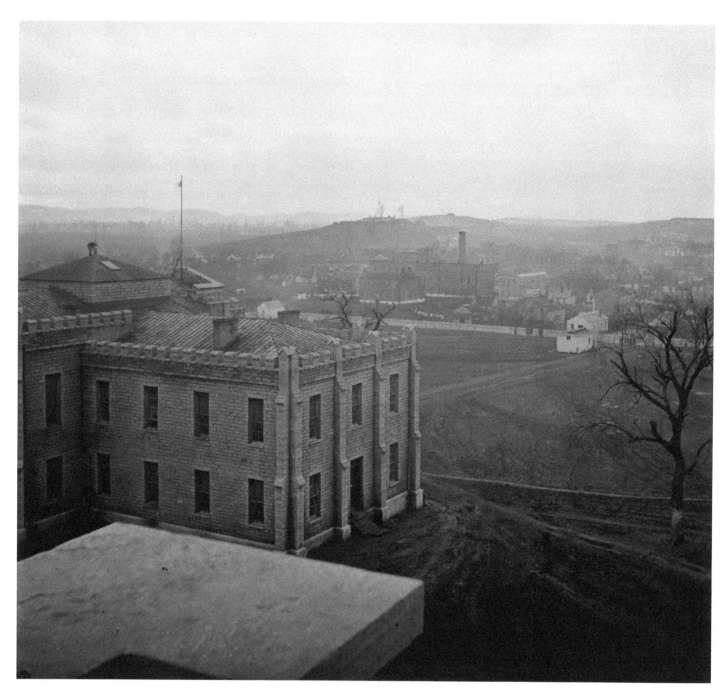

A Civil War photograph taken from the roof of Lindsley Hall shows the three-story College Hill Armory with its tall smokestack in the center, and Fort Negley beyond and slightly to the left. The building in the foreground housed the Literary Department of the University of Nashville.

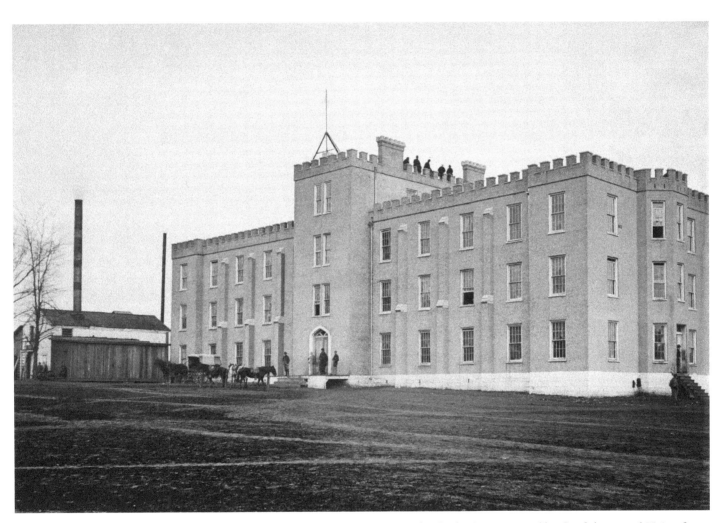

The University of Nashville's Lindsley Hall was built in 1855. During the Civil War, it was used by Confederate and Union forces as a hospital.

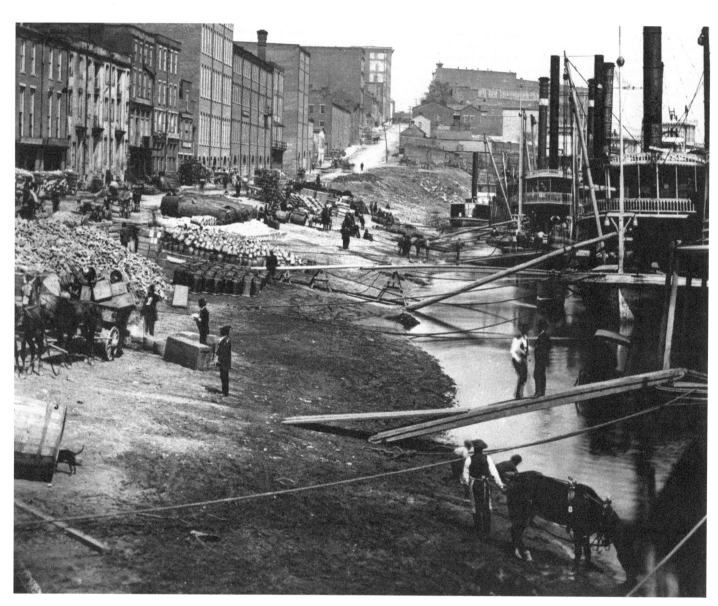

The Nashville Wharf (Front Street), circa 1875.

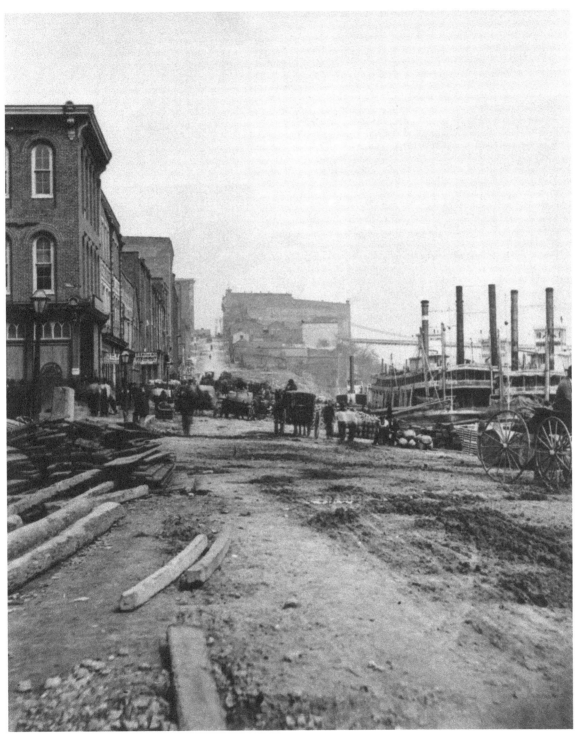

Front Street along the riverfront is unpaved in this photograph from the late 1800s.

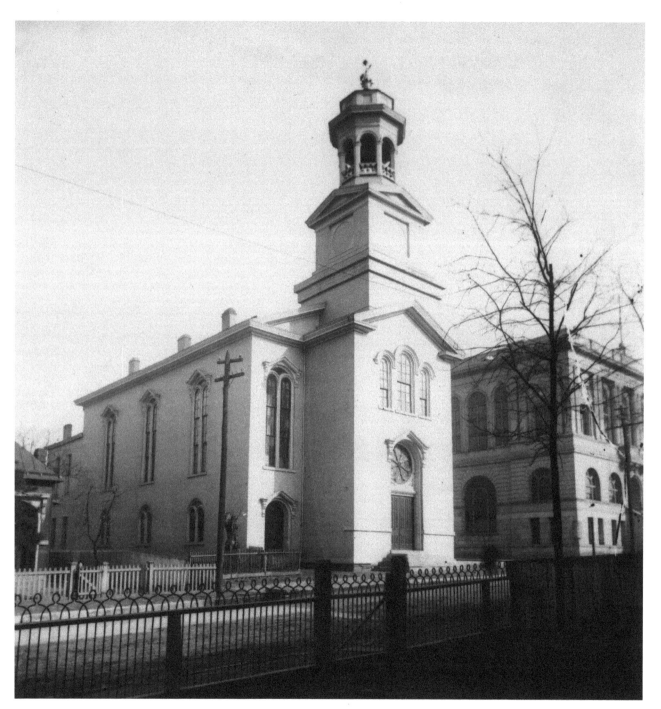

Constructed in the late 1850s, the Elm Street Methodist Church is still a landmark. It now serves as home to the Tuck Hinton Architectural Firm. To the right is the Medical Department of Vanderbilt University, constructed in 1895 at the corner of Fifth and Elm.

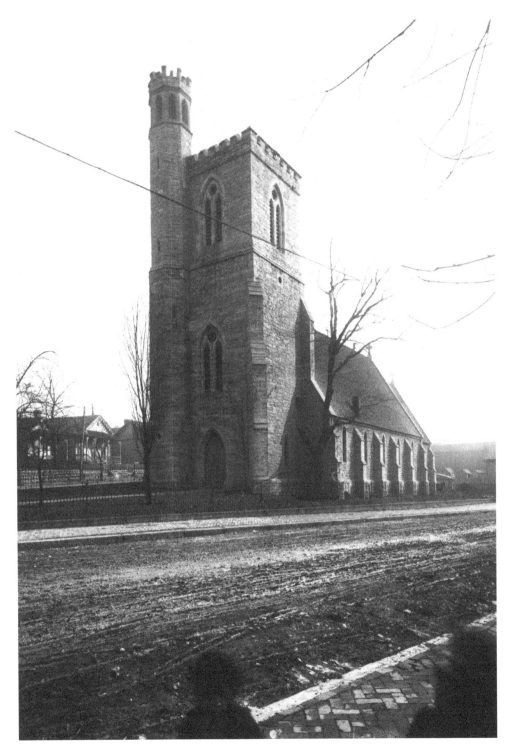

Holy Trinity Church, circa 1887. During the Civil War, the altar was used as an operating table by the Union Army. This building still serves the congregation meeting there today.

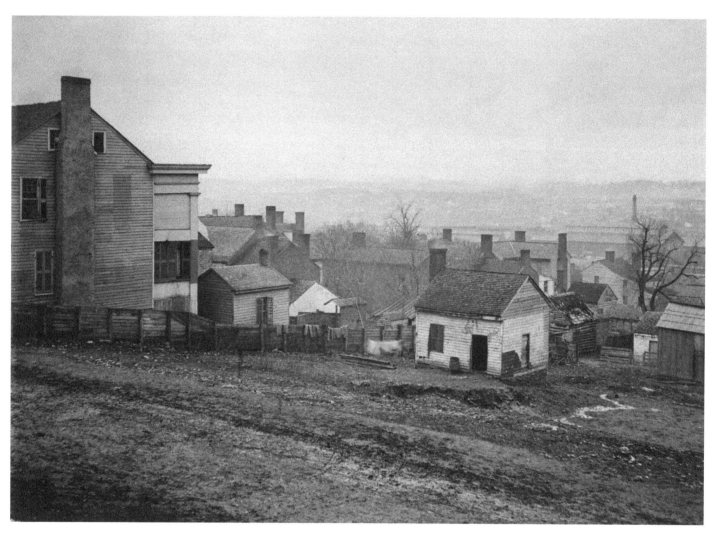

Looking south from Vine Street in 1864. The building down the hill on the right was a railroad repair shop built by the Federal Army.

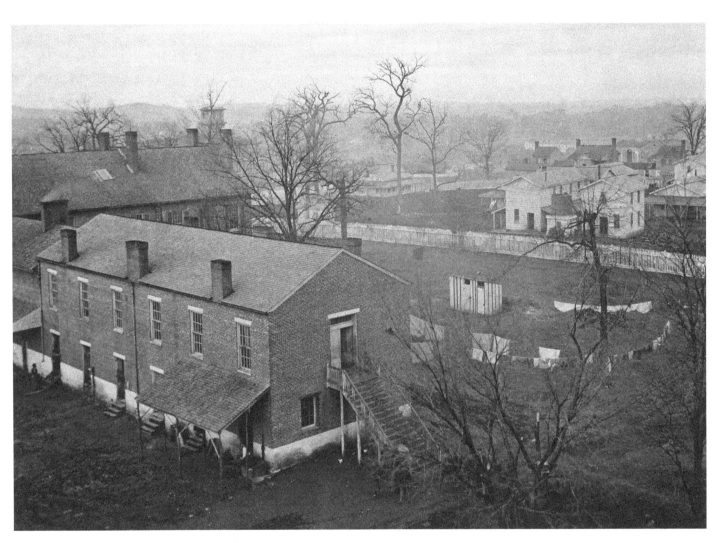

This photograph was taken from the roof of the University of Nashville's Lindsley Hall. The building in the foreground was the home of the University of Nashville's chancellor, John Barrien Lindsley.

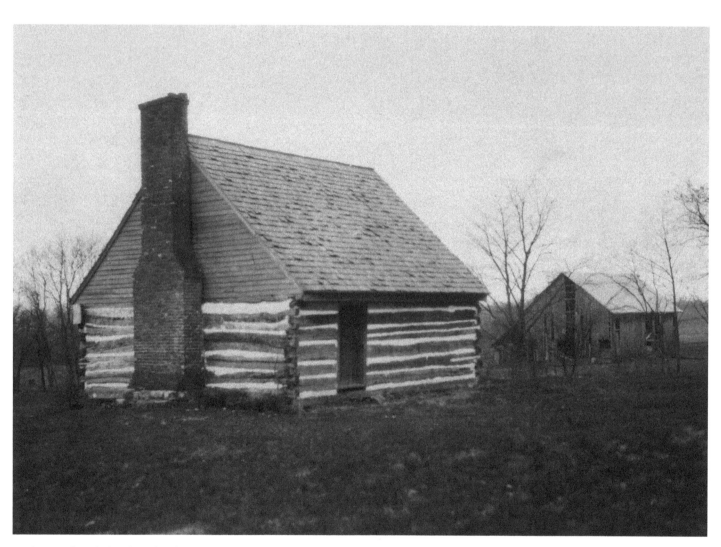

Andrew and Rachel Jackson lived in this log cabin before the Hermitage mansion was constructed. Jackson built the cabin, which originally had two floors, in 1804.

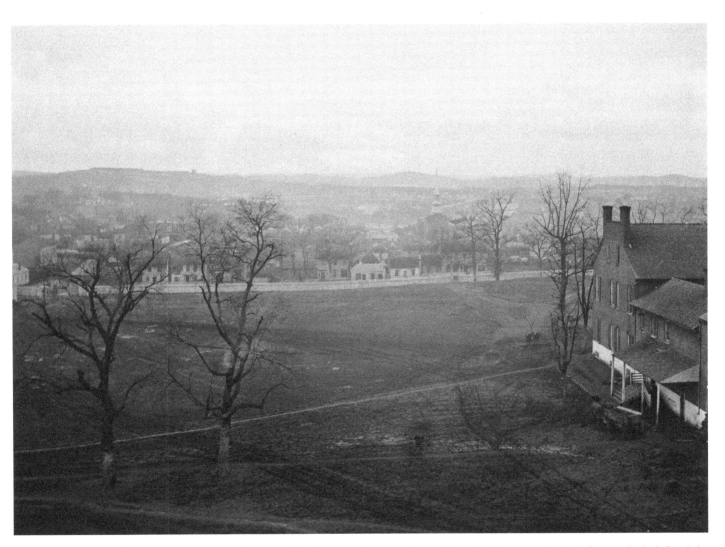

An 1864 view from the roof of Lindsley Hall. Summer Street is obscured by the white-washed plank fence, which defined the University of Nashville's perimeter.

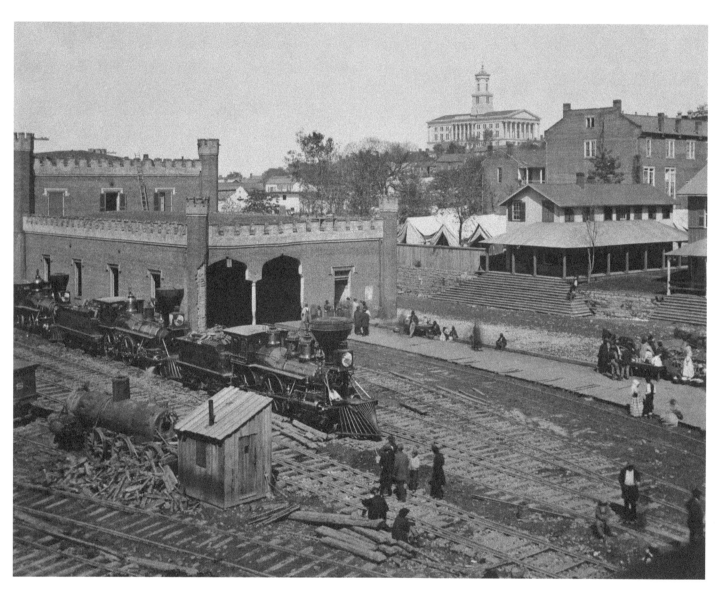

The Nashville & Chattanooga train depot in 1864 is pictured here, with the State Capitol in the background.

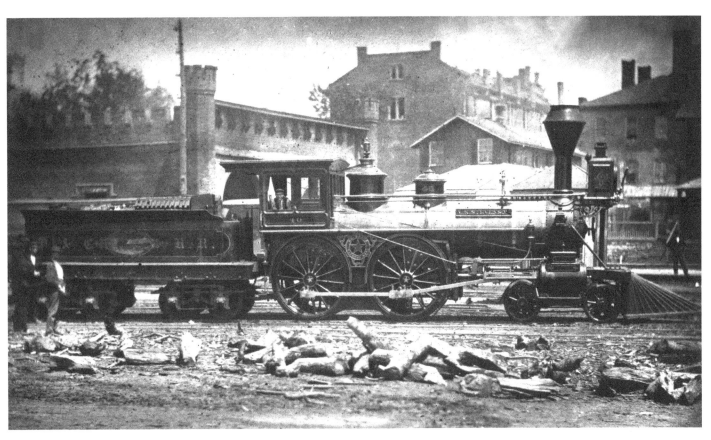

The Nashville and Chattanooga Locomotive V. K. Stevenson at the Nashville & Chattanooga terminal, circa 1870.

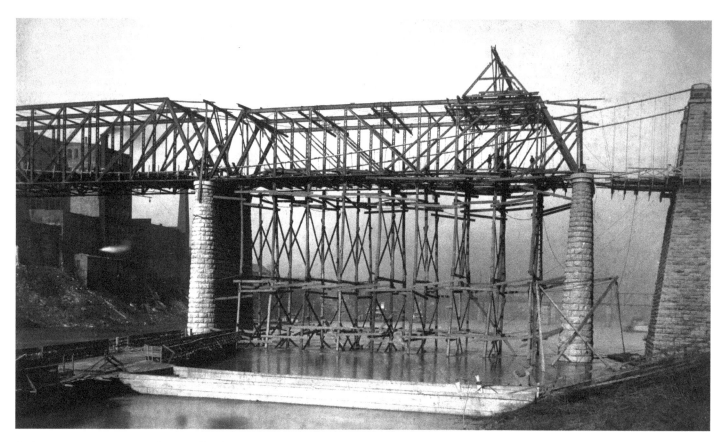

Facing downtown in 1885, the Woodland Street Bridge is under construction across the Cumberland River.

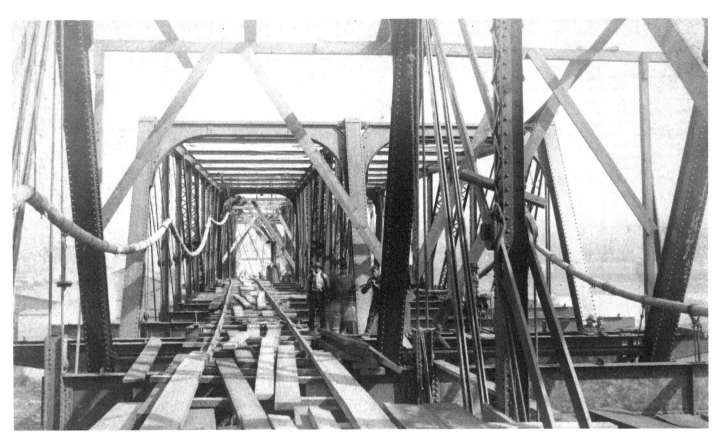

This 1885 close-up of the Woodland Street Bridge under construction depicts men standing on planks among the cables.

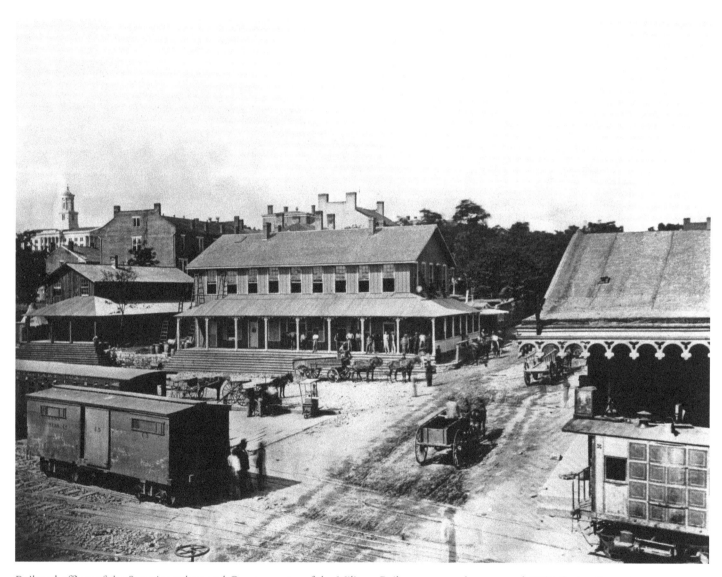

Railroad offices of the Superintendent and Quartermaster of the Military Railway are seen here around 1862. Spring Street is visible on the right. In the center on the hill between the two hip-roofed buildings, the top portion of Polk Place is visible. The State Capitol is on the left.

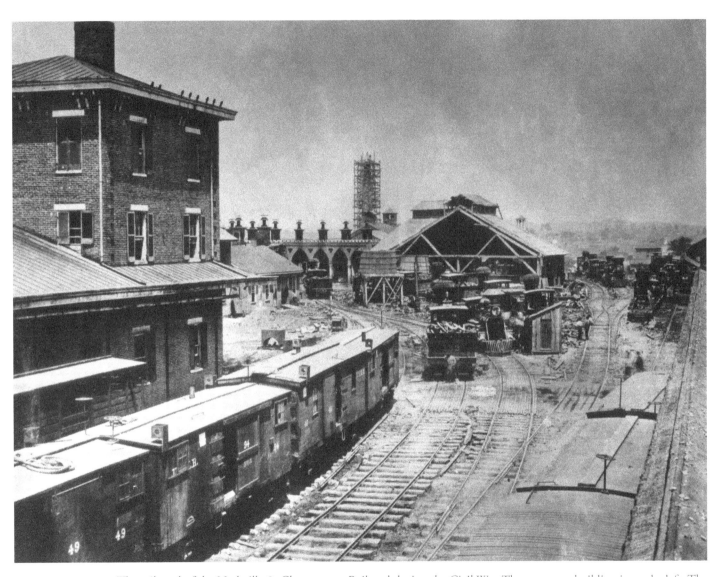

The rail yard of the Nashville & Chattanooga Railroad during the Civil War. The passenger building is on the left. The scaffolding in the center, erected by Union forces, is adjacent the roundhouse that was being demolished to make way for a new repair shop.

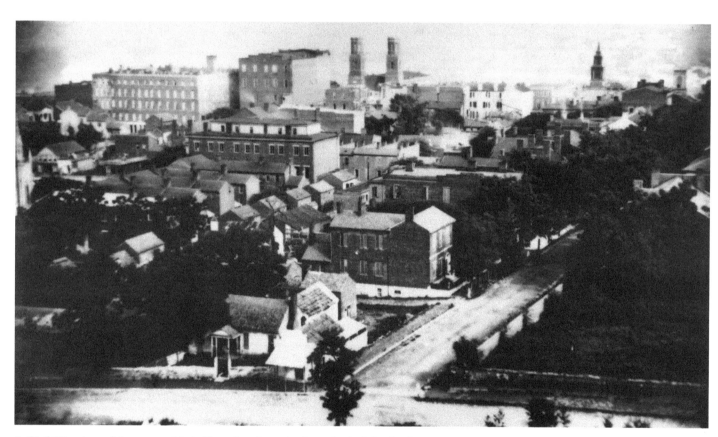

A Civil War view of downtown Nashville, taken from the State Capitol. In the distance are, from left to right: the Maxwell House Hotel, the Masonic Lodge, First Presbyterian Church, McKendree Methodist Church, and Christ Episcopal Church.

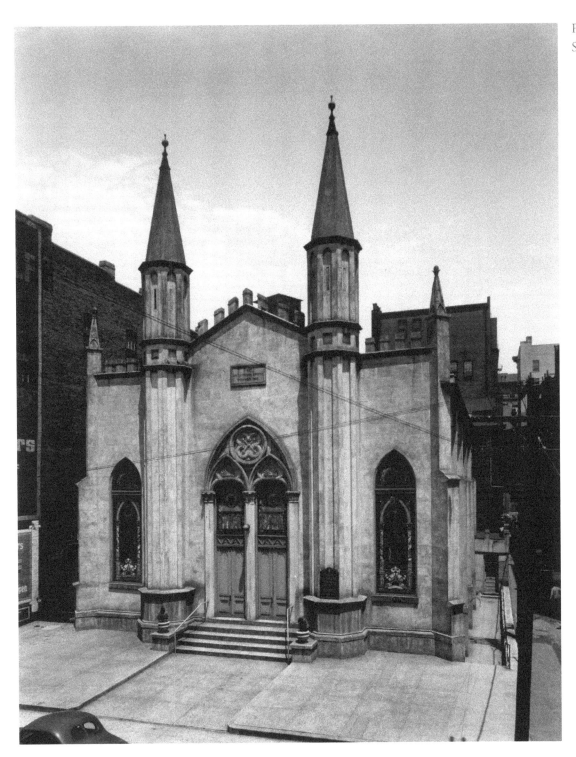

First Baptist Church,
Summer Street, circa 1880.

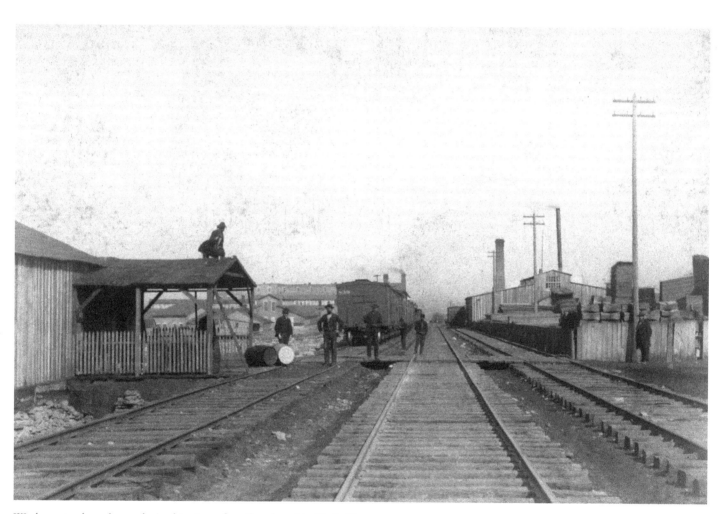

Workers stand on the tracks in this view of a railroad yard in Nashville.

This view of the Nashville Railway Yard shows Fisk's Main Building (left) and Fisk Jubilee Hall (right) on the hill in the background. The cornerstone of the Main Building was laid in 1873. Jubilee Hall was completed two years later.

The north side of Union Street
around 1875.

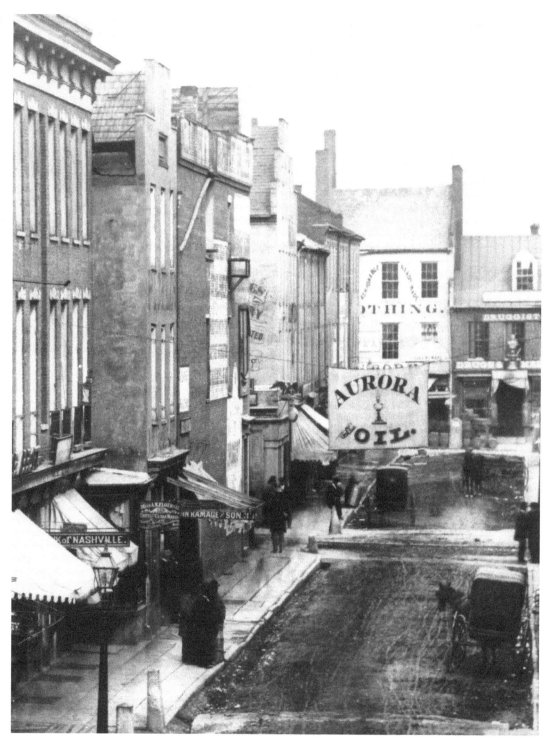

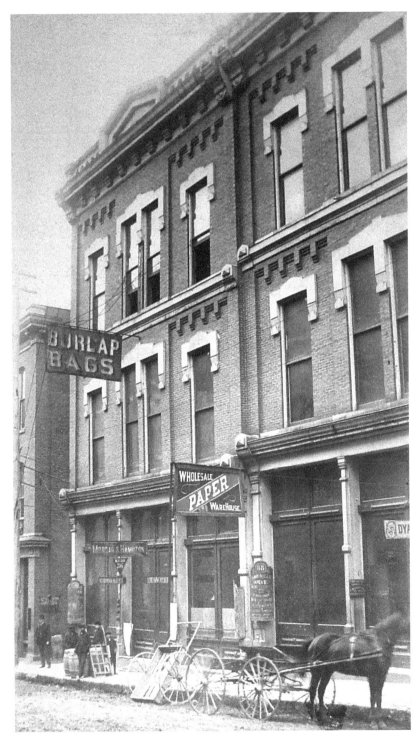

American Paper Box Company (ca. 1880s) was one of the suppliers for the many printing companies of Printers Alley.

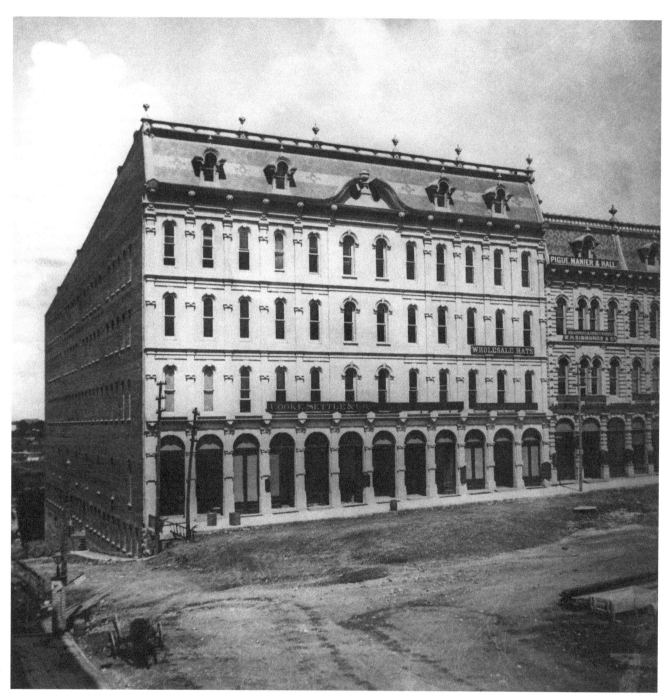

Northeast corner of Nashville's public square around 1874.

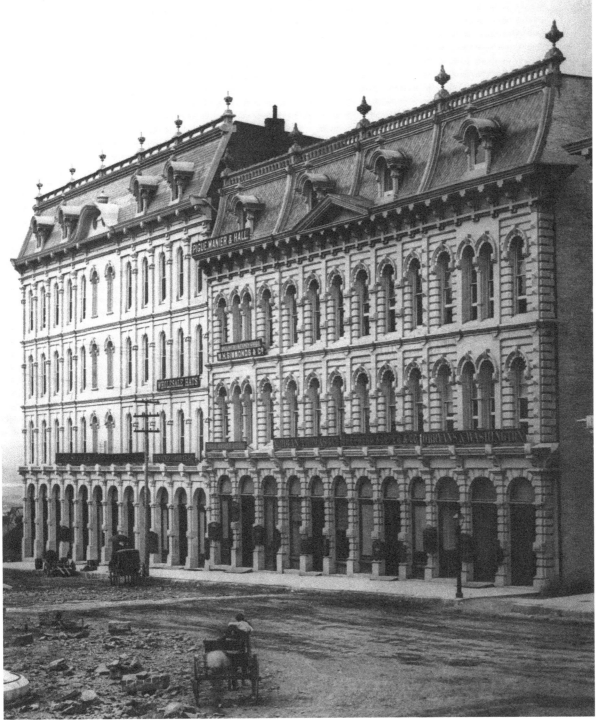

East side of
Nashville's public
square around
1874.

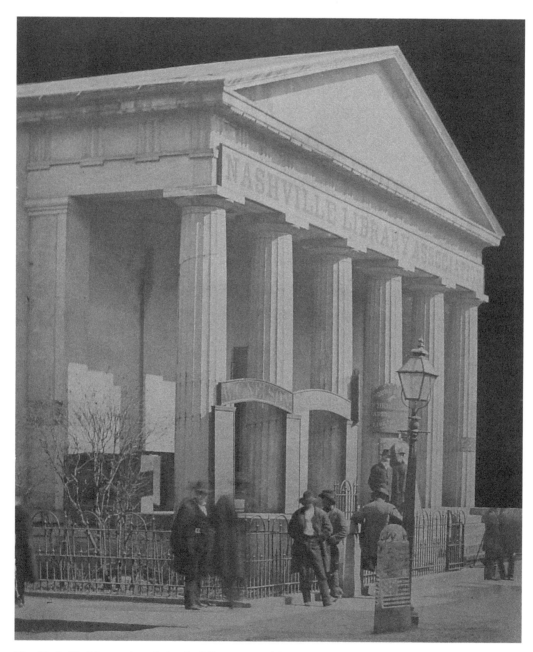

The Nashville Library Association building, pictured here in 1882, was once home to the Bank of Tennessee building.

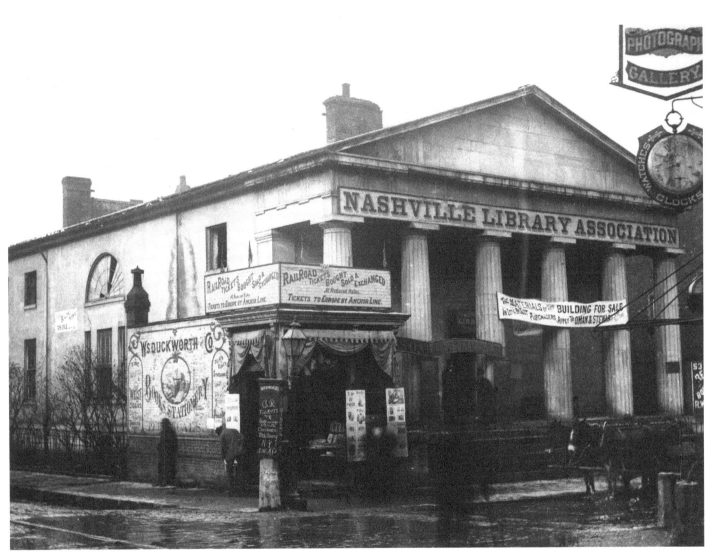

Nashville Library Association on the corner of Cherry Street (Fourth Avenue) and Union Street, 1881.

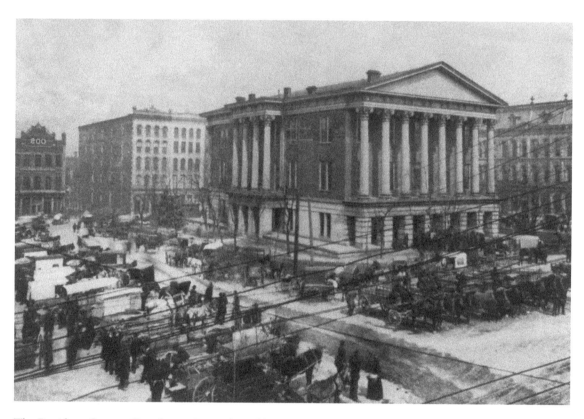

The Davidson County Courthouse sits on the public square. The building, designed by Francis Strickland, was constructed in 1856.

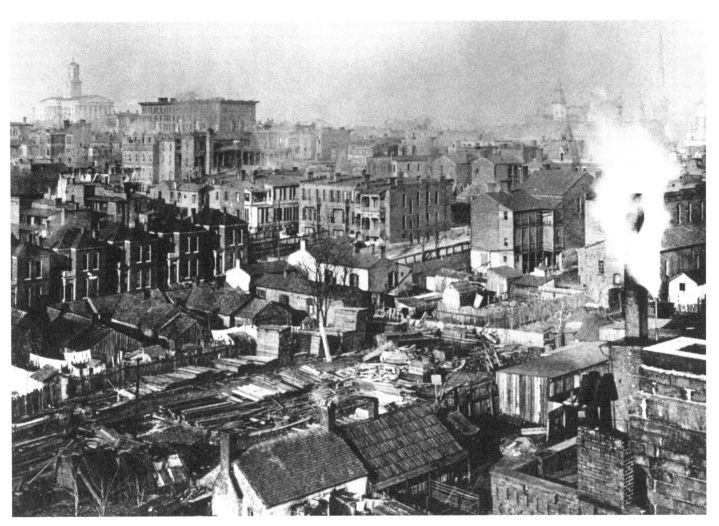

A late 1800s view from Broad Street. The State Capitol, at upper left, towers over Nashville.

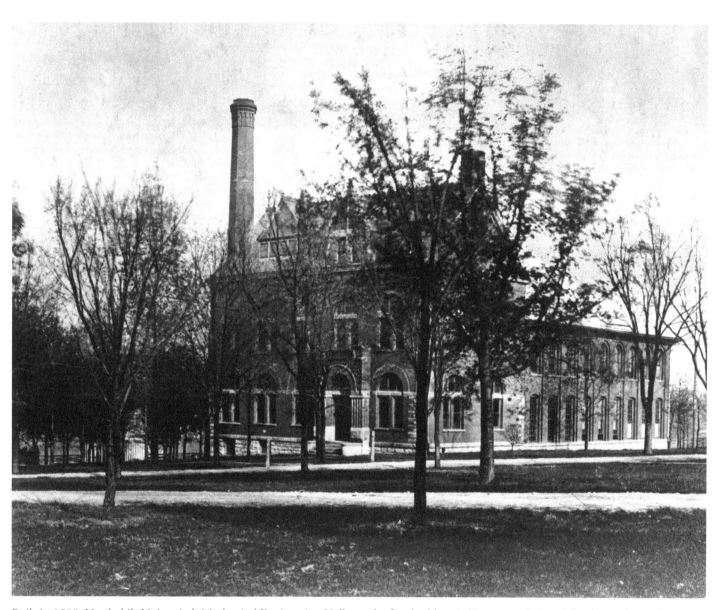

Built in 1888, Vanderbilt University's Mechanical Engineering Hall was the first building in Tennessee designed for the teaching of engineering. The front portion of the building remains today as a part of Owen Graduate School of Management.

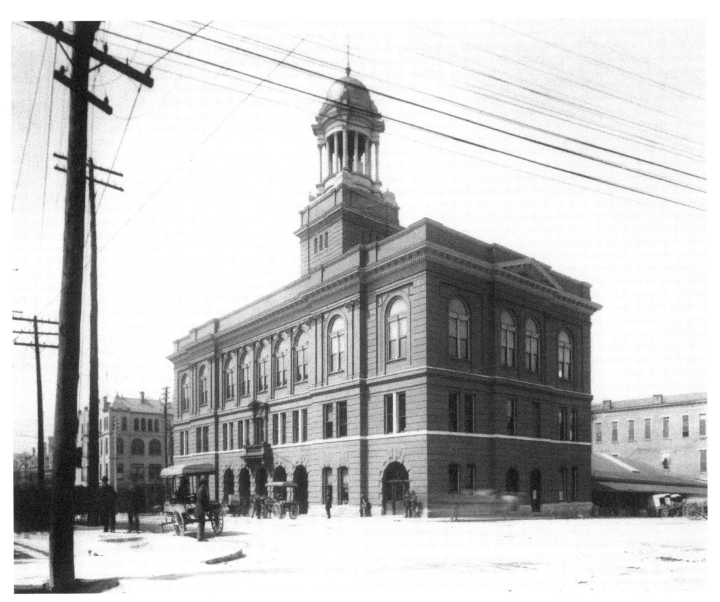

The Nashville City Hall faces Deaderick Street in 1890.

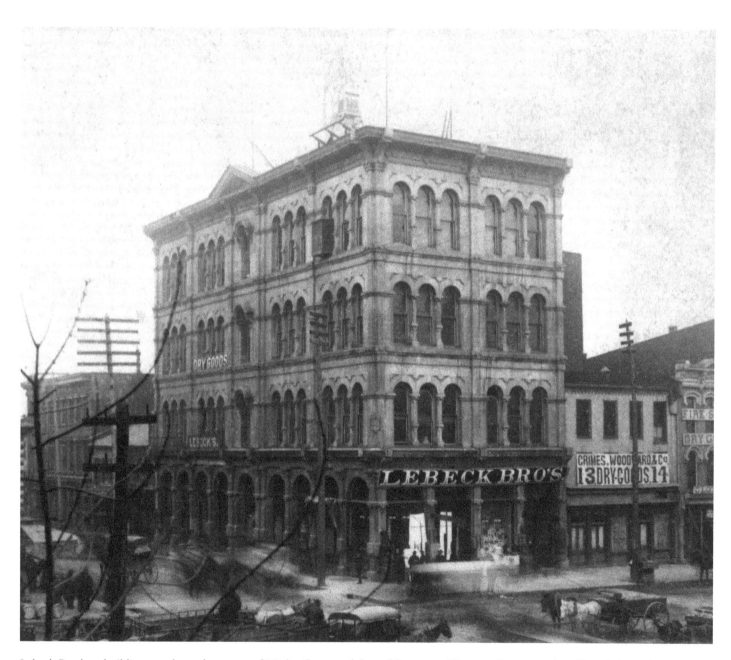

Lebeck Brothers building stands on the corner of Market Street and the public square. The store later moved to Church Street between Fifth and Sixth avenues. Lebeck closed in 1940, and the building was sold to Denton & Company, who, in turn, sold it to Fred Harvey, January 18, 1942.

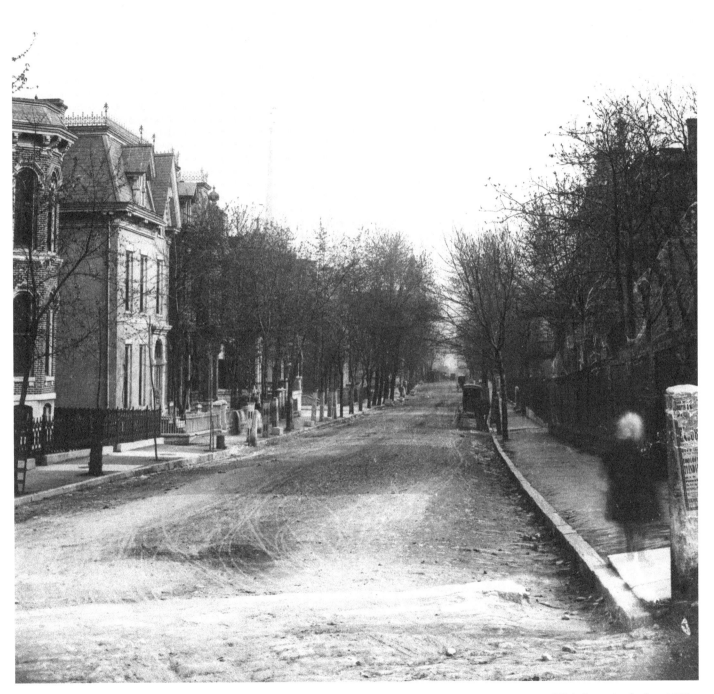

High Street in the late 1800s.

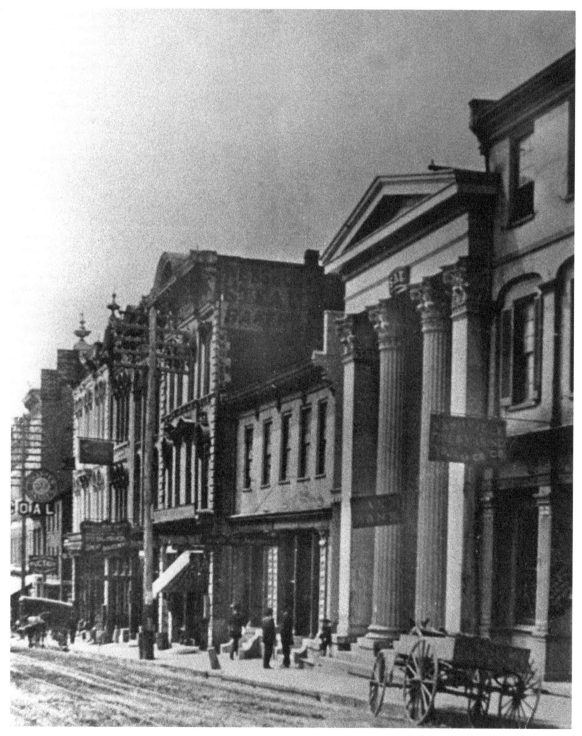

The west side of College Street looks south from Union Street around 1885.

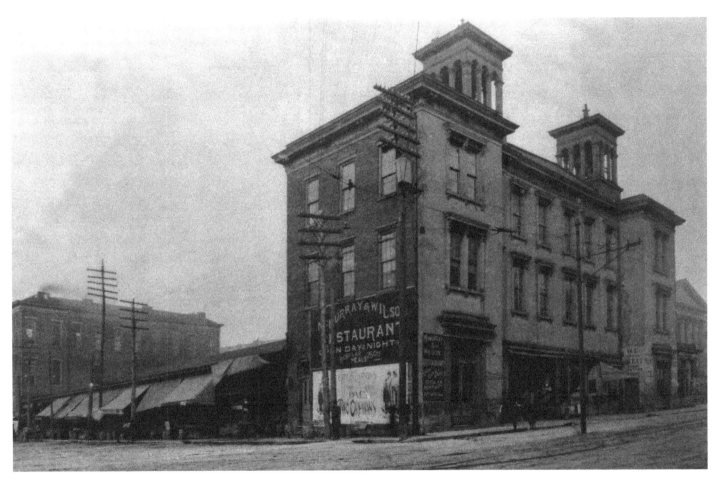

A later view of the Nashville Market House, circa 1875-85. This photograph was taken after the introduction of electricity in Nashville. McMurray & Wilson's offers "regular meals" for 25 cents.

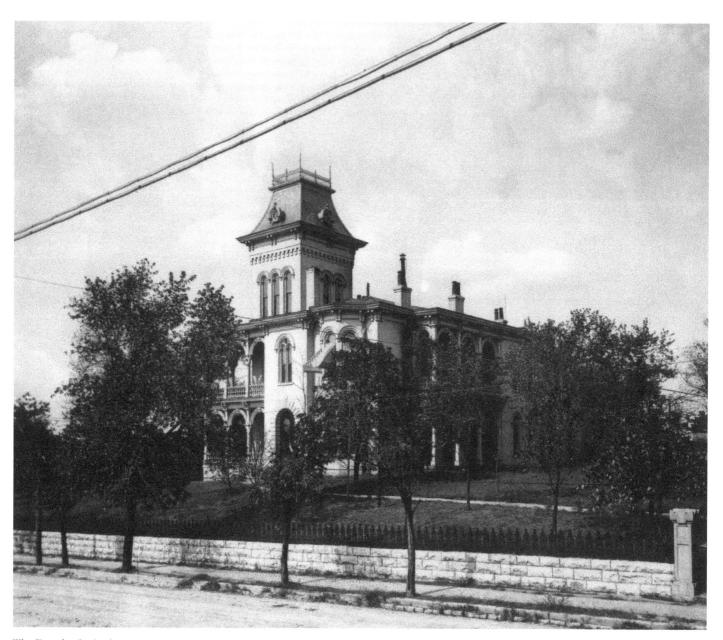

The Douglas Sanitarium.

Dr. William T. Briggs' Infirmary on South College Street stands opposite the medical school grounds (ca. 1894).

Belmont Mansion interior. The mansion, once known as the Belle Monte estate, was home to the wealthy Joseph and Adelicia Acklen before the Civil War.

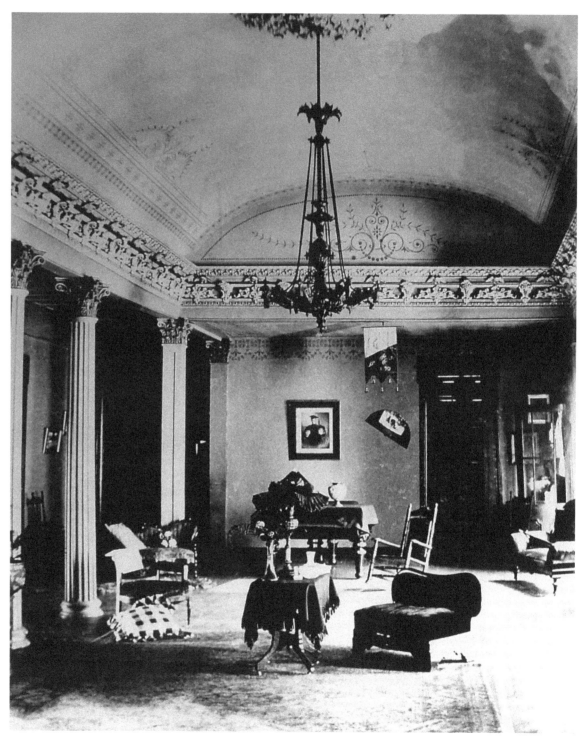

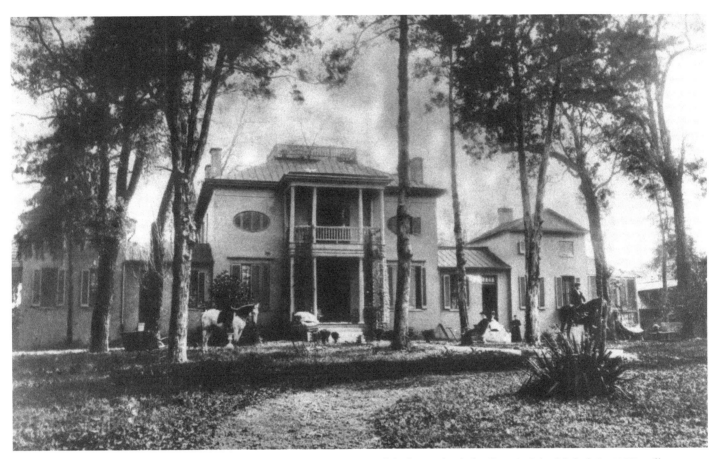

An 1890s view of Woodlawn Plantation facing Harding Pike. A portion of the house, built for Captain John Nichols in 1807, still stands at 127 Woodmont Blvd.

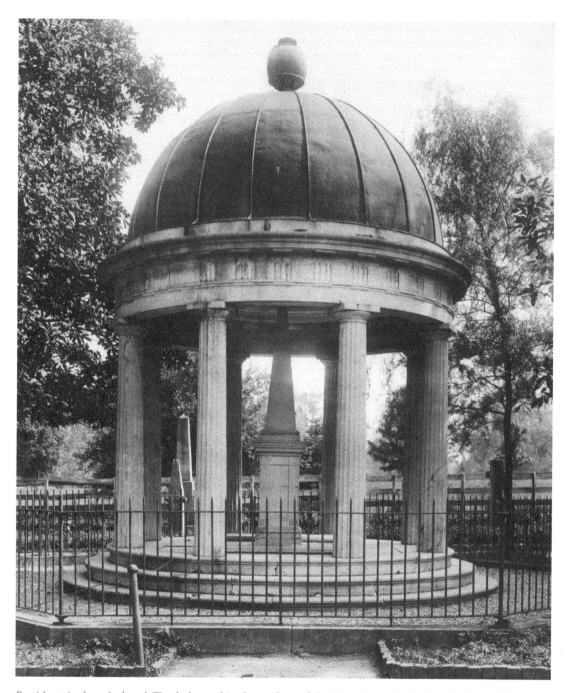

President Andrew Jackson's Tomb, located in the gardens of the Hermitage. Andrew's wife, Rachel Donelson Jackson, died in 1828 just before Andrew took the oath of office. His niece Emily Donelson served as First Lady during his presidency. Andrew was buried next to Rachel in 1845.

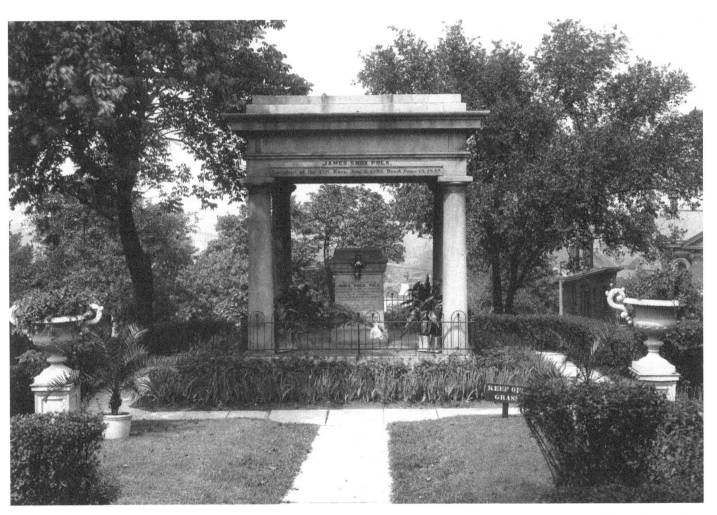

The James Knox Polk Tomb, located on the grounds of the State Capitol. Polk was president of the United States from 1845 to 1849. He and his wife, Sarah, were originally buried in the garden of their mansion, Polk Place, close to North Vine Street (now 7th Ave. North). They were re-interred on the State Capitol grounds in 1893.

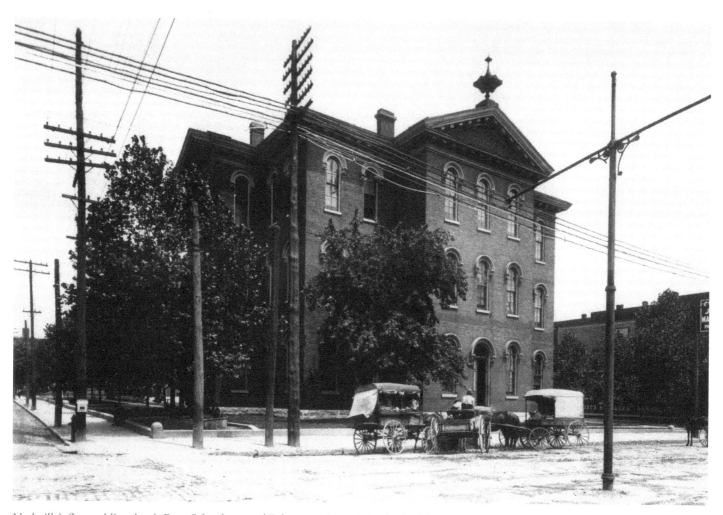

Nashville's first public school, Fogg School, opened February 26, 1855, in this building on the northeast corner of Broad and Spruce Streets.

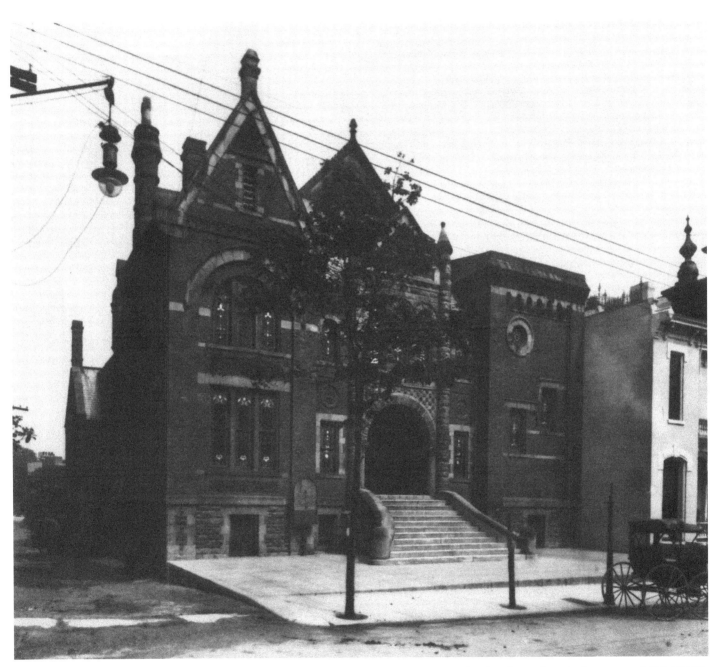

Vine Street Christian Church's new building on Vine Street was completed in September 1889 at a cost of $21,177.79.

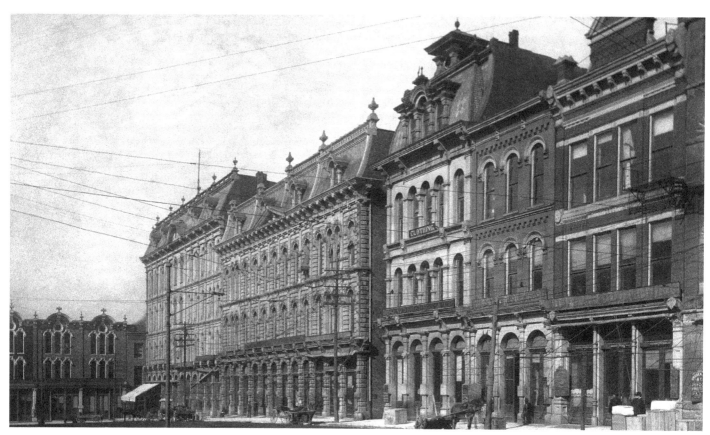

East side view of Nashville's public square, circa 1898.

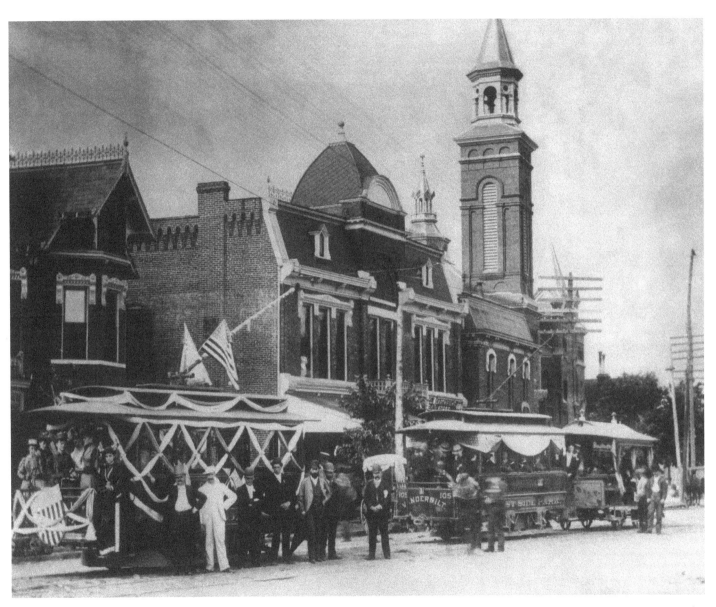

Nashville inaugurated its first electric streetcar service on April 30, 1889. This photograph, taken that day, shows the Vanderbilt and West Side Park streetcar in front of West End Methodist Episcopal South Church on the corner of Mulberry and Broad streets.

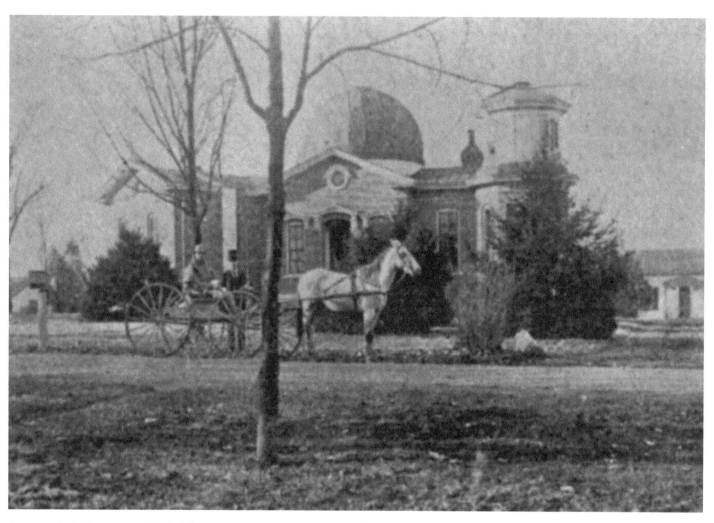

Astronomical Observatory, Vanderbilt University campus, circa 1895. It was named Barnard Observatory in 1942 in memory of Edward Emerson Barnard, one of America's most noted astronomers, an instructor at Vanderbilt from 1883 to 1887. The observatory was razed in 1952.

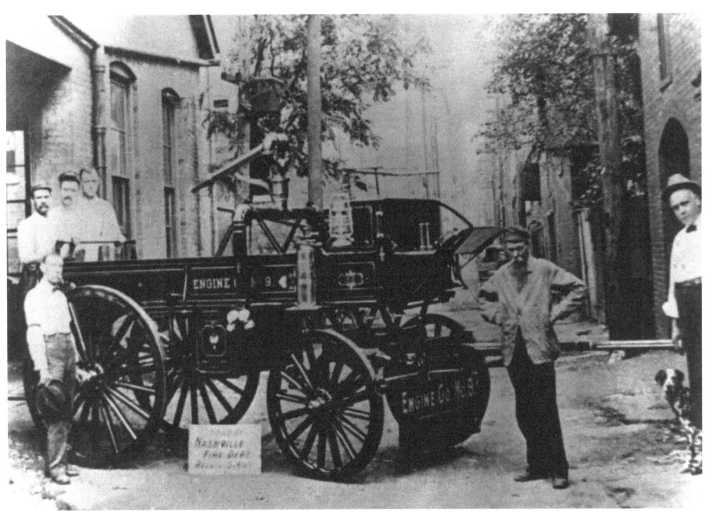

Nashville Fire Department Company, Engine #9. It was built by the department's repair shop in 1895.

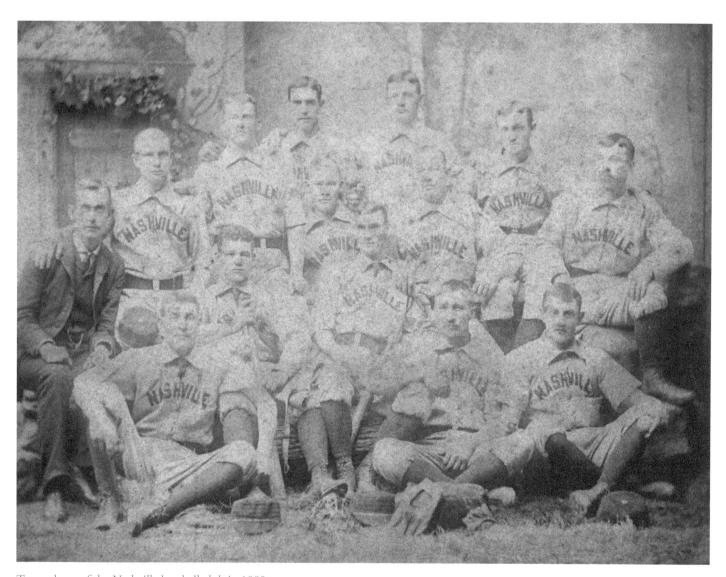

Team photo of the Nashville baseball club in 1880.

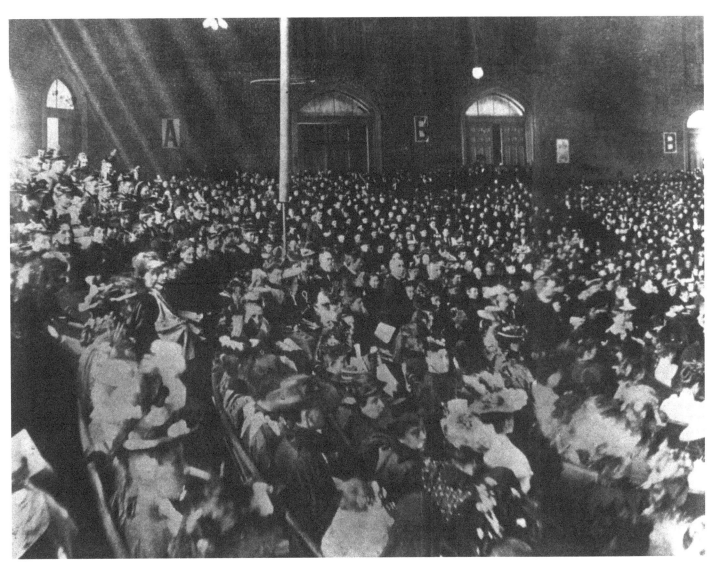

A ladies meeting at the Union Gospel Tabernacle (Ryman Auditorium) is conducted by the evangelist Sam Jones in 1896.

Unveiling of the Confederate Monument in Mount Olivet Cemetery, May 16, 1896. An estimated 10,000 people were in attendance.

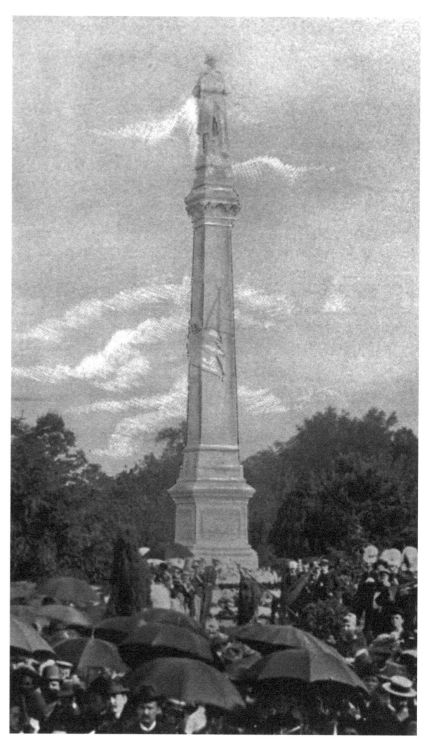

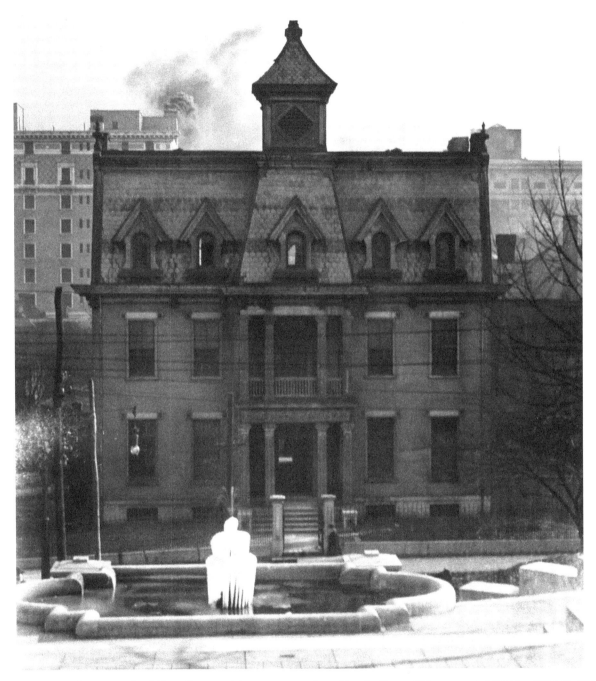

This house, known as the Bishop Byrne residence, was purchased by the State of Tennessee in 1907 for $23,000. When this photograph was taken sometime after the completion of the Hermitage Hotel (left) in 1910, and the dedication of the YMCA Building (right) in 1912, the building was used for state offices.

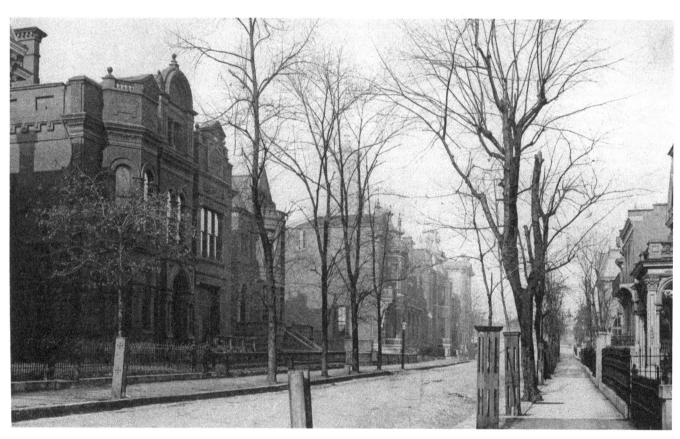

High Street (Sixth Avenue North), 1894.

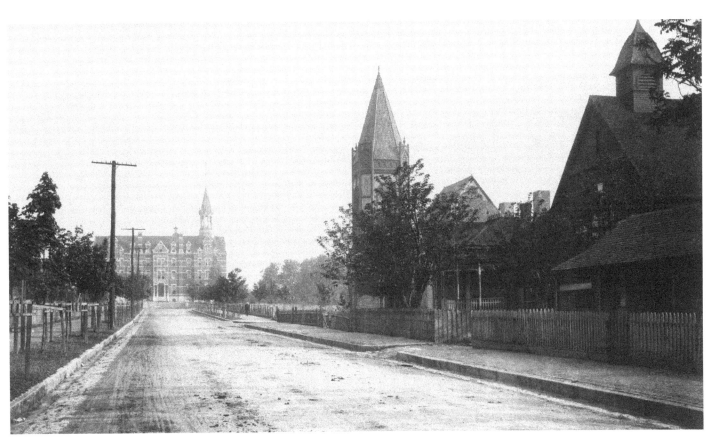

Addison Avenue on the Fisk University campus in 1899. Fisk Jubilee Hall is at the end of the street, and Fisk Memorial Chapel, with its distinctive tower, is on the right.

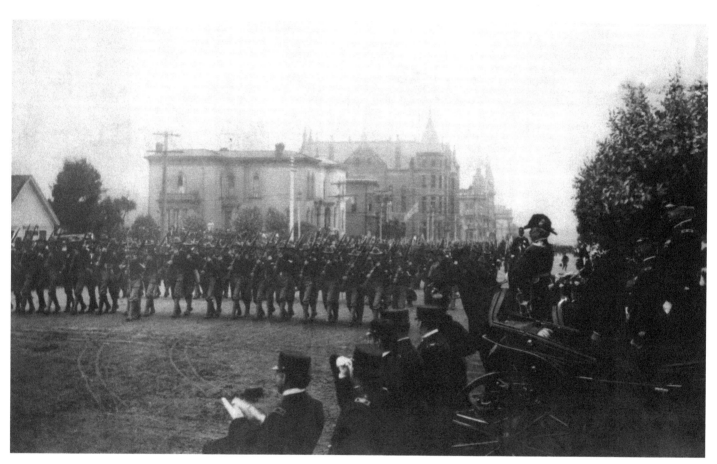

American soldiers from the Spanish-American War march in Nashville.

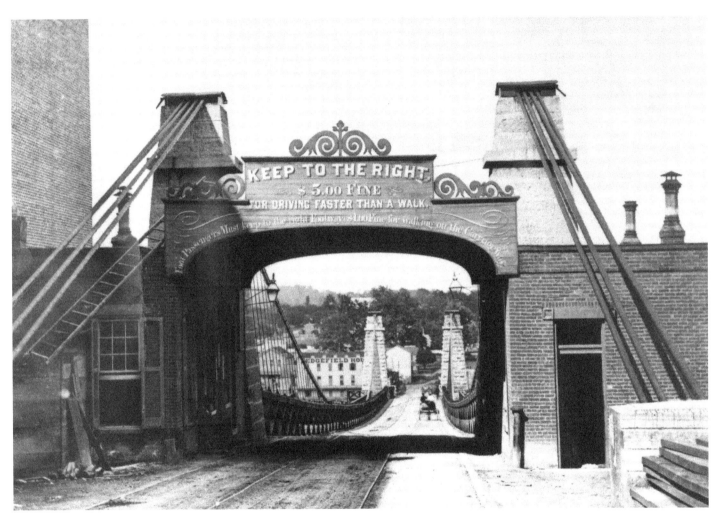

The suspension bridge rebuilt following the Civil War. The masonry towers on the west and east ends were remnants of the first suspension bridge, destroyed by retreating Confederate forces in February 1862.

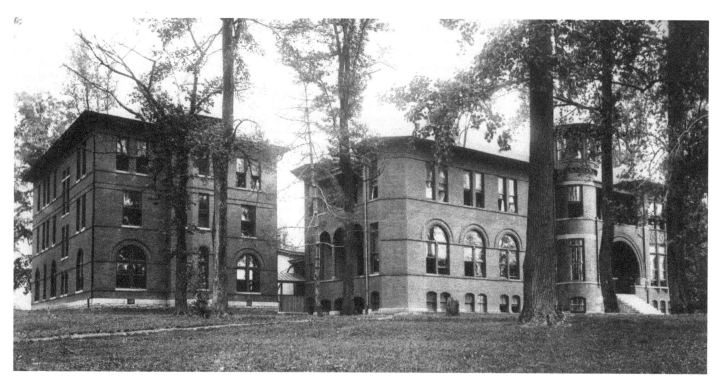

Boscobel College for Young Ladies located in East Nashville.

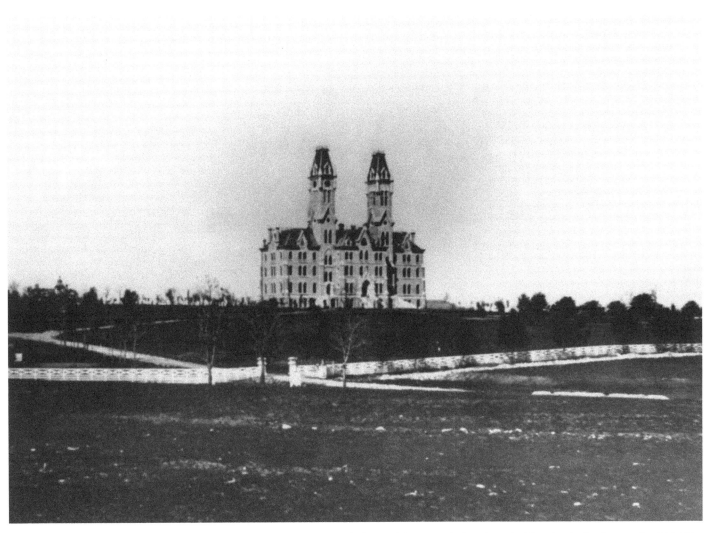

The main entry gate to Vanderbilt University at the end of Broad Street with the Main Building in the background, 1875. The wooden fence was built around the campus to prevent livestock from intruding. The stone gateposts remain today.

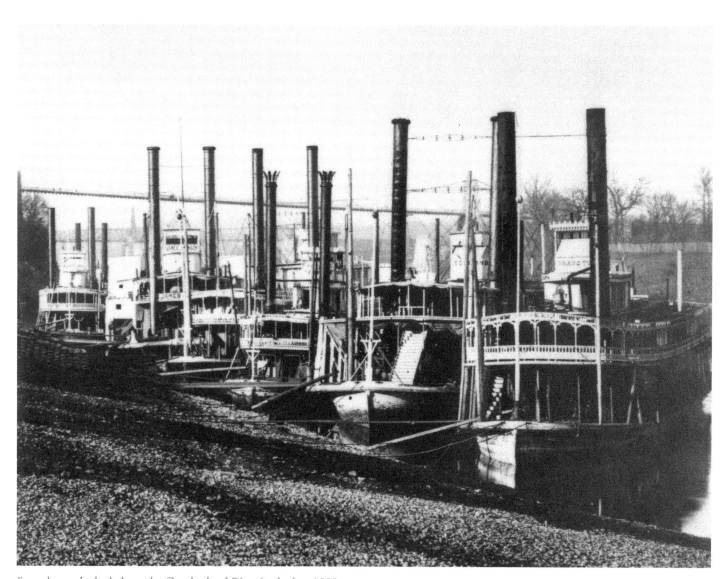

Steamboats docked along the Cumberland River in the late 1800s.

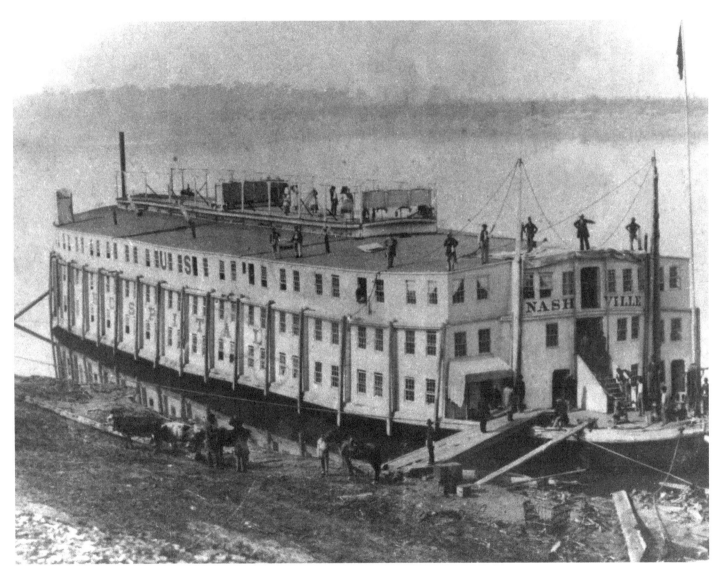

Civil War hospital ship named for Nashville.

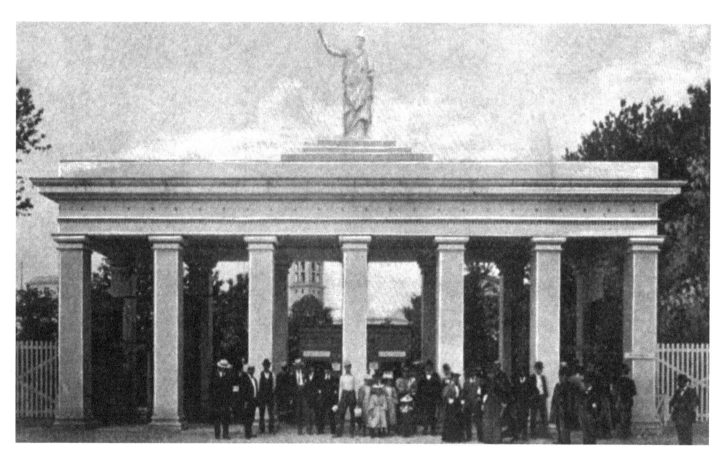

Entrance to the Tennessee Centennial Exposition in 1897. The exposition saw 1.8 million visitors over a six-month period.

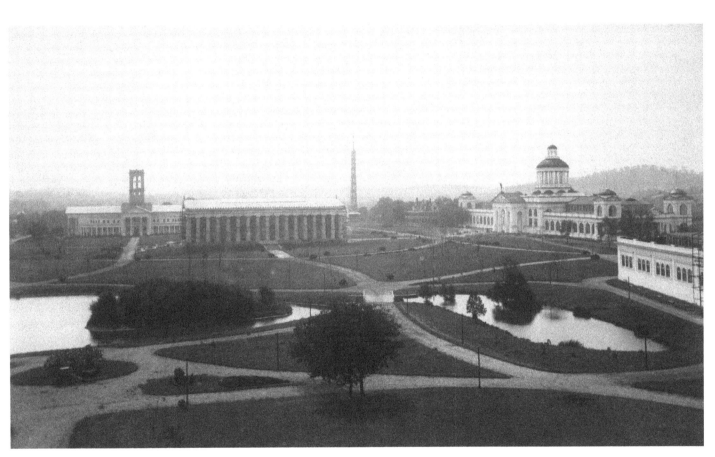

The Tennessee Centennial Exposition of 1897, featuring many buildings with Lake Watauga in the foreground. The Parthenon is flanked by the Auditorium on the left and the Commerce Building on the right.

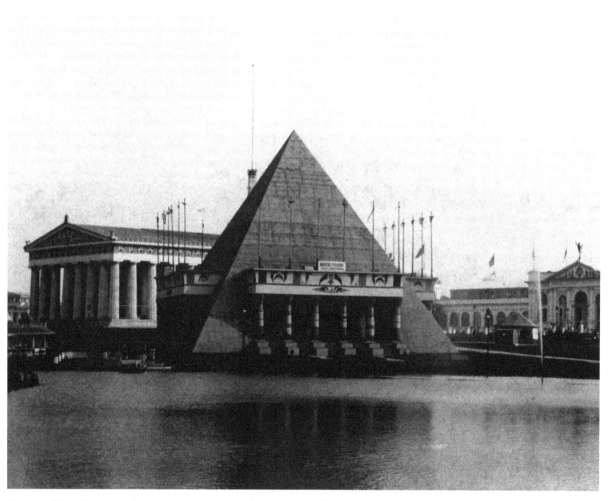

A view of the Tennessee Centennial Exposition of 1897. From the left are the Parthenon, the Pyramid, and the Commerce Building. In front is Lake Watauga.

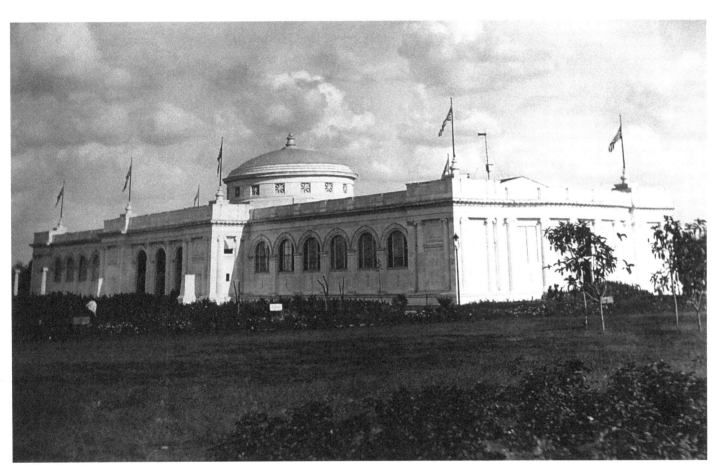

The Government Building at the Centennial Exposition.

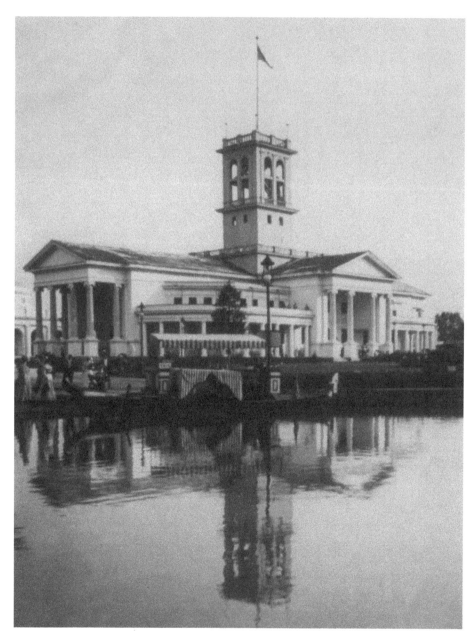

The Auditorium at the Centennial Exposition.

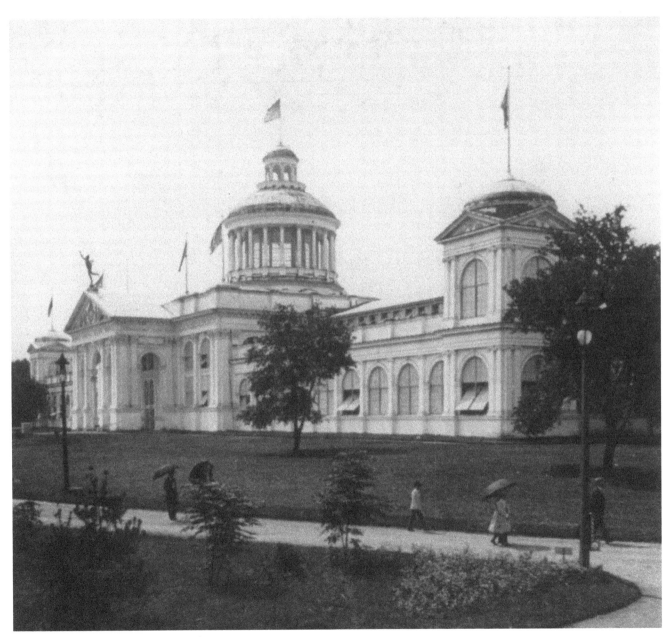

The Commerce Building at the Centennial Exposition. The Statue of Mercury, at left, was later placed on top of Union Station.

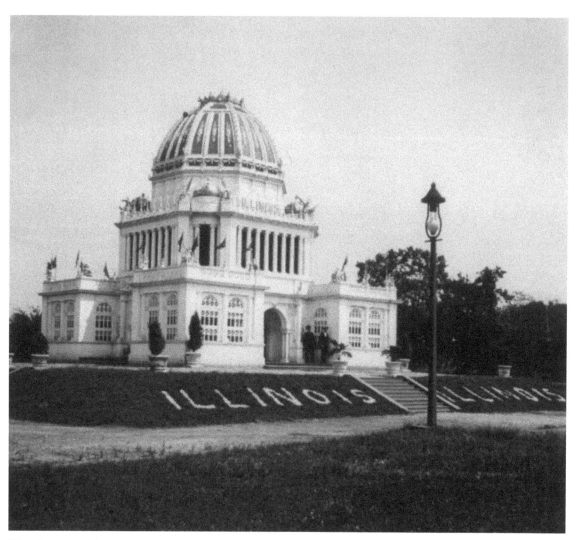

The Illinois Building at the Centennial Exposition.

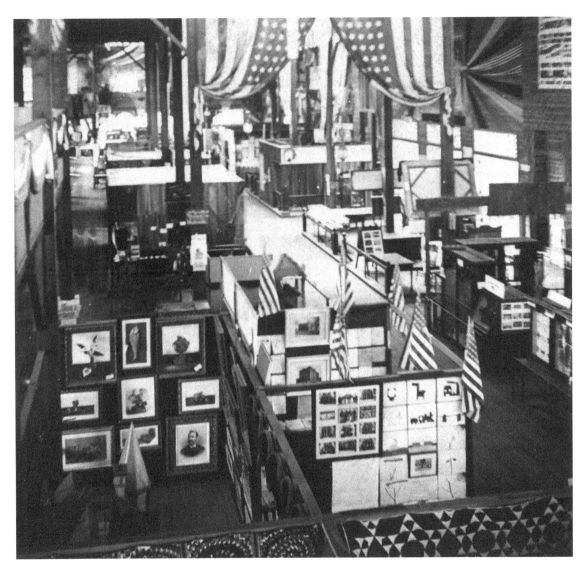

Interior view of a building at the Tennessee Centennial, 1897.

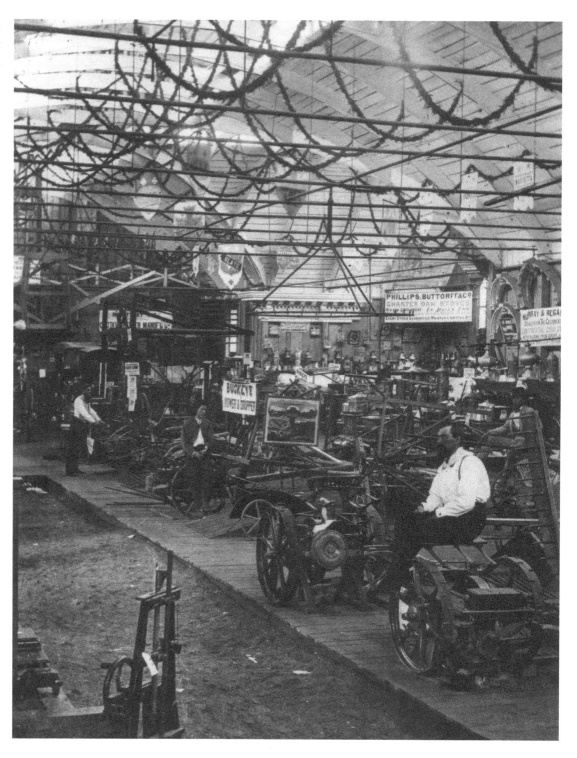

Inside Machinery Hall in the Machinery Building at the Tennessee Centennial Exposition.

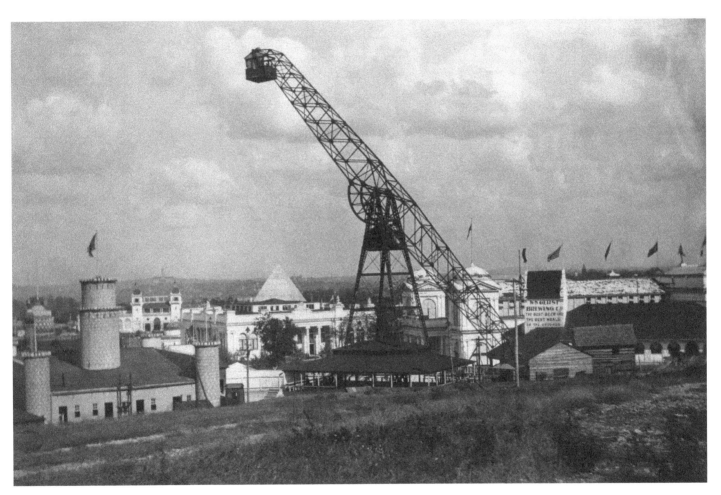

A view from Tip Top Hill of the Giant Seesaw. The Seesaw was the centerpiece of the Midway at the Centennial Exposition. It was later taken to Omaha for its Trans-Mississippi Exposition, where it also proved popular.

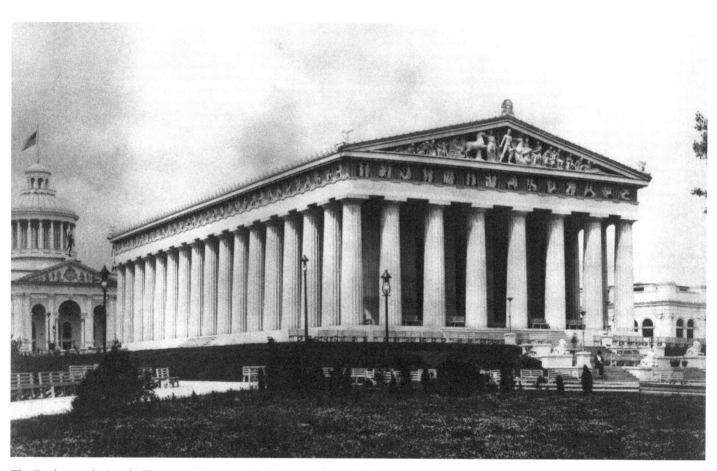

The Parthenon during the Tennessee Centennial Celebration of 1897. The Parthenon was the first of 36 buildings erected for the exposition. The Commerce Building is on the left.

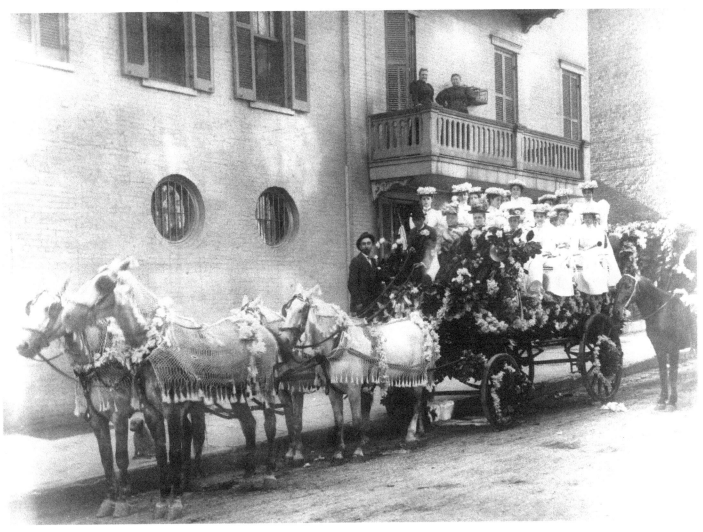

A horse-drawn carriage on the corner of High and Church streets is ready to depart for the Tennessee Centennial Exposition.

Following Spread: Interior of the Parthenon with statues sitting on workbenches during the building's reconstruction, as a permanent structure made of concrete, in the 1920s.

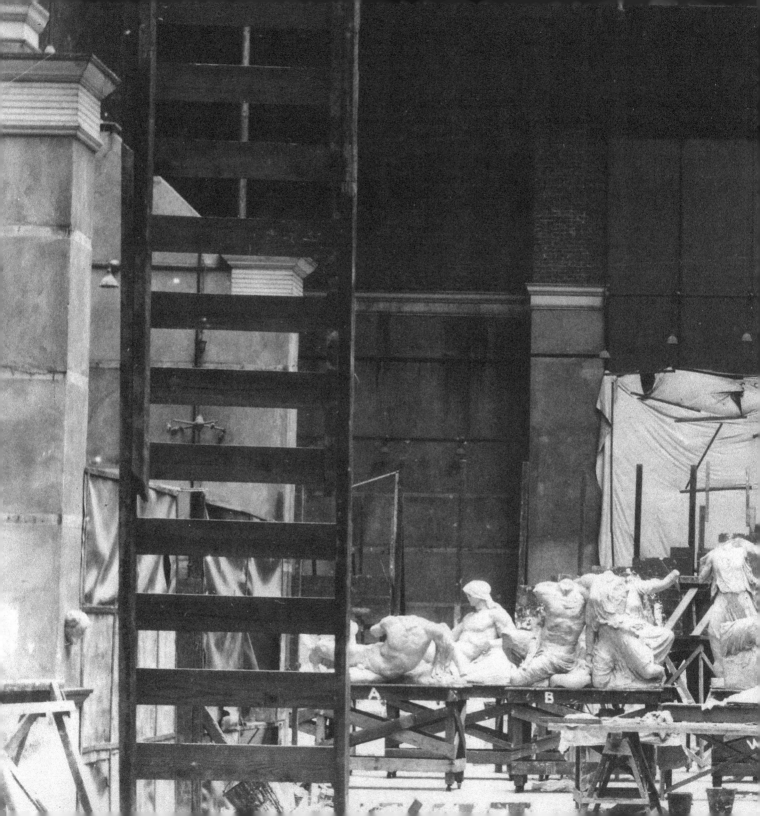

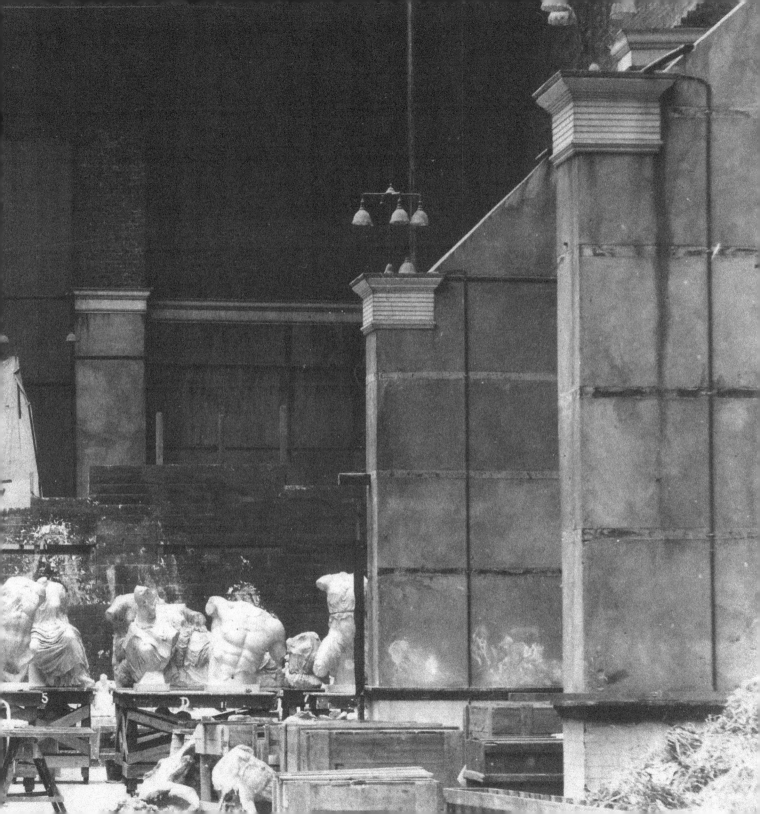

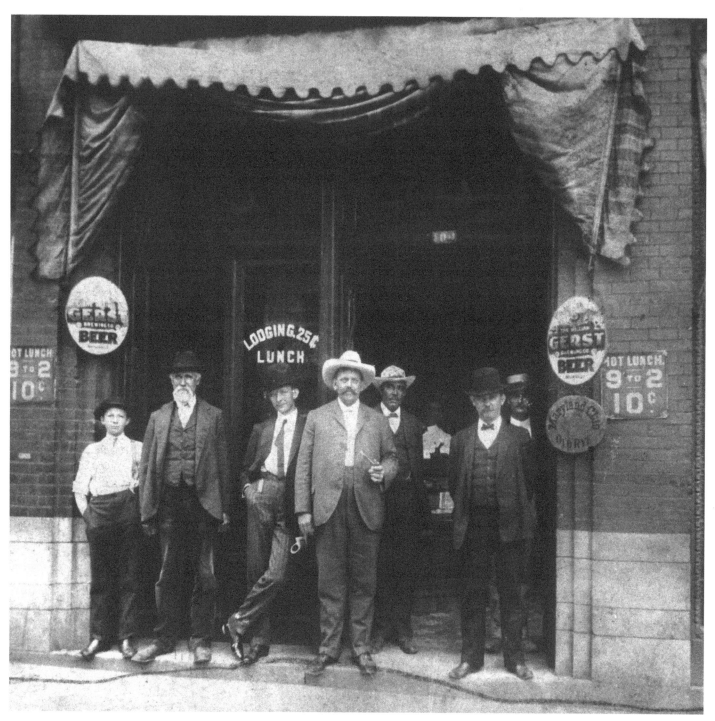

The storefront of the Silver Dollar Saloon advertises Gerst Beer and a hot lunch for 10 cents in 1900.

A City at the
Turn of the Century

1900–1917

Nashville was evolving from a war-beaten Civil War town to a sophisticated city exploring art, entertainment, and education. At the turn of the century, Nashville's population was growing steadily, and its development over the next two decades would include many cultural, architectural, and political changes.

The city's first library, Carnegie Library, opened in 1904. During that same year, downtown's first skyscraper was erected. In 1900, Union Station opened, followed by the Nashville Arcade in 1903 and the Hermitage Hotel in 1910. As the city continued to expand, the need for entertainment venues, parks, and transportation increased.

Nashville saw the beginnings of a public park system with the purchase of Centennial Park. In 1912, the city witnessed the opening of Hadley Park, "the first and only public park purchased by any municipality in the world for the exclusive use of colored citizens."

In 1902, Nashville experienced two fires at two of the local theaters: the Grand Opera House and the Vendome. Other theaters in Nashville during this time included the Masonic, the Orpheum, and Union Tabernacle Church, which was renamed Ryman Auditorium in 1904. In addition, the Bijou Theatre was erected on the former site of the Grand and over the next decade it became one of the South's leading theaters for African-American audiences.

Organized sports continued to evolve in the early 1900s with the formation of baseball's Southern Association in 1901. The Nashville Volunteers made Sulphur Dell baseball field their home for approximately the next 60 years.

Transportation continued to evolve as the automobile slowly gained popularity. The sounds of galloping horses pulling wagons and carriages was being replaced with the clamorous gasoline engine. In 1910, the Marathon Motor Car Company began manufacturing automobiles in Nashville. And during a 1911 demonstration, a Model T Ford was driven up the steps of the State Capitol in an effort to prove that the automobile could replace the horse.

Nashville endured two major disasters during this era. In 1912, the city's water reservoir ruptured, flooding the southern part of town. Then, in 1916, East Nashville was devastated by fire. The fire lasted only a few hours but destroyed more than 500 homes.

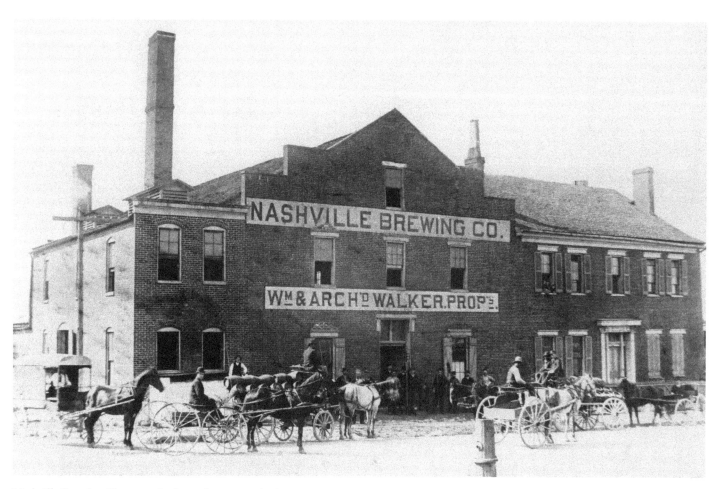

Nashville Brewing Company is shown here around 1900.

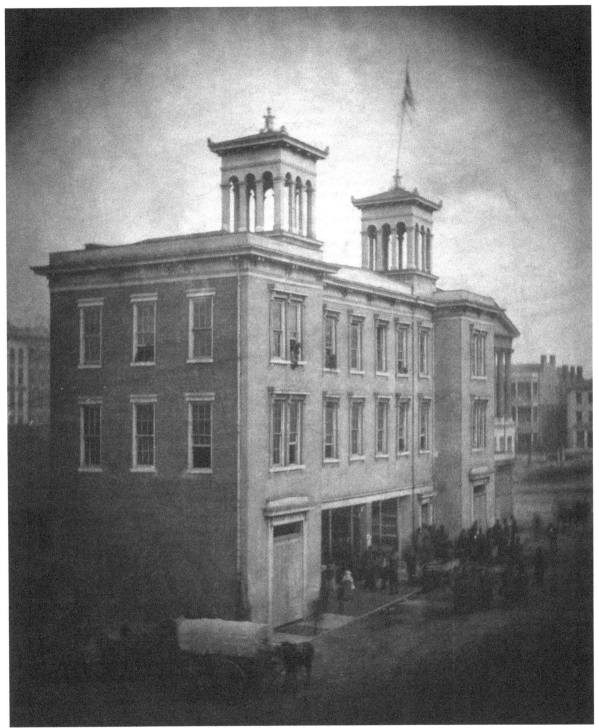

The Market House,
built in 1828.

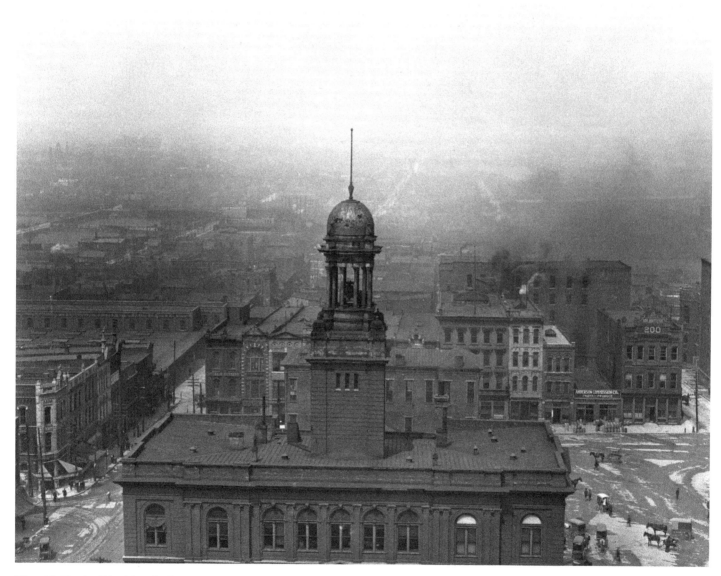

The old City Hall building looks north in this early photograph.

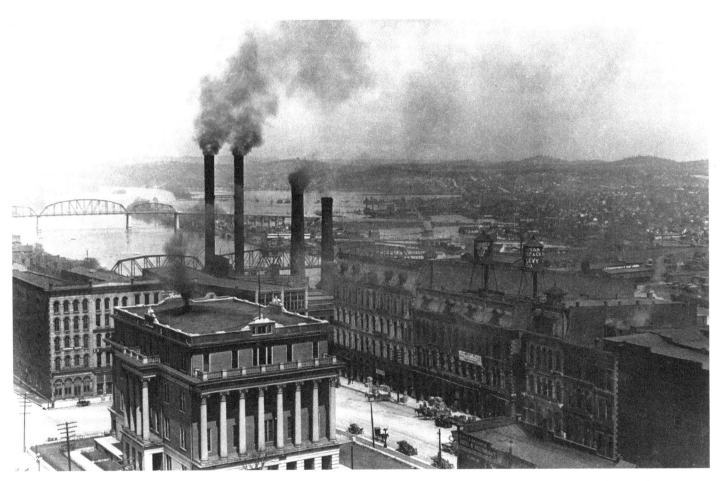

The downtown Courthouse with the railroad bridge and the Jefferson Street Bridge in the background, circa 1915.

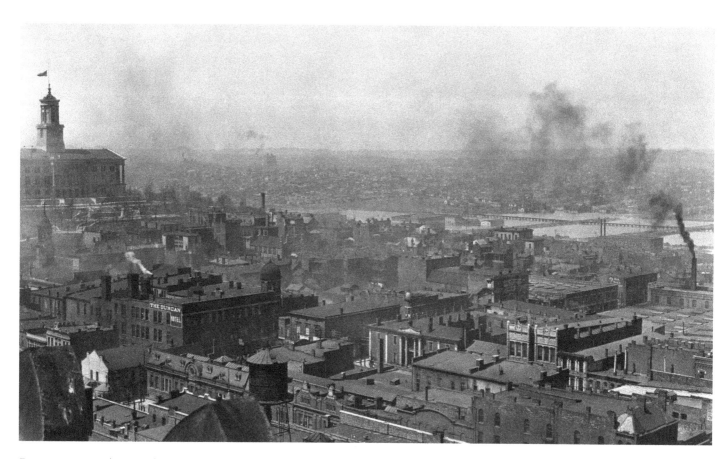

Downtown view showing the State Capitol and the Duncan Hotel. The hotel, at left-center, can be identified by its small dome.

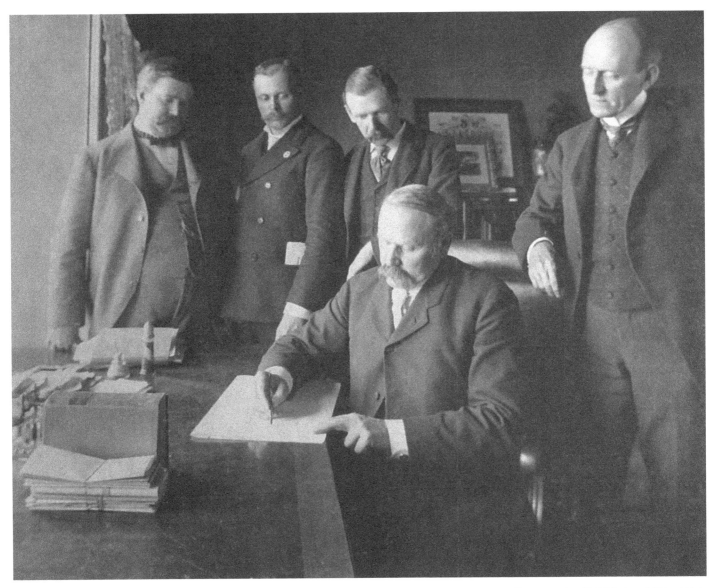

Governor Benton McMillin signs the Child Labor Bill in 1901.

Union Gospel Tabernacle (Ryman Auditorium), circa 1900. The tabernacle was envisioned by riverboat captain Thomas Green Ryman after he was converted by southern evangelist Samuel Porter Jones. The first revival was held within its walls in May 1890.

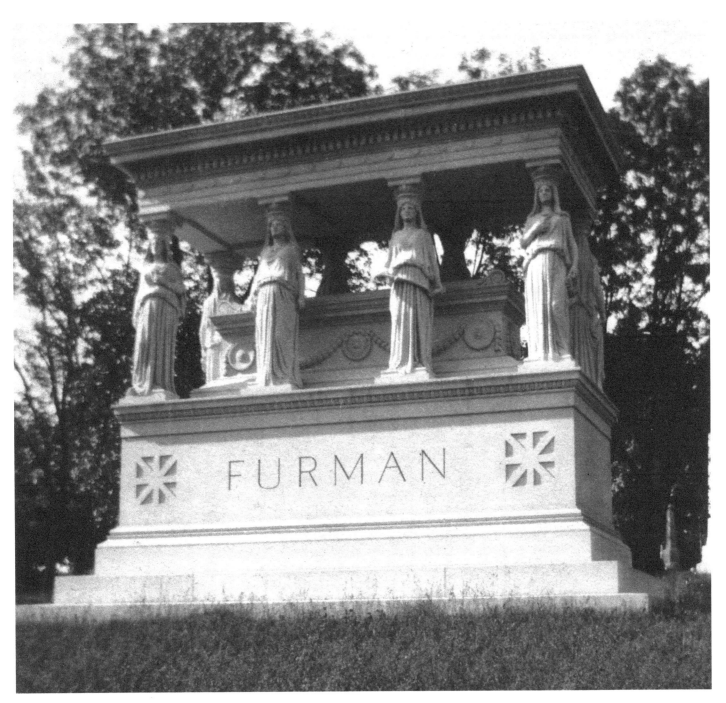

The Furman Monument, pictured here around 1908 or 1909, is the largest monument in Mt. Olivet Cemetery.

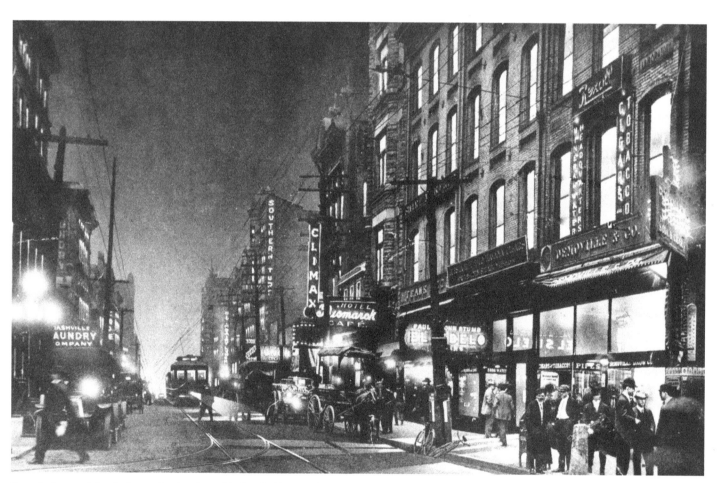

Fourth Avenue North shows the Southern Turf and Climax saloons on the right side of the street. The six-story Utopia Hotel is to the right of the Climax.

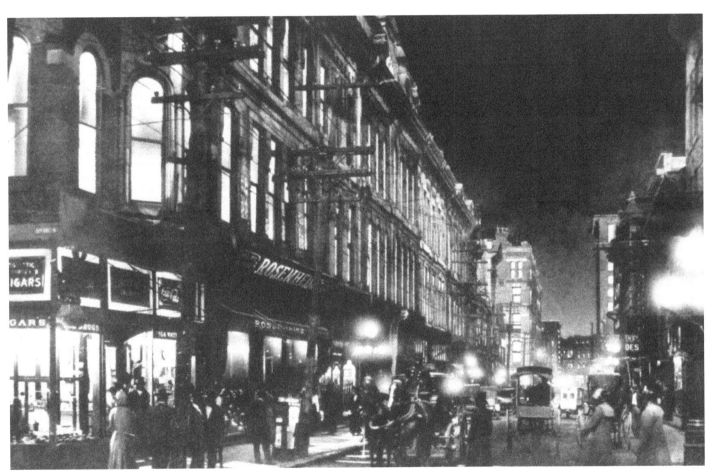

Nightlife on Union Street near Summer Avenue (Fifth Avenue) around 1900.

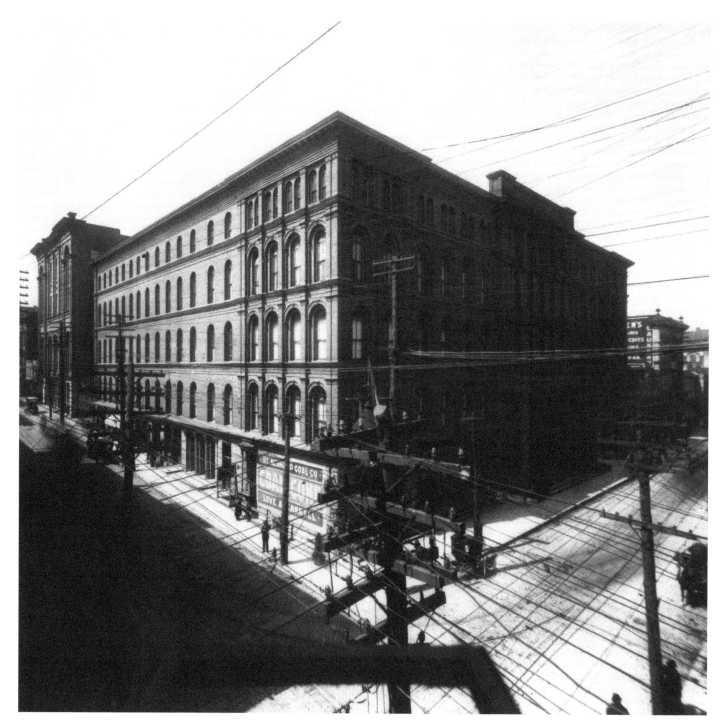

The Maxwell House, Nashville's finest hotel, is the origin of the name for Maxwell House Coffee.

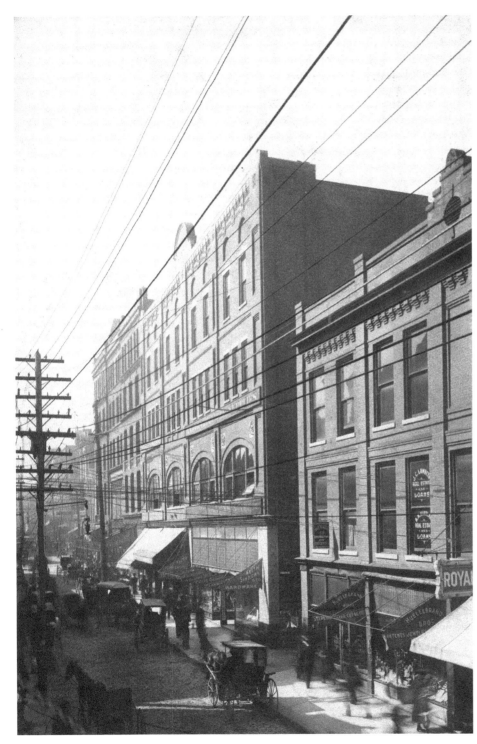

Union Street showcases several businesses including Huellebrand Brothers Jewelry and Keith Simmons Hardware, 316-318 Union Street, in 1906.

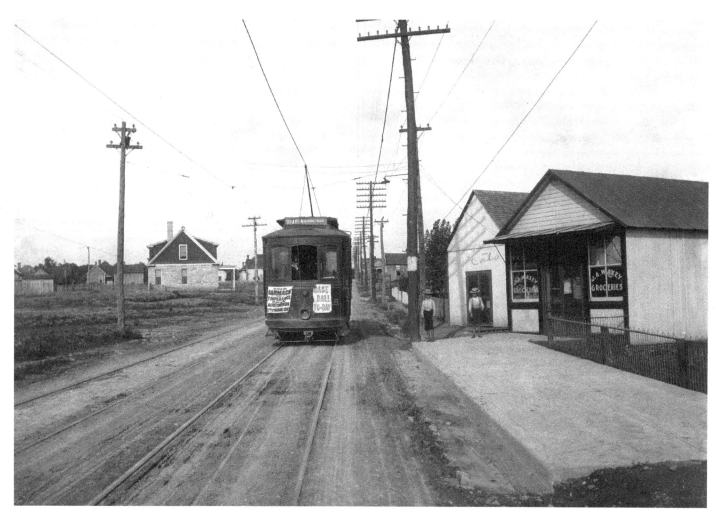

In 1907, an electric streetcar rolls down Buchanan Street advertising baseball games and an Edward W. Carmack speech at the Ryman in favor of prohibition.

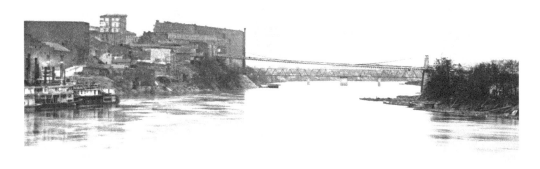

The Cumberland River, just below the current site of the Shelby Street Pedestrian Bridge, is in this view recorded before 1885. The suspension bridge at Woodland Street is in the background.

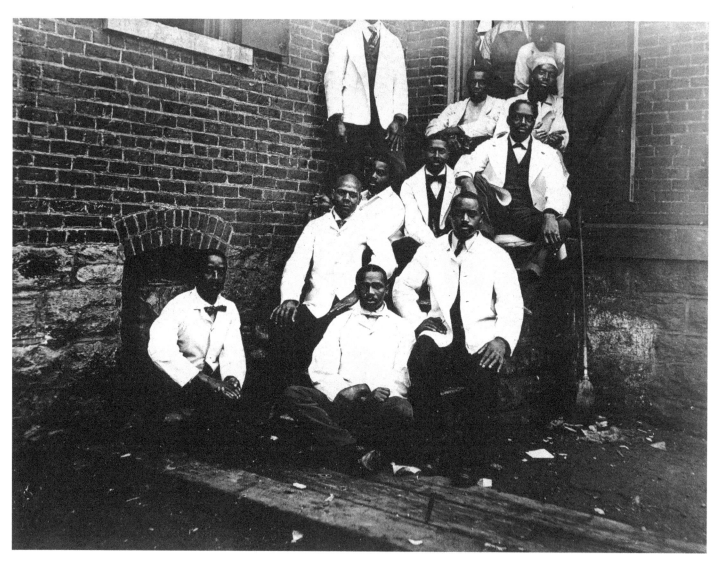

Unidentified cooks, porters, and servers are seated on the steps of West Side Hall at Vanderbilt University.

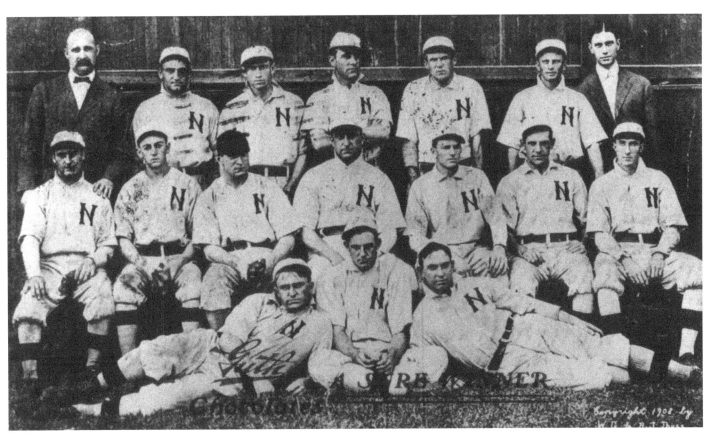

A 1908 group photo of the Nashville baseball team. President Fred E. Kuhn is standing at top-left. Star pitcher, Hub Pardue, is lying on the ground on the left side.

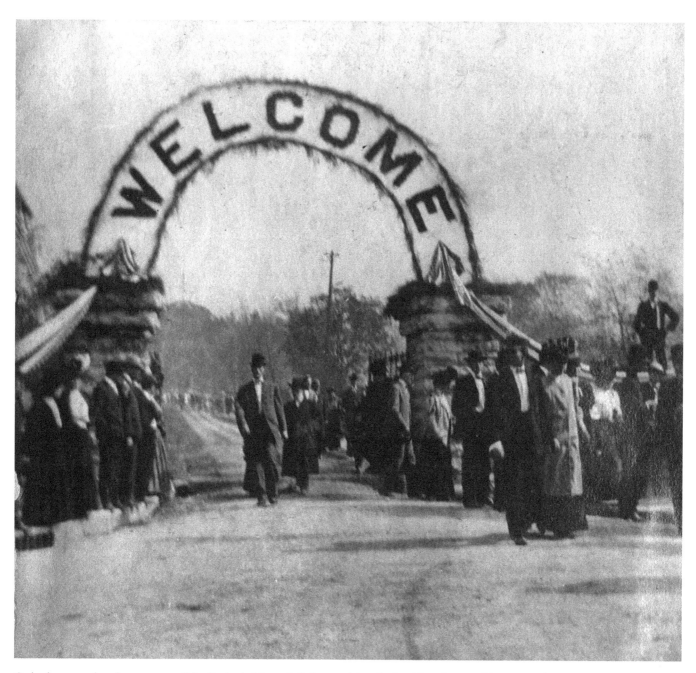

Onlookers stand at the entrance of the Peabody Normal College waiting for President Roosevelt's motorcade to pass by on October 22, 1907. Roosevelt passed by many of the educational facilities of Nashville, including University of Nashville's Medical School, Hume Fogg, Buford College, Belmont College, Radnor College, Boscobel College, Saint Cecelia Academy, and Peabody College, then located on "College Hill" at Second and Lindsley. This area also included the University of Nashville and Montgomery Bell Academy.

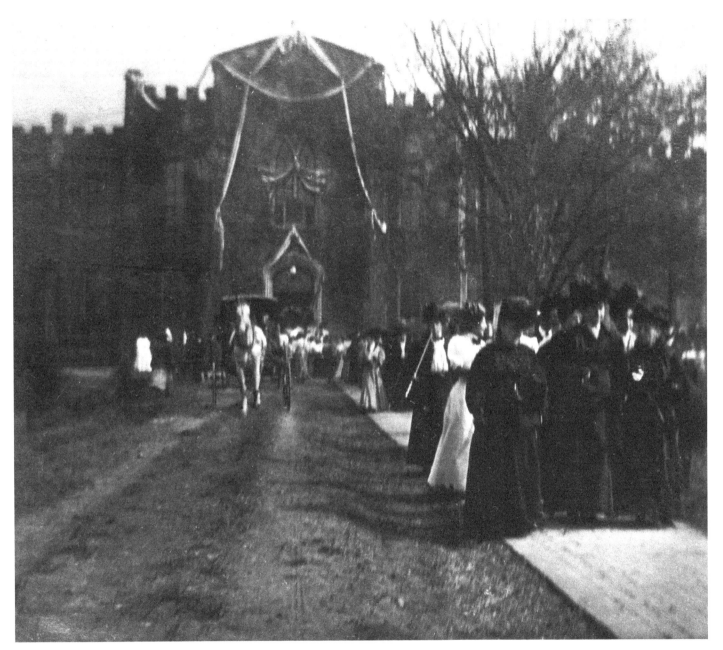

A crowd gathers outside the University of Nashville awaiting President Roosevelt's visit. Roosevelt arrived at Union Station by rail car and proceeded by carriage up Broadway Street and down Eighth Avenue, finally circling back and stopping at Ryman Auditorium, where he delivered a speech. He then changed to a Peerless Automobile and headed to 2nd Avenue, where Peabody and the University of Nashville were located, proceeding to the Hermitage where he again spoke to the crowds. He returned to Union Station by 1:00 P.M. and was then on his way to Chattanooga.

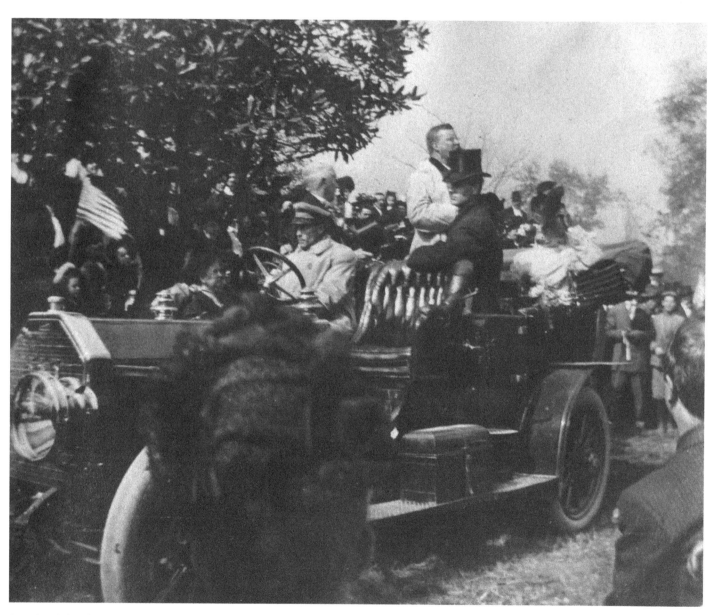

President Theodore Roosevelt's motorcade during a visit to Nashville in 1907. It is said that during this trip, President Roosevelt drank a cup of coffee at Nashville's most opulent hotel, the Maxwell House, and, upon finishing the coffee, exclaimed "good to the last drop," and thus a slogan was born.

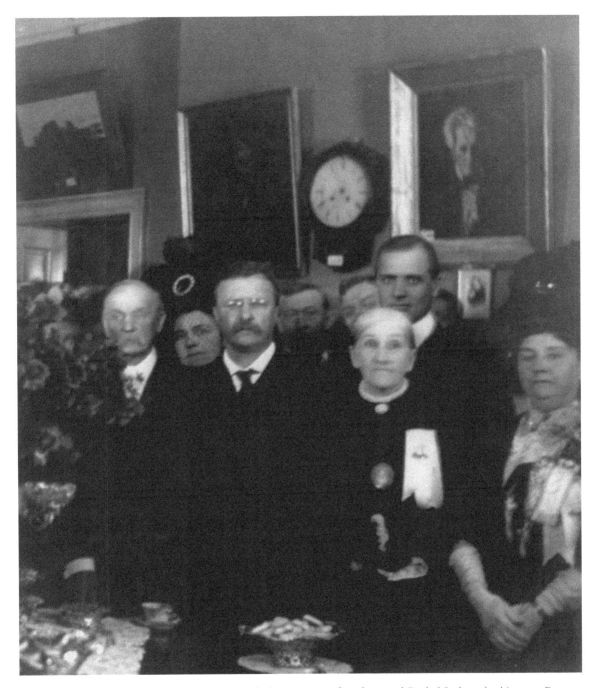

Teddy Roosevelt's visit to the Hermitage with the portraits of Andrew and Rachel Jackson looking on. Regent, Mrs. Mary C. Dorris is at the extreme right. To her left is Mrs. Andrew (Amy) Jackson III, whose idea it was to create a memorial association to preserve and care for the Hermitage.

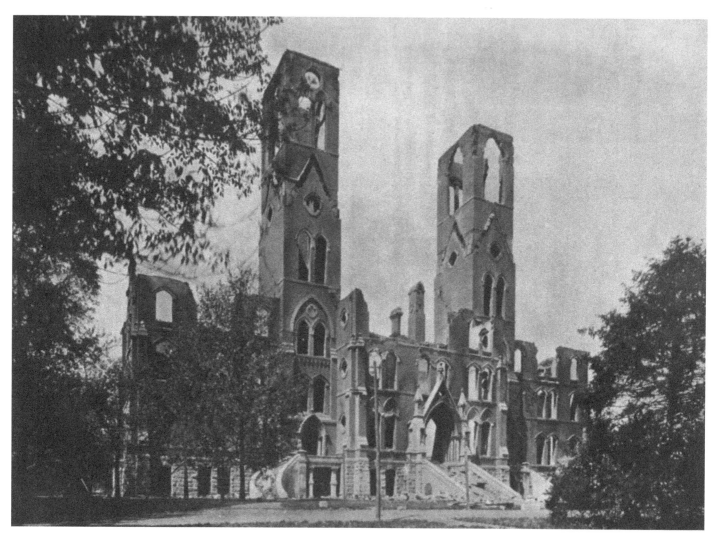

The main building on Vanderbilt's campus is pictured here after the fire of April 20, 1905.

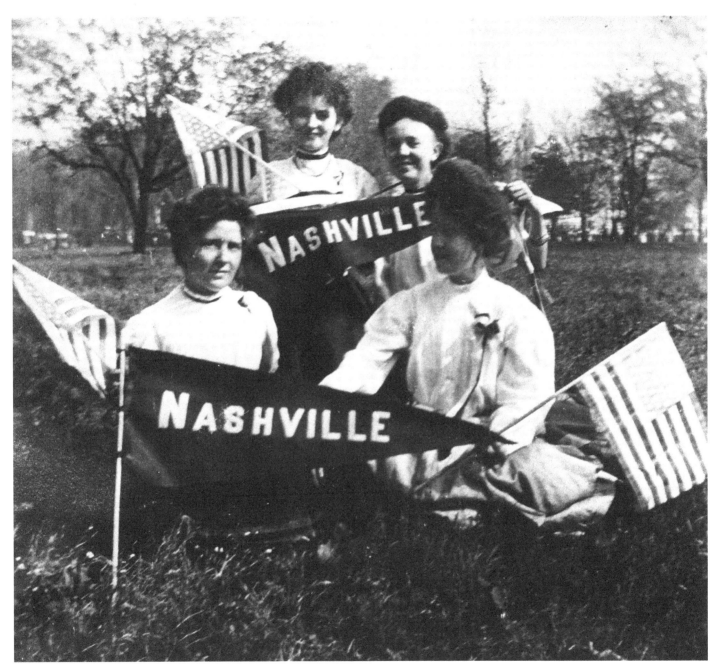

University of Nashville coeds wave flags and banners in honor of Theodore Roosevelt's visit in 1907.

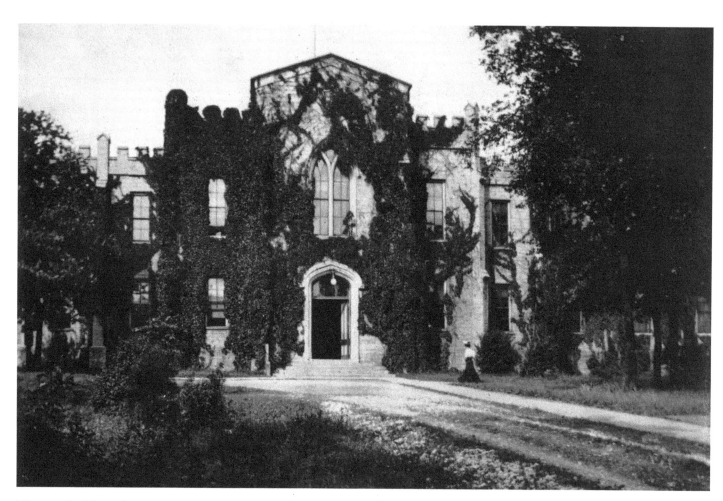

The main building of University of Nashville–Peabody Normal College, circa 1907. In later years, the crenellated, fortresslike structure served as home to the Children's Museum, a much-loved institution that featured live alligators, a model railroad that crisscrossed a miniature Nashville, field trips to local rock quarries, and two shrunken heads.

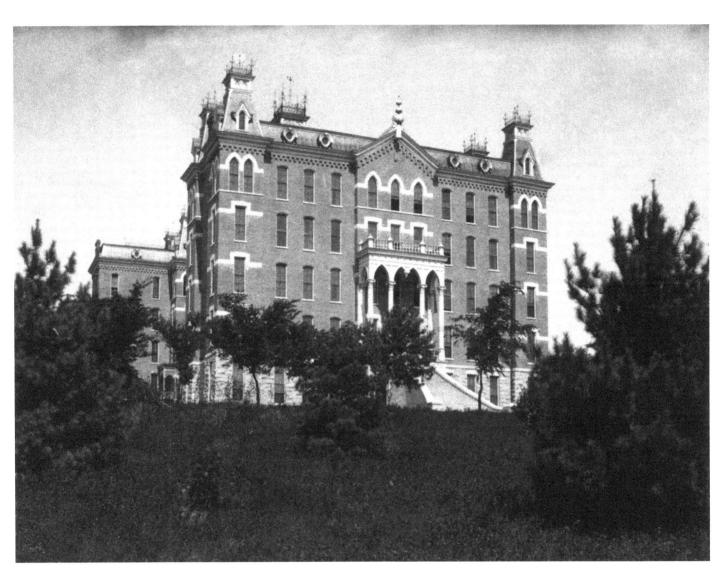

Established as the Biblical Department of Vanderbilt University in 1875, the Divinity School was housed in Wesley Hall from 1880 to 1932.

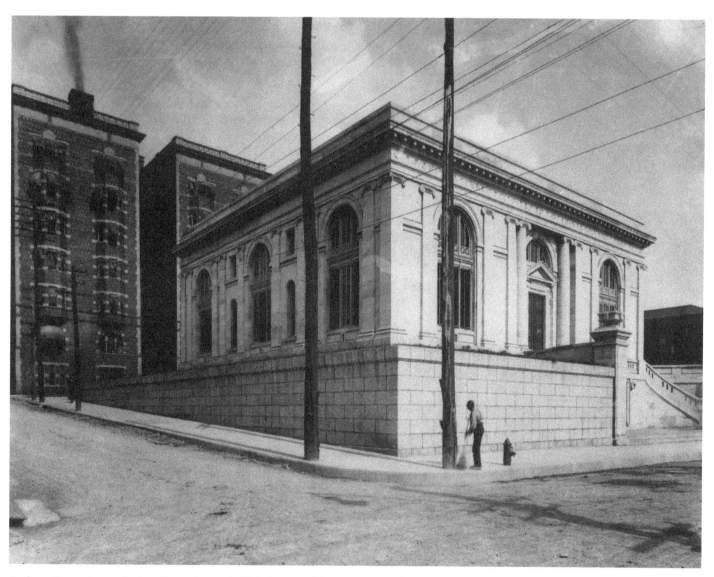

Andrew Carnegie was the benefactor for Nashville's Carnegie Library, pictured here. It was constructed in 1904 for $99,999.97, on time and 3 cents under budget. The Polk Flats is in the background.

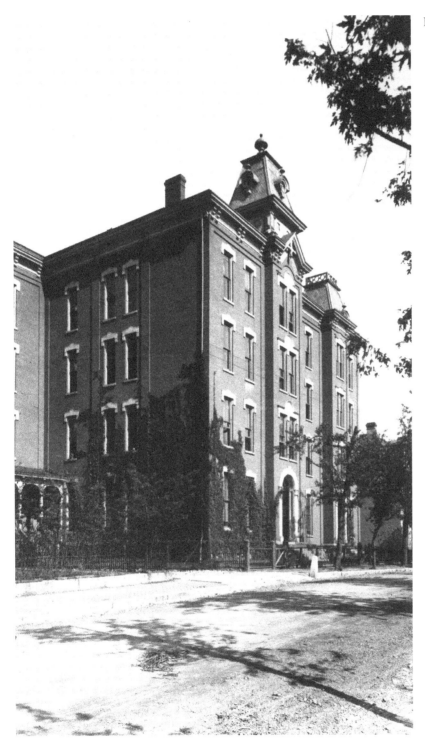

Nashville College for Young Ladies.

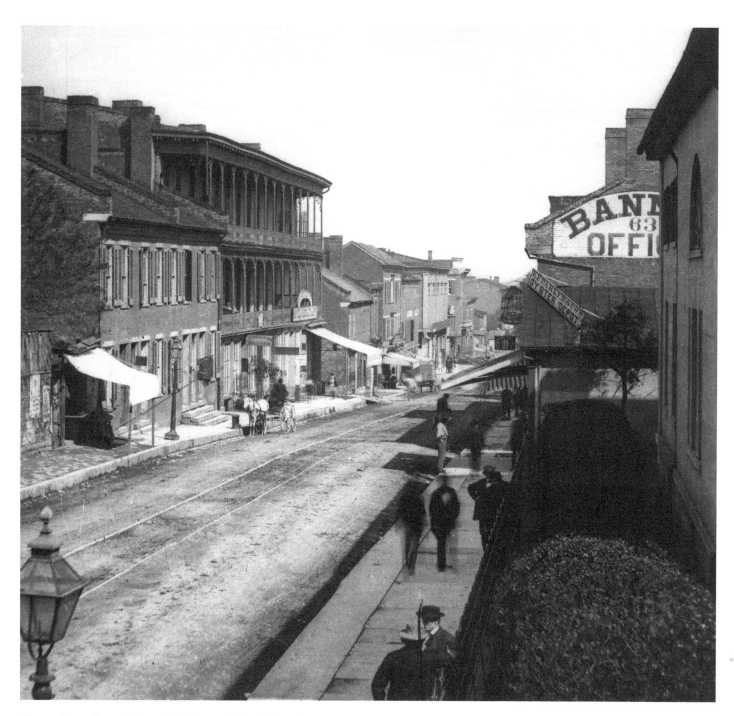

Cherry Street (Fourth Avenue) looks north from Union Street.

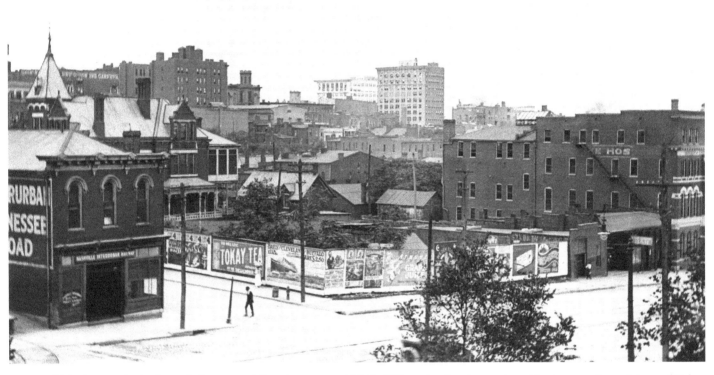

This view overlooks Seventh Avenue and Broadway around 1910. Billboards advertise products like Armour Grape Juice and Tokay Tea. The Jackson Building is visible to the left of the tower of First Presbyterian Church.

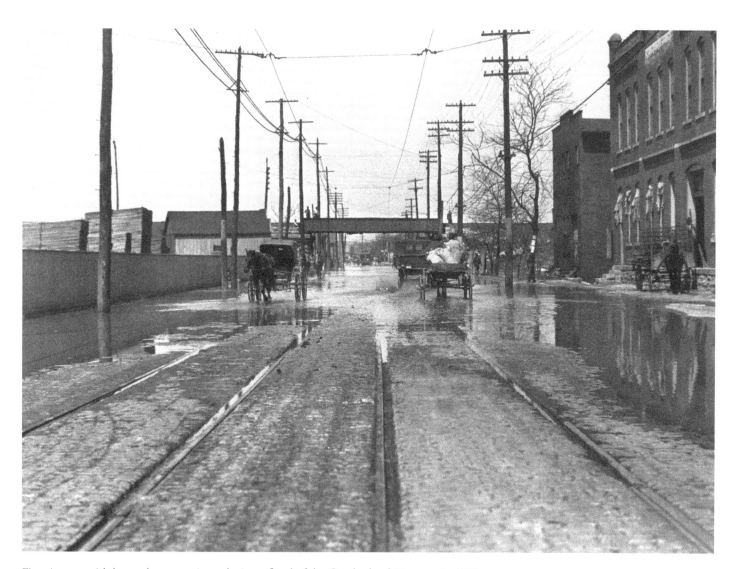

First Avenue with horse-drawn carriages during a flood of the Cumberland River, early 1900s.

Hartman Saloon and Hotel located at 921 Broad Street.

The Vine Street Temple (Synagogue), located on Vine Street (Seventh Ave. North). Its first cornerstone was laid in 1874 with former President Andrew Johnson in attendance for the event. The building was demolished in 1954.

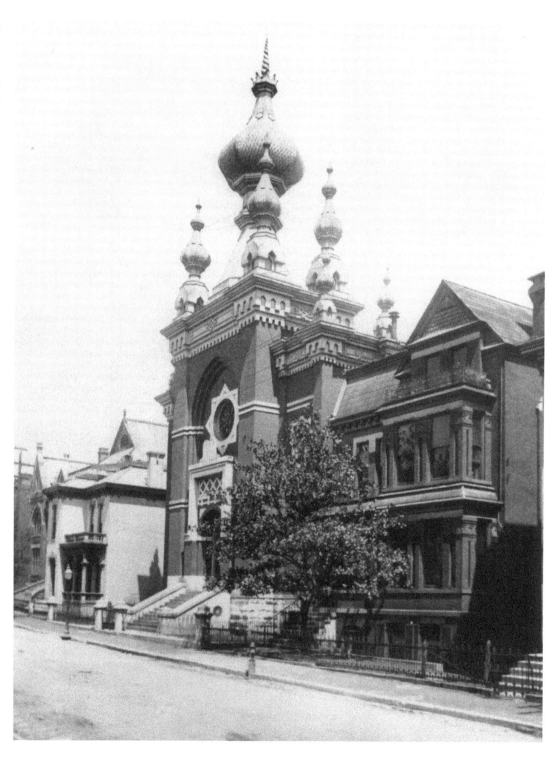

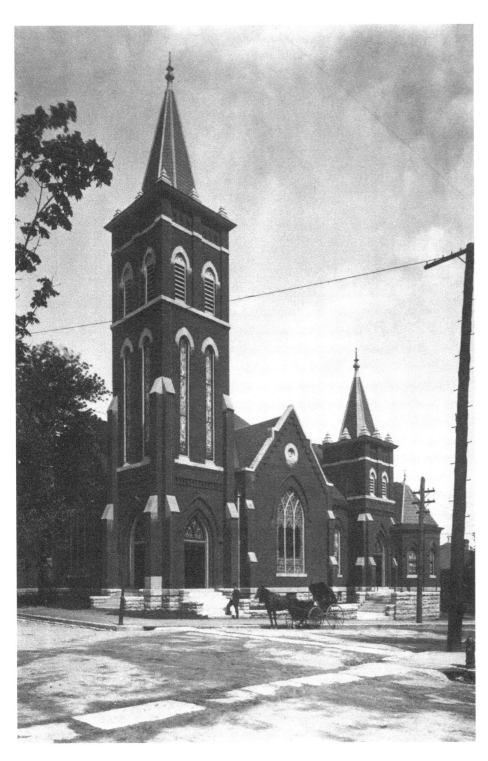

Edgefield Baptist Church, located at the corner of Seventh and Russell. Thanks to a great bucket brigade, it survived the East Nashville Fire of 1916. This was the first Baptist church in Nashville located east of the Cumberland River. Edgefield Baptist Church was organized on April 14, 1867, meeting at Stubbs Hall at the corner of Tulip (Fifth) and Woodland streets. The congregation still meets here today.

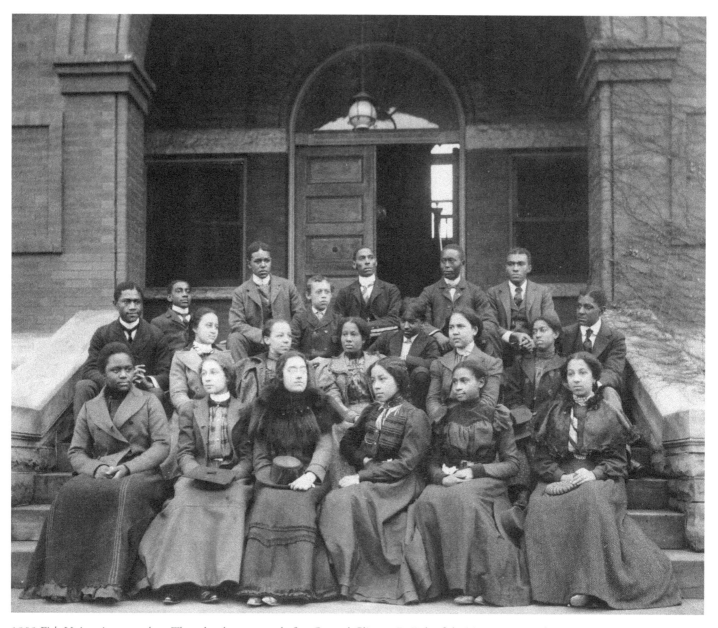

1909 Fisk University prep class. The school was named after General Clinton B. Fisk of the Tennessee Freedmens Bureau. According to this photograph, the 1909 prep class appears to have had more female students than males.

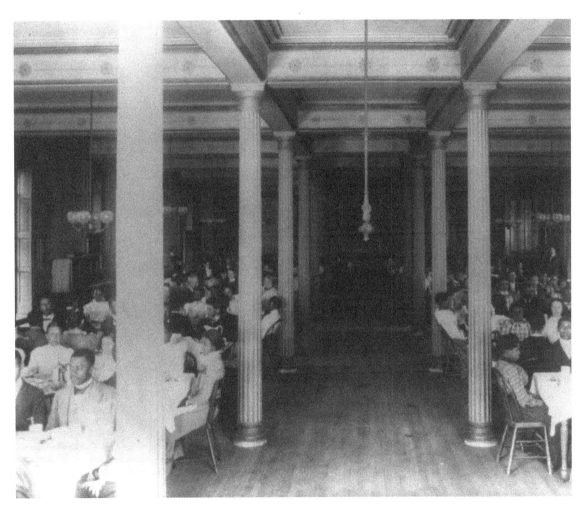

Fisk dining hall.

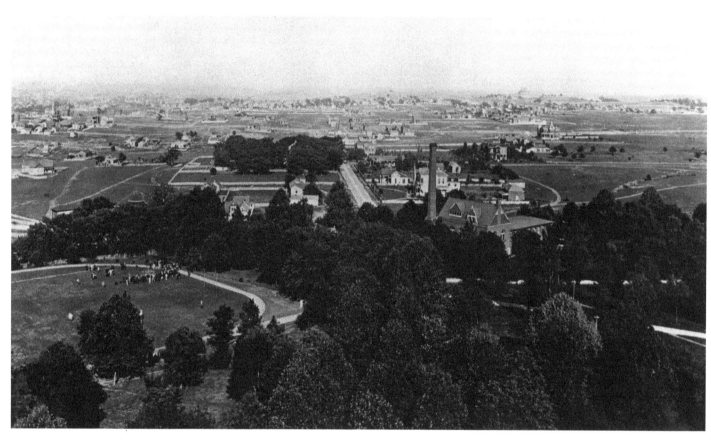

A view from the top of Vanderbilt's University Hall looking toward Nashville's downtown. Broad Street is in the center of the photograph beyond the Mechanical Engineering Building with its smokestack, erected in 1888. Vanderbilt's original athletic field is in the left foreground.

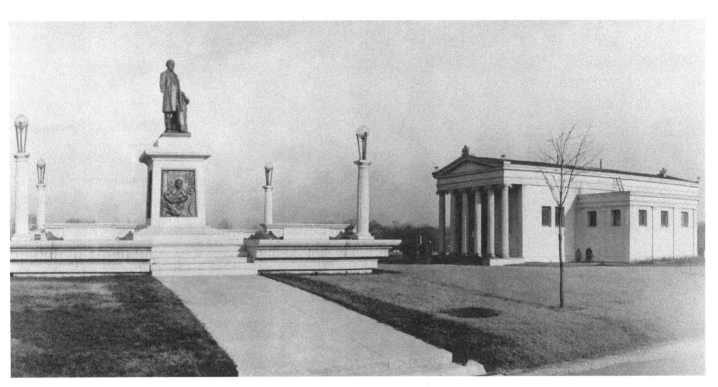

This statue of John W. Thomas was erected in 1907 in Centennial Park. Thomas was the Chairman of the Centennial Executive Committee of the Exposition.

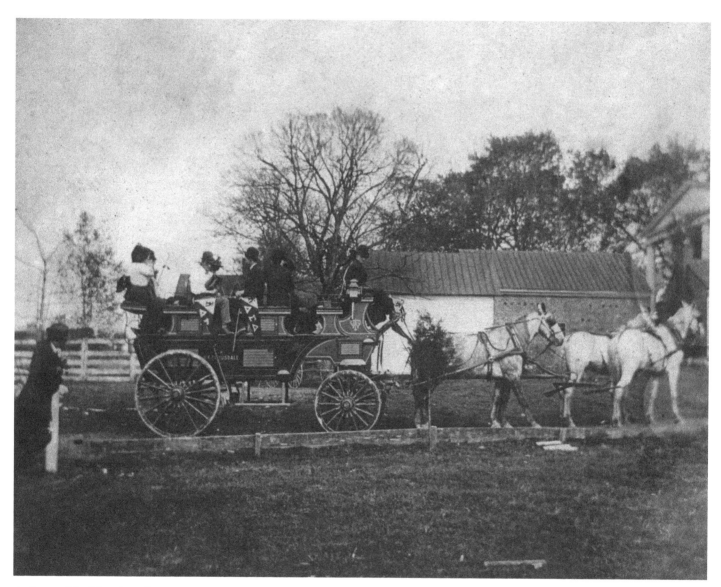

A photo of the Hermitage horse carriage, circa 1907-9.

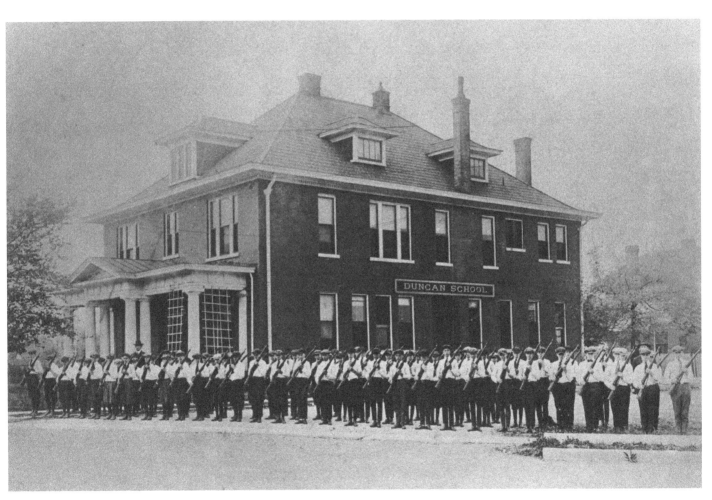

Duncan College Preparatory School for Boys was founded in 1908. The school was located on 25th Avenue South and closed in 1952. The school graduated some 752 men and 6 women, including many community leaders.

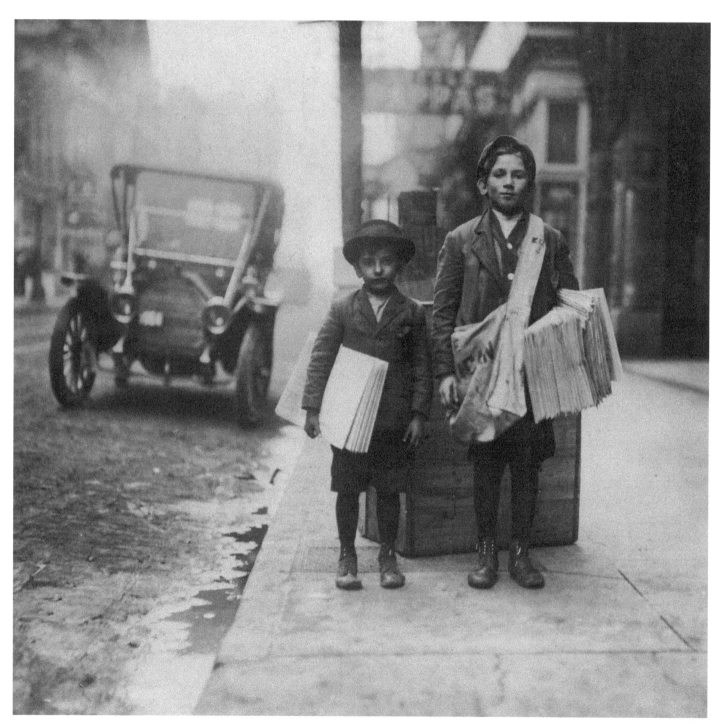

Newsboys get ready to distribute the daily paper.

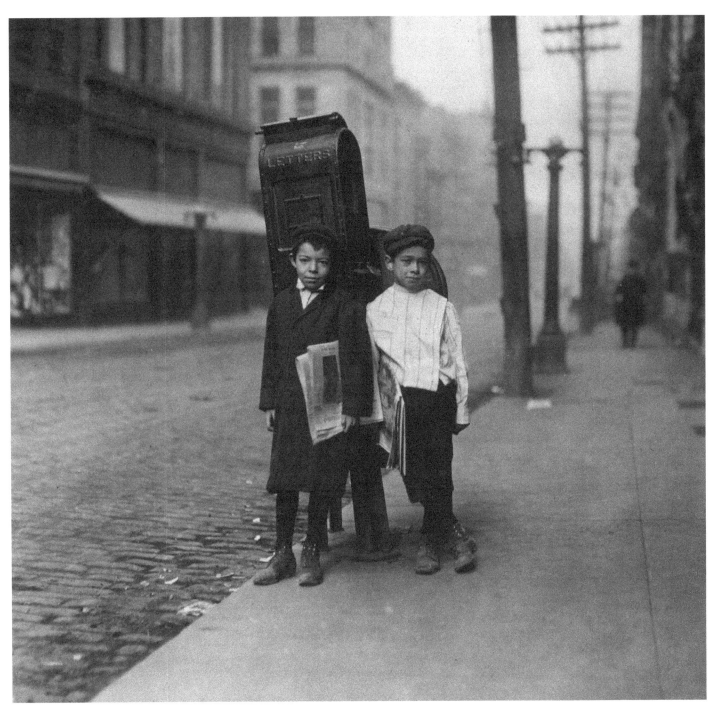

Two seven-year-old boys sell the Sunday paper.

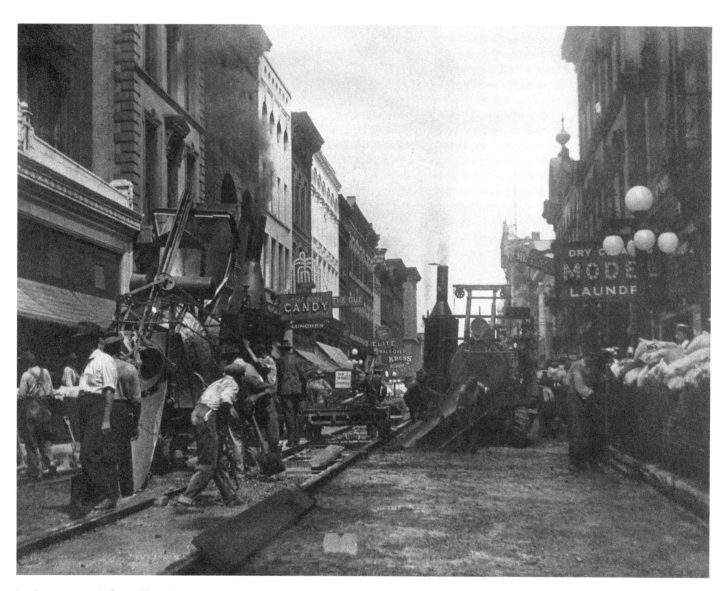

In this view north from Church Street, streetcar tracks are being laid on Fifth Avenue, 1910.

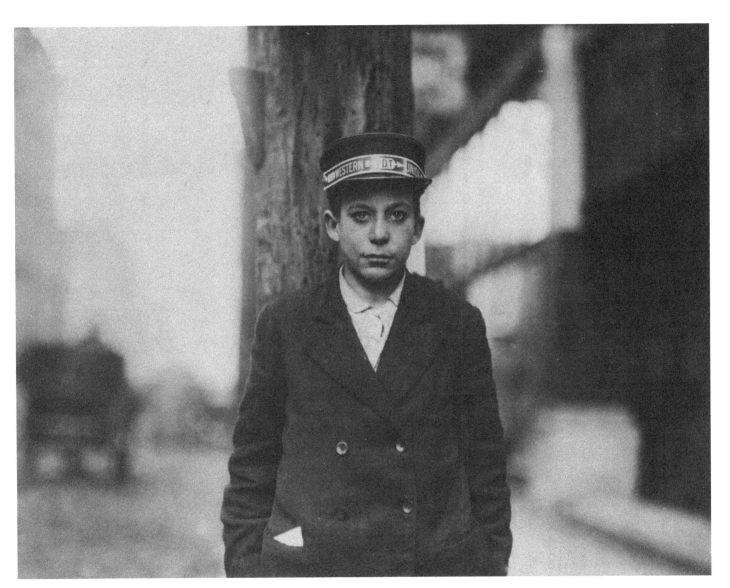

Pictured here in 1910 is thirteen-year-old Western Union messenger, Richard Truck.

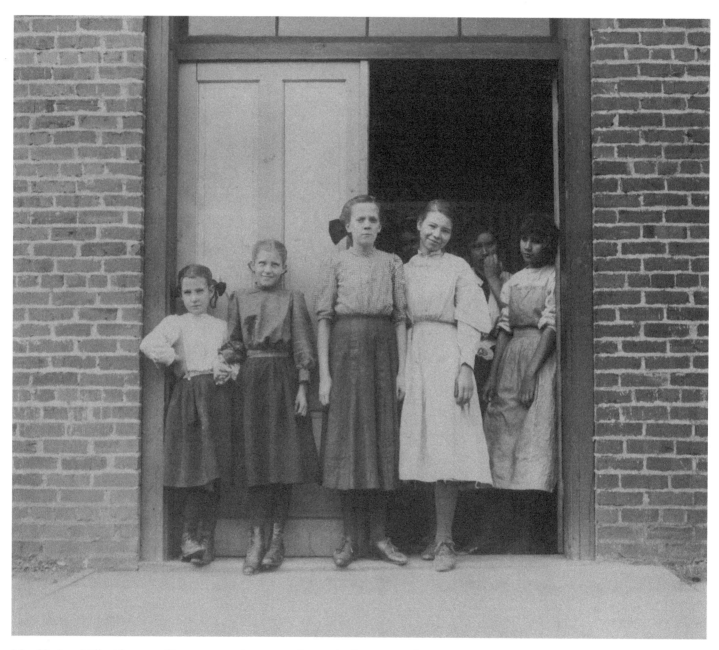

May Hosiery Mill with some of its young employees standing on its front steps, circa 1910.

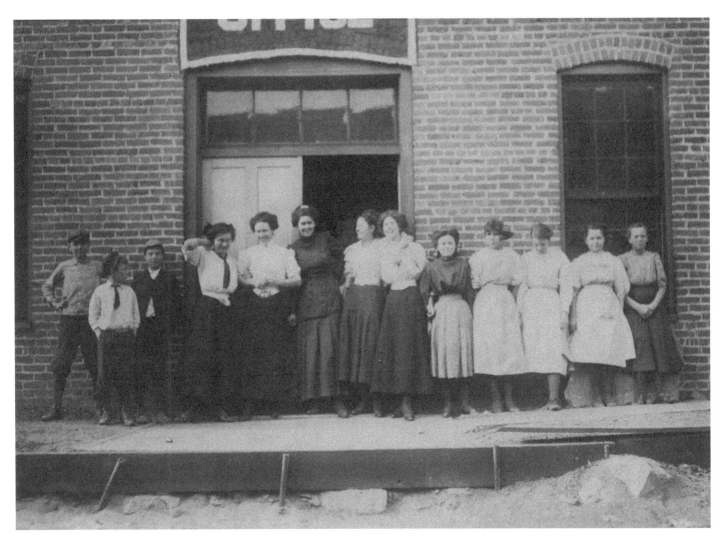

The front office of the May Hosiery Mill with employees.

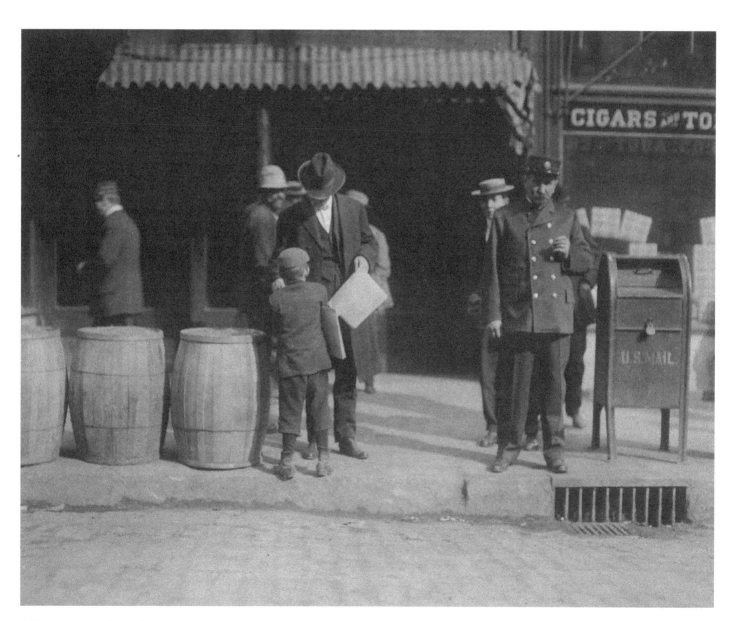

A Tennessee newsboy sells a paper to a businessman.

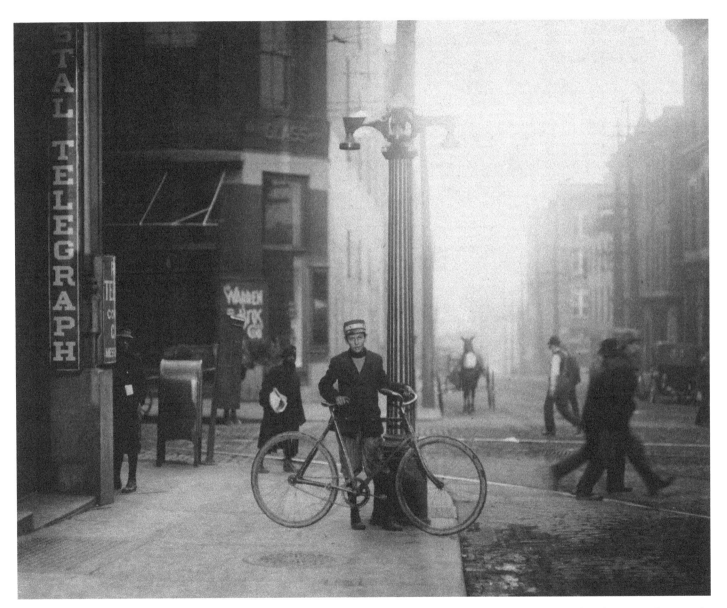

An early postal telegrapher. Four modes of transportation are captured in this 1910 photograph.

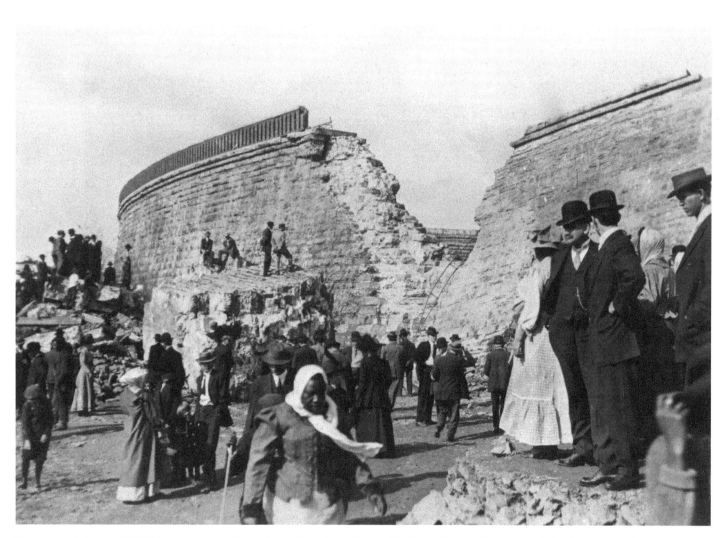

The reservoir break of 1912 flooded part of South Nashville with millions of gallons of water. The reservoir is still in use today.

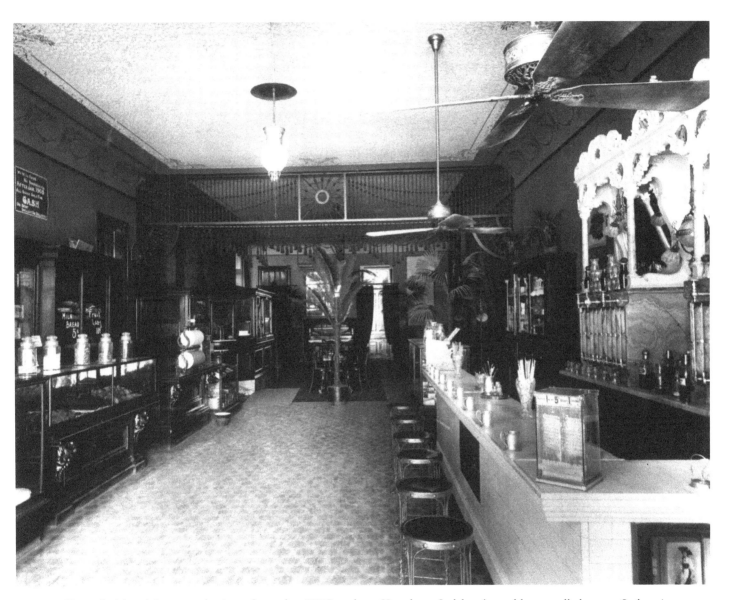

Henry Sudekum's ice cream business, located at 817 Broadway. Years later, Sudekum's would eventually become Sealtest ice cream.

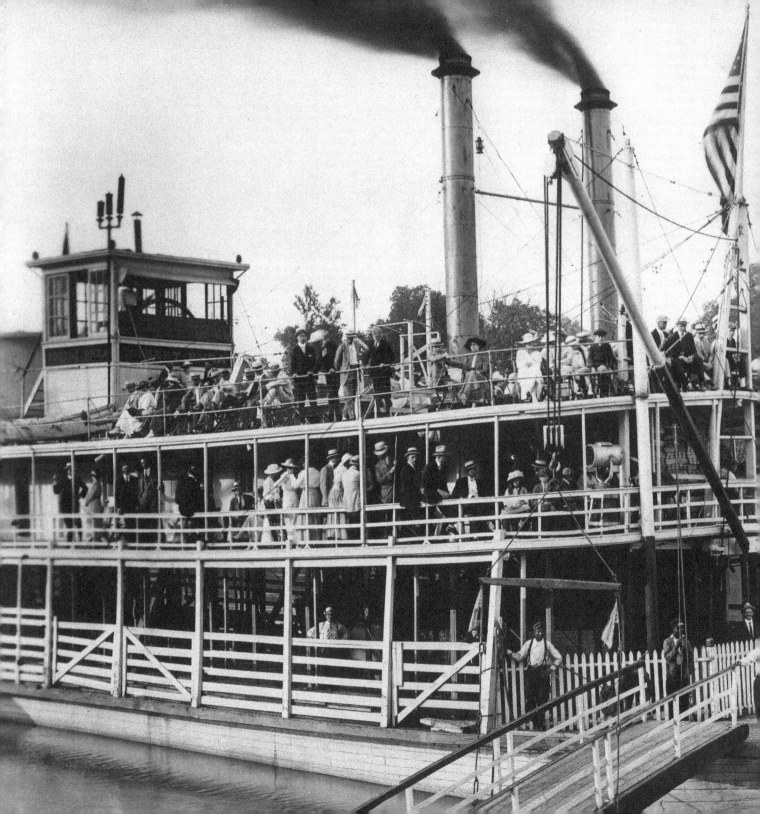

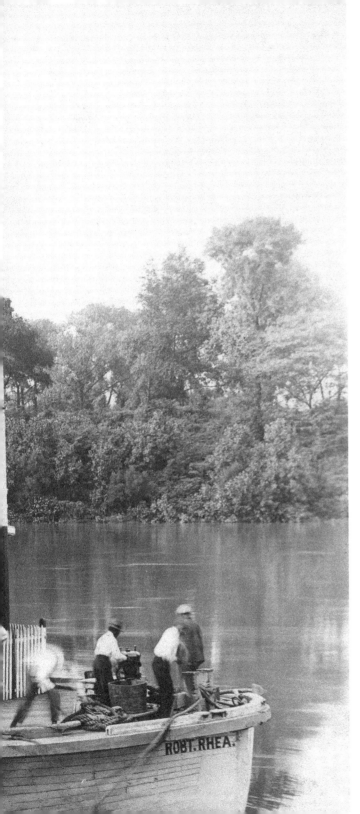

Banking of a steamboat on the Cumberland in 1915. Steamboats would unload their passengers and goods to the backs of the buildings on First Avenue.

Shown here is destruction caused by the East Nashville fire of 1916. Five hundred houses were destroyed.

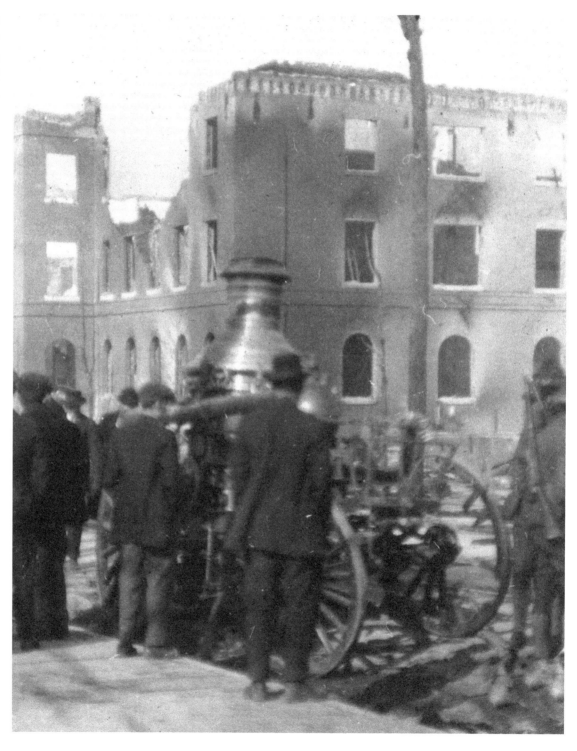

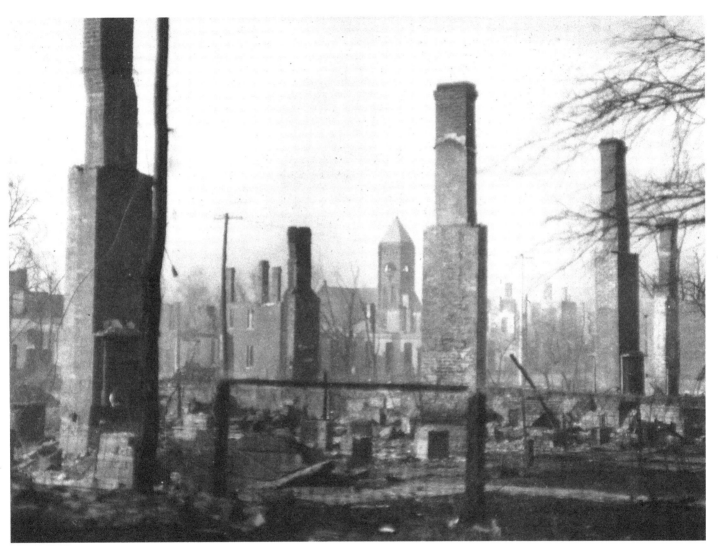

The East Nashville fire lasted only hours but left more than 2,500 people homeless. The Tulip Street Methodist Church bell tower is visible in the center of the photograph.

The remaining shell of Warner School immediately after the fire of 1916. The blaze caused more than $2 million in damages to Nashville's eastside.

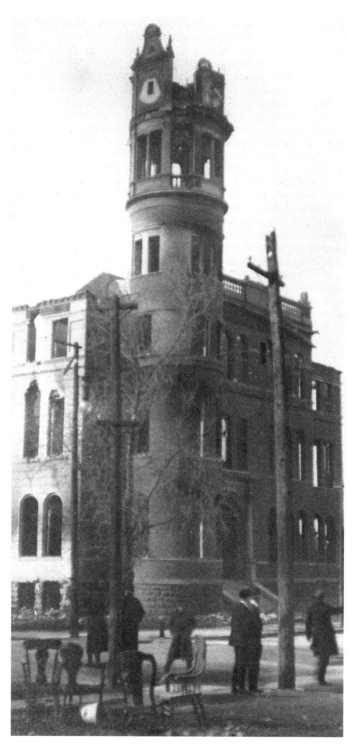

This parade shows the Nashville Fire Department Engine #9, circa 1905.

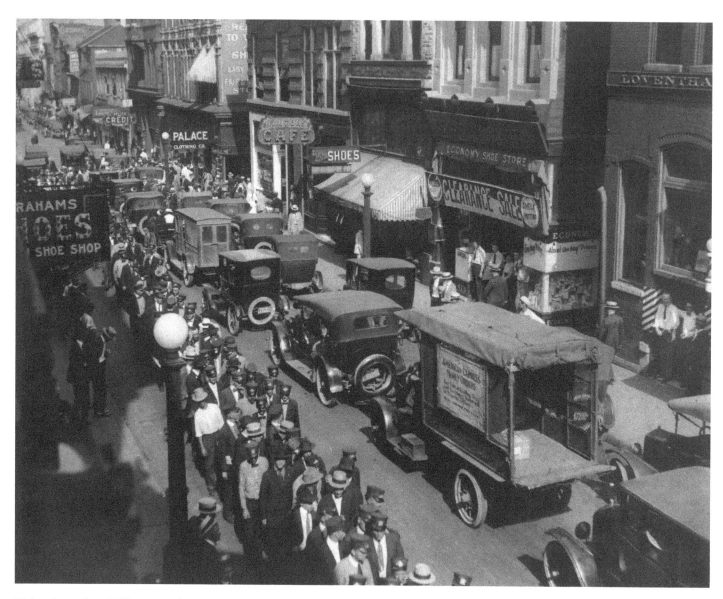

Union Street from Fifth Avenue during a parade for World War I soldiers around 1919.

THE FIRST WORLD WAR AND A DEVELOPING METROPOLIS

1917–1939

During World War I and the years between the wars, Nashville would see tremendous growth and change as well as widespread attention.

Prohibition began in 1919 and lasted until 1933. Although many Nashville citizens (along with many Americans) believed the ban would improve morality and decrease violence, others took to producing moonshine for which the state gained an infamous repuation. The Women's Suffrage movement, spearheaded by the Nashville Equal Suffrage League, would ultimately lead Tennessee into casting the deciding vote for the ratification of the 19th Amendment in 1920.

In 1930, a run on banks began in Nashville and swept through the middle South, marking the beginnings of the Depression years. In order to help create jobs, the Tennessee Valley Authority was established in 1933. Along with it came less expensive electric power that encouraged economic growth and development in the city.

As American transportation continued to evolve, Nashville followed suit. The capital city's first airfield, Hampton Field, appeared in 1916. It was followed by Blackwood Field in 1921, McConnell Field in 1927, Sky Harbor Airport in 1930, and Berry Field in 1938.

When the United States entered World War I, thousands of Tennesseans fought for the country, and over 3,000 lost their lives. The construction of the War Memorial Building followed the close of the war, and around 20 years later in 1937, a state museum was created in its lower level.

Nashville experienced several disasters in this transitional era, including several tornadoes with the worst striking East Nashville in 1933. The Dutchman's Grade Train Wreck in 1918, which killed 101 people, and a Typhus outbreak in 1939 marked other events that, though unfortunate, brought national attention to the area. The city also endured several floods, the most devastating occuring in 1927 and 1937. Despite the resulting economic difficulties, Nashvillians remained resilient.

In the 1920s, a new radio station forever changed the landscape of the city. WSM Radio Station by the National Life and Accident Company went on the air in 1925. The Grand Ole Opry began broadcasting the following year and became the institution that led to the creation of "Music City USA."

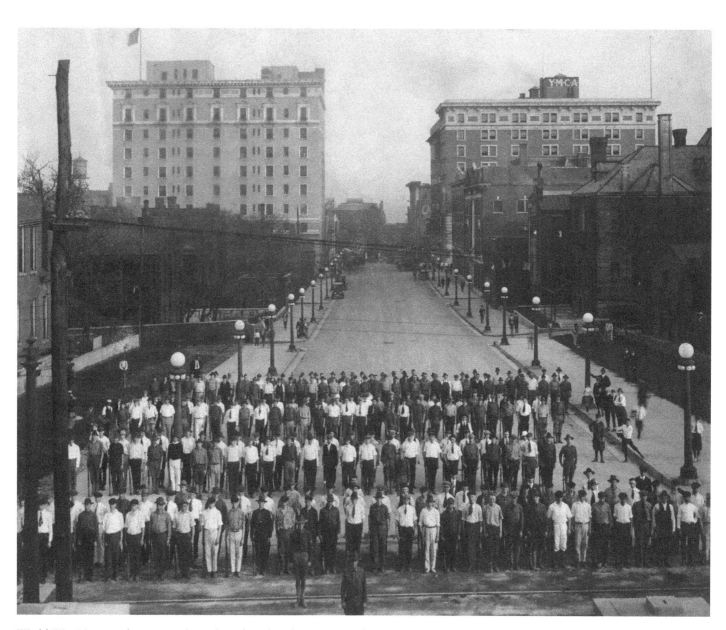

World War I Recruits line up on Capitol Boulevard in downtown Nashville.

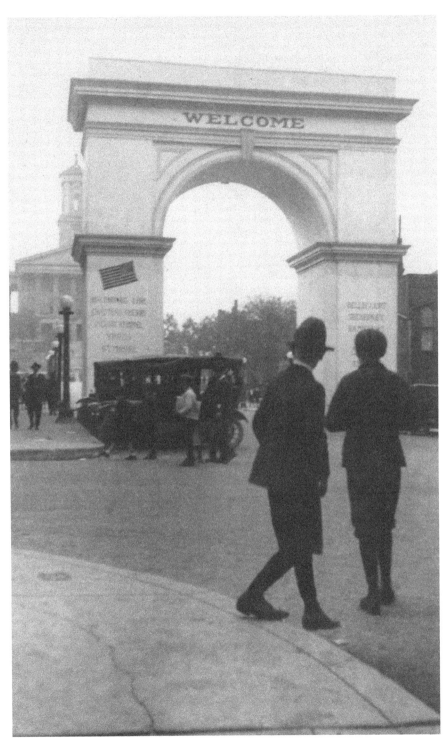

World War I Memorial Welcome Arch located in front of the State Capitol, 1919.

In November 1917, two French soldiers, Captain Loriot and Lieutenant Delaroche-Vernet, stand with a U.S. soldier, Captain Hobson, near the statue of Cornelius Vanderbilt in front of College Hall on the Vanderbilt campus. The Commodore's statue was paid for by Nashville citizens and the faculty of the university and displayed first at the Tennessee Centennial Exposition. The sculptor was Giuseppe Moretti.

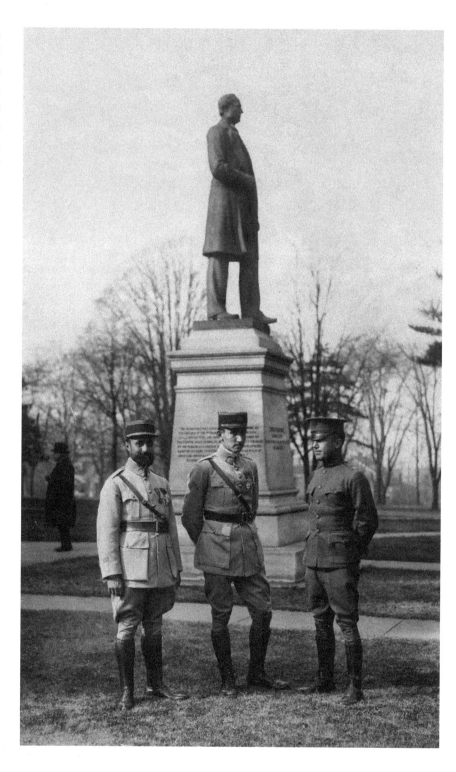

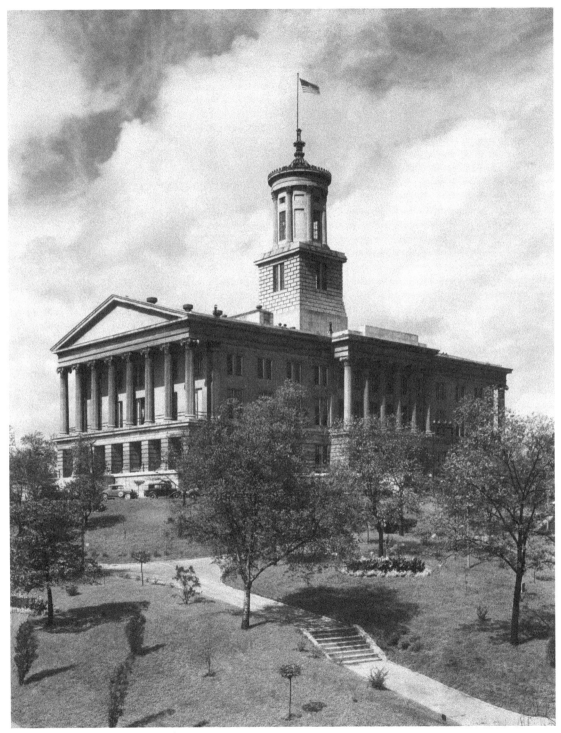

The State Capitol, 1920. Construction started in 1845 and was completed in 1859. The building was designed by William Strickland, who died during construction and is buried in the northeast wall on the first floor.

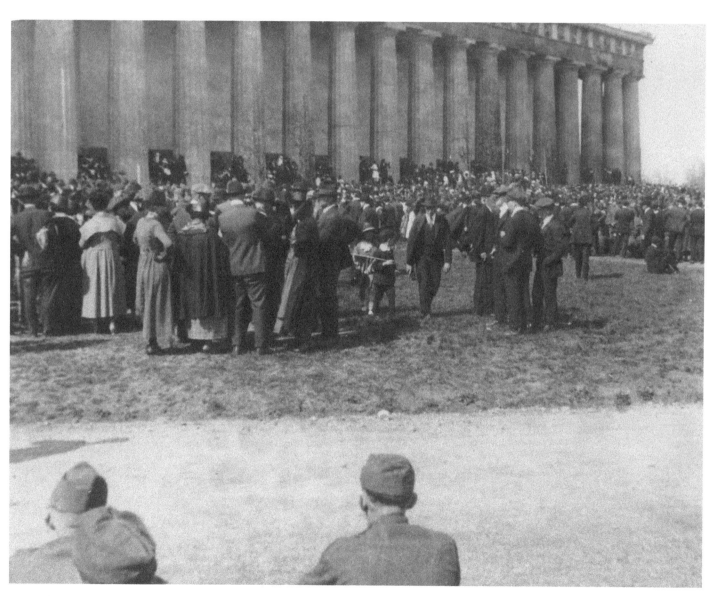

A crowd gathers in Centennial Park in the spring of 1919 to celebrate the end of World War I. The first Parthenon replica, made of plaster, brick, and wood, stands in the background. It was soon replaced by a permanent concrete structure.

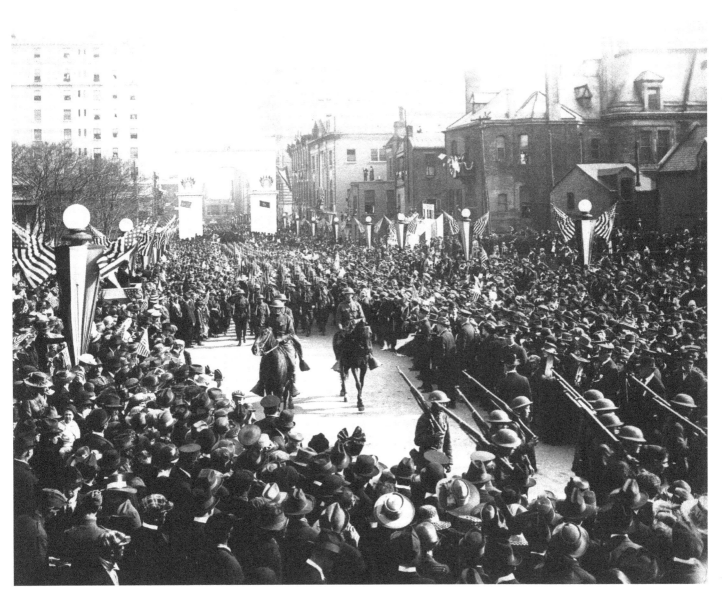

Crowds gather at the parade celebrating the return of soldiers at the end of World War I.

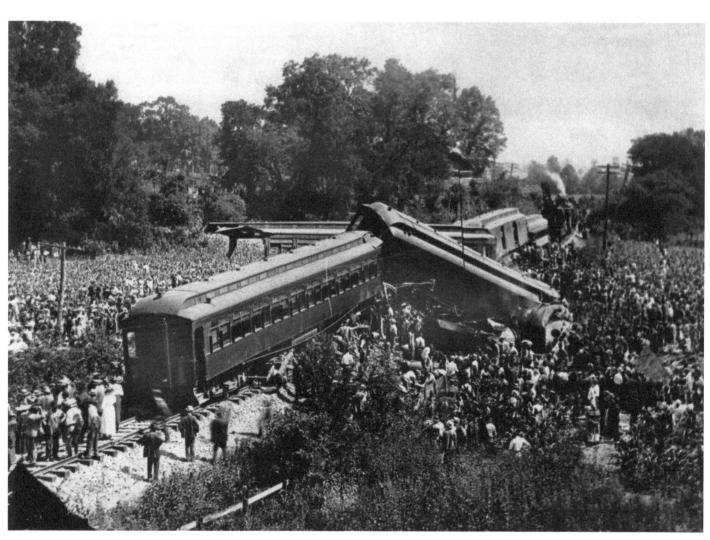

On July 9, 1918, a Nashville, Chattanooga & St. Louis Railroad train derailed at Dutchman's Bend, killing over 100 people and injuring more than 170. It was the worst train wreck in U.S. history. A greenway off White Bridge Road now gives hikers access to the site, where a sign describes the tragedy.

Sixth Avenue showcases the transition from the horse and buggy to the automobile, 1919. The R. D. Ezell Auto Company, at 106 6th Avenue North, is on the right side of the street.

Nashville Banner building, 1920s. This building adjoined Printers Alley. Of the two main newspapers after 1920, the *Nashville Banner* was Republican and the *Nashville Tennessean* was Democratic. The building stands today, across Church Street from Noel Place, home to Turner Publishing.

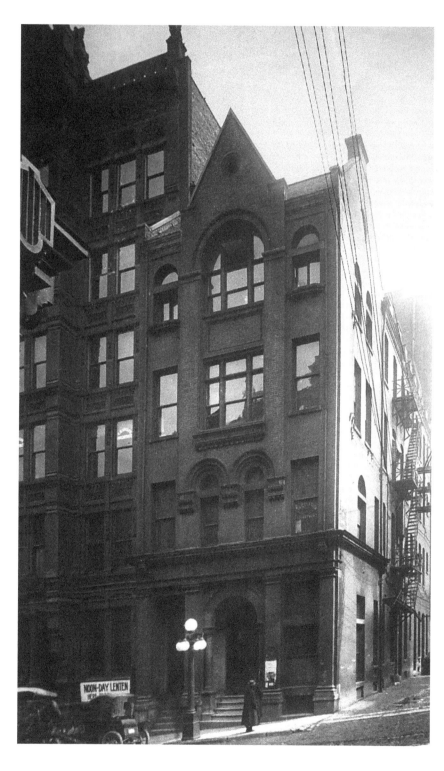

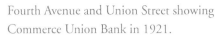
Fourth Avenue and Union Street showing
Commerce Union Bank in 1921.

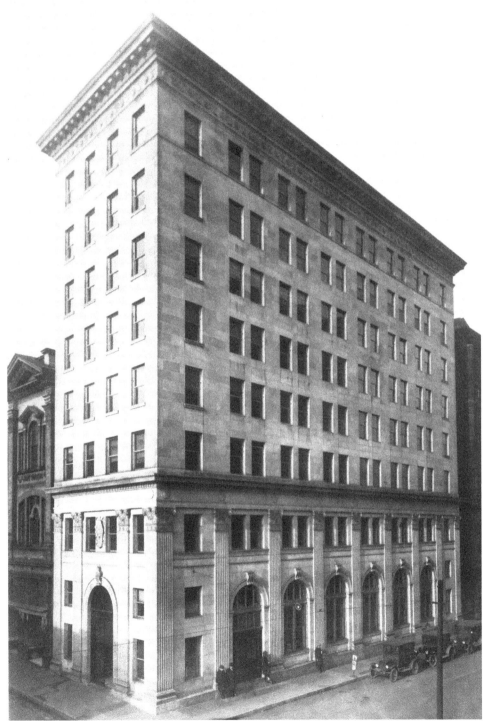

The Frost Building, erected by the Southern Baptist Sunday School Board on Eighth Avenue in 1913, still serves Baptist publishing today. The building was named for Dr. J. M. Frost, Executive Secretary of the board.

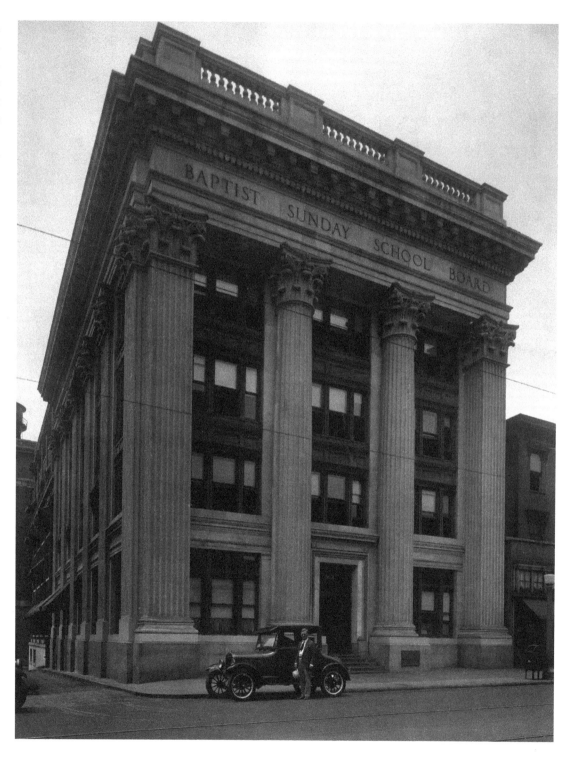

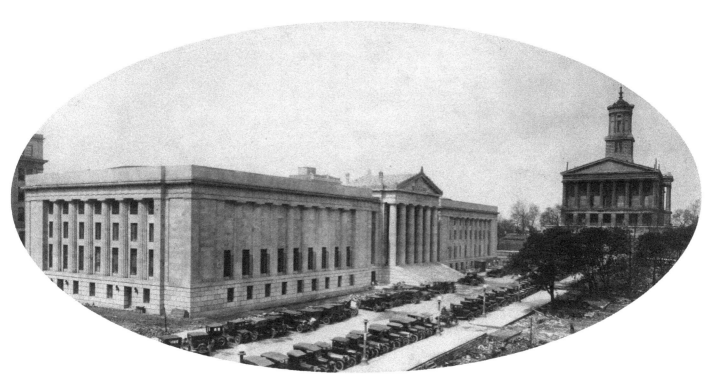

War Memorial Square with the State Capitol located to the right. The
automobiles are parked on what has become War Memorial Plaza.

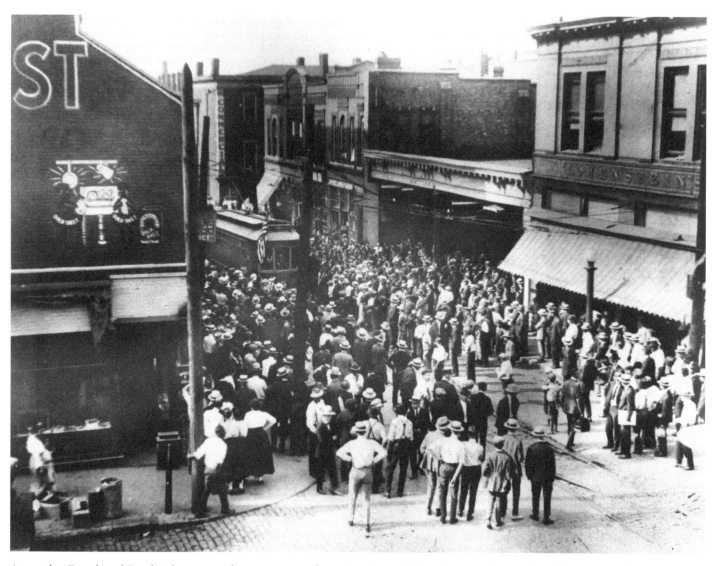

A crowd at Fourth and Deaderick streets at the streetcar transfer station. From this location people transferred from one car line to another, on this day to attend a baseball game at Sulphur Dell.

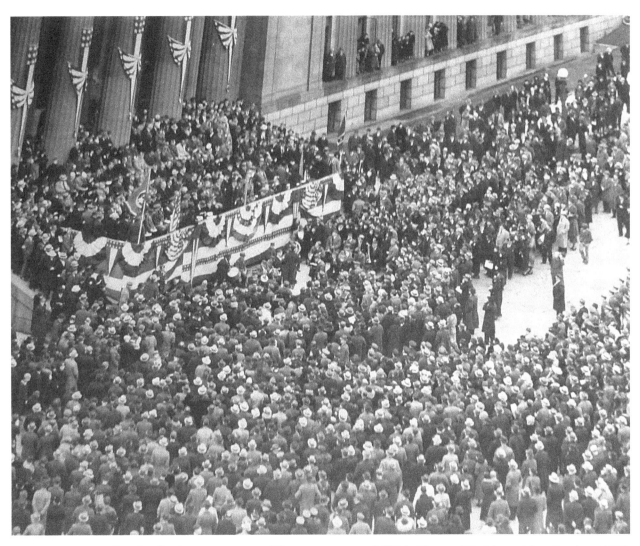

Crowds gather for the inauguration of Tennessee governor Hill McAlister at War Memorial Auditorium, 1933.

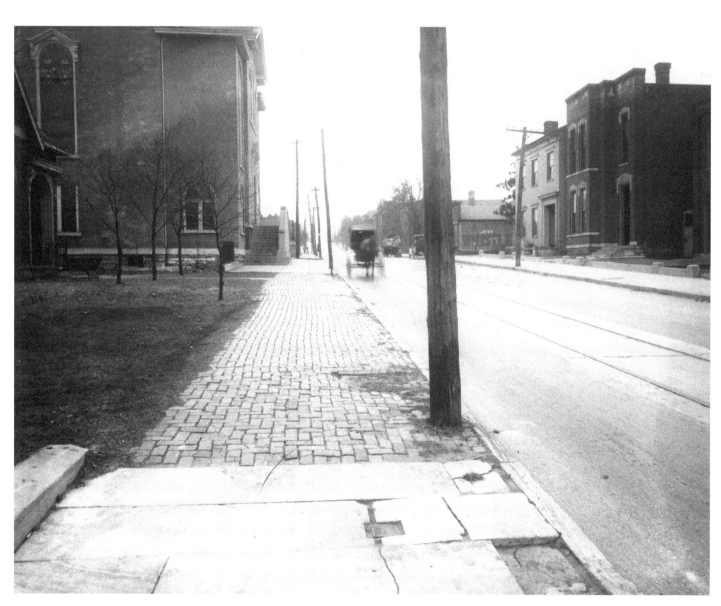

Elm Street in 1921 with a view of Elm Street Methodist Church to the left.

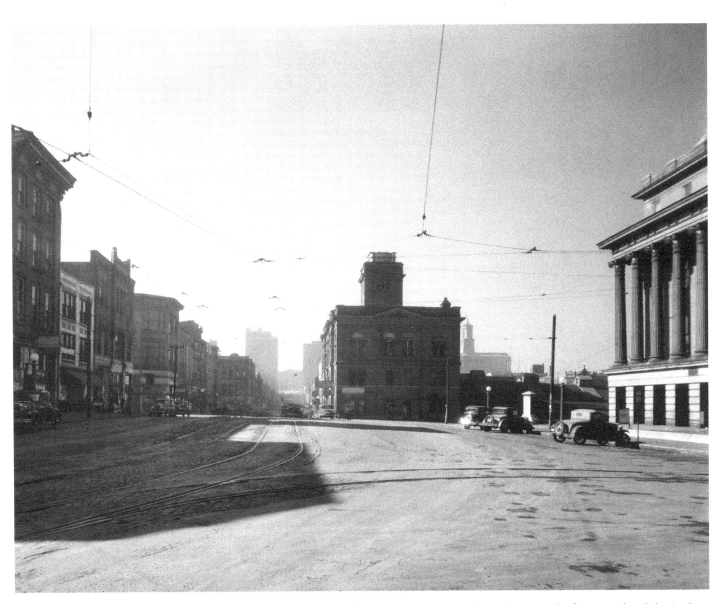

View of the Public Square, with the City Hall and the Davidson County Courthouse shown in the foreground and the Andrew Jackson Hotel, the Cotton States Building, and the State Capitol shown in the distance, late 1920s.

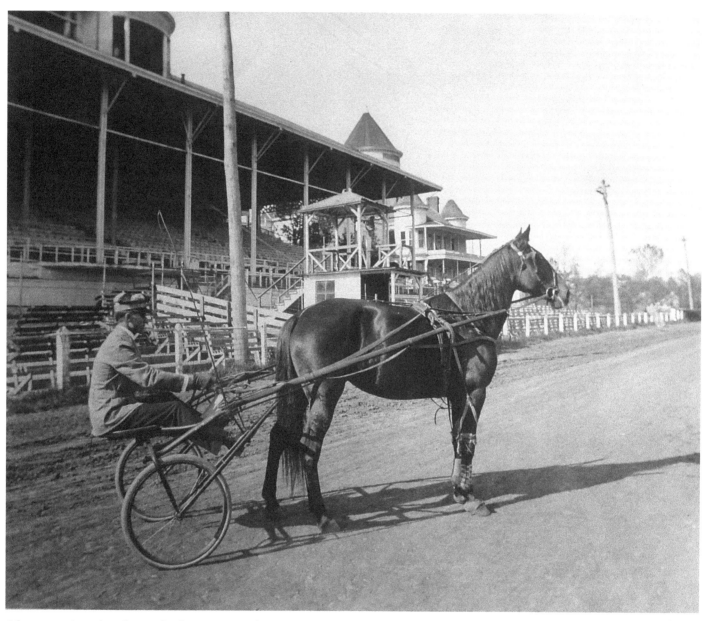

A harness racing takes place at the State Fairgrounds.

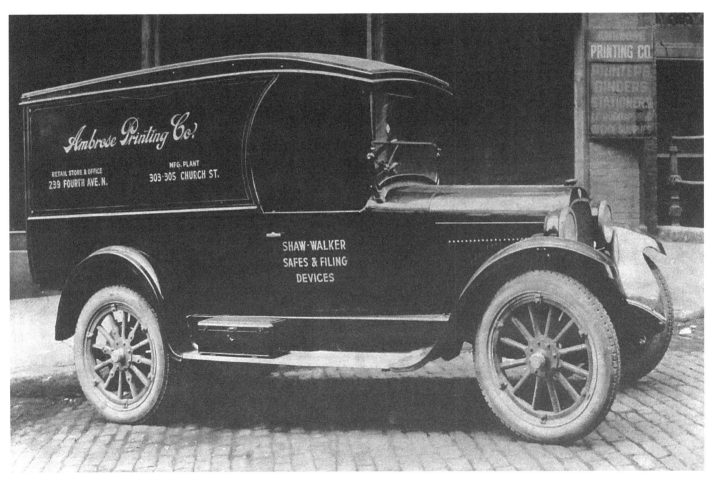

Ambrose Printing Company's Flat Panel Dodge Brothers' Delivery Truck, circa 1922–1924. Ambrose was one of the original printers of Printers Alley, starting business in 1865. They were the last to vacate the alley, in 1976, and are now located in Metro Center.

The interior of the Parthenon as it appeared in 1932. From 1920 to 1931, it was rebuilt as a permanent structure.

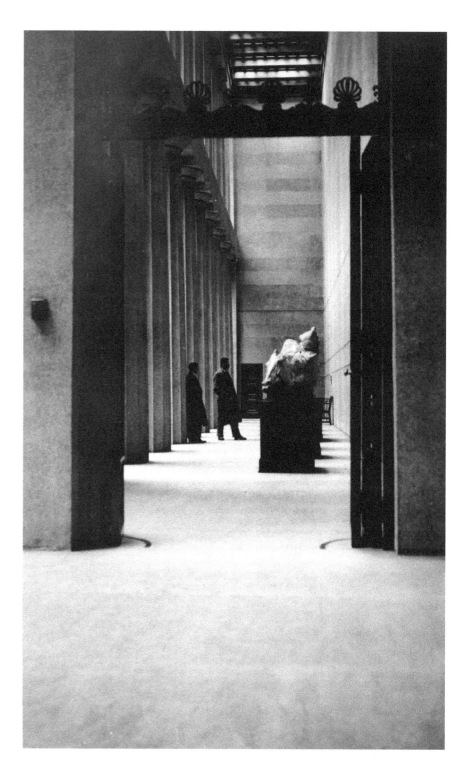

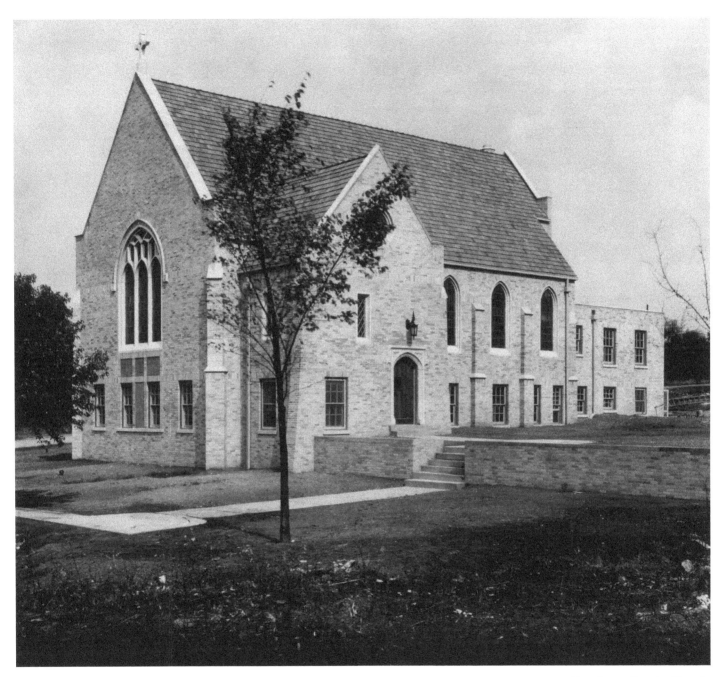

Woodmont Baptist Church.

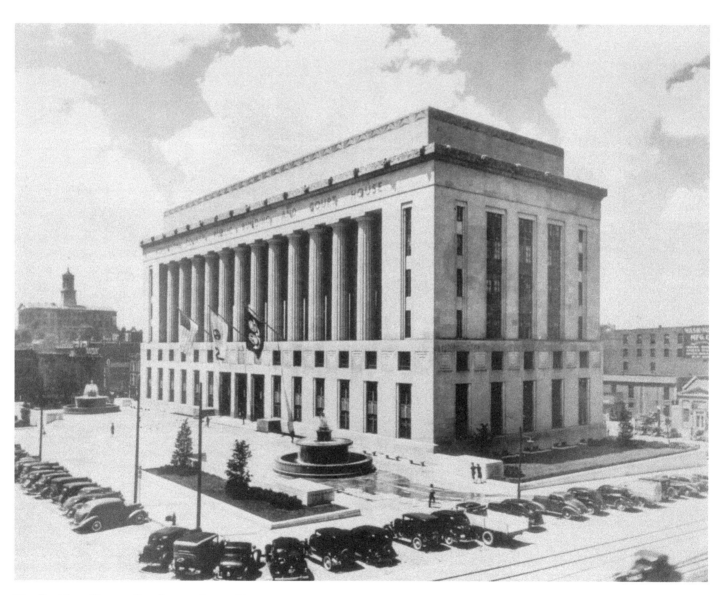

The Davidson County Courthouse, circa 1939.

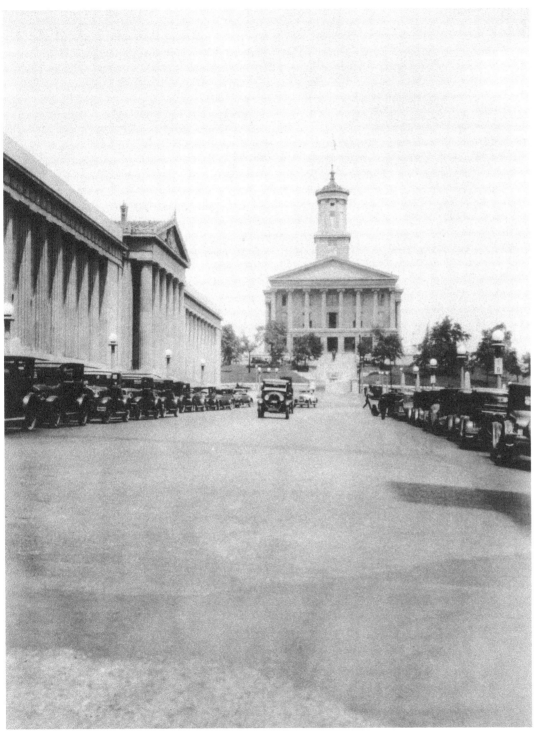

South facade of the State Capitol. The War Memorial Building stands on the left, built in 1925 in honor of the 3,400 Tennesseans lost in World War I.

Academic procession for the inauguration of Oliver C. Carmichael as the third chancellor of Vanderbilt University, February 5, 1938, held in the War Memorial Auditorium.

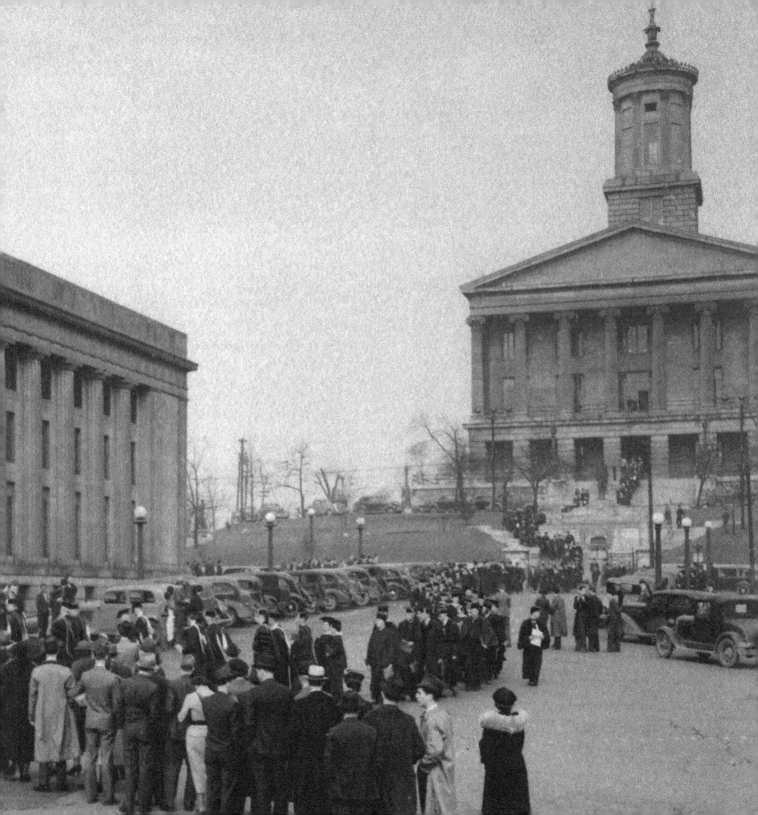

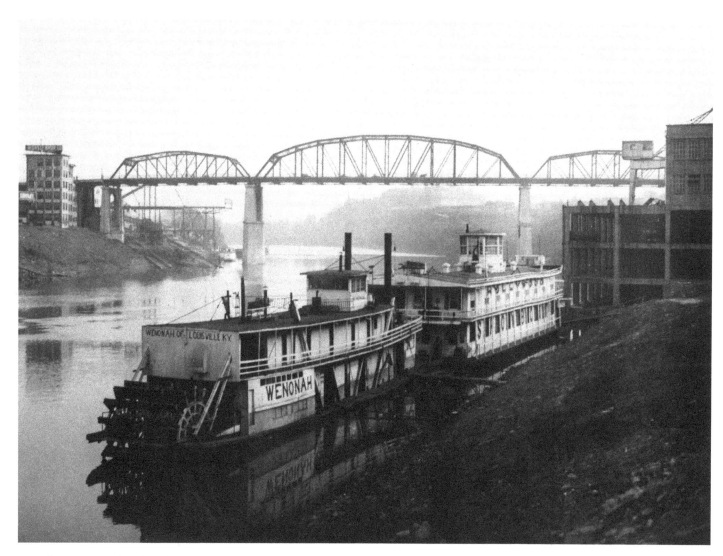

Steamboats *Wenonah* and *Hollywood* are moored on the Cumberland River at the Nashville riverfront. Items were unloaded from the paddlewheel boats to the rear of the buildings on First Avenue, and merchants sold the goods through the fronts of their buildings on Second Avenue. The Nashville Bridge Company's six-story building rises across the river beside the Shelby Street Bridge.

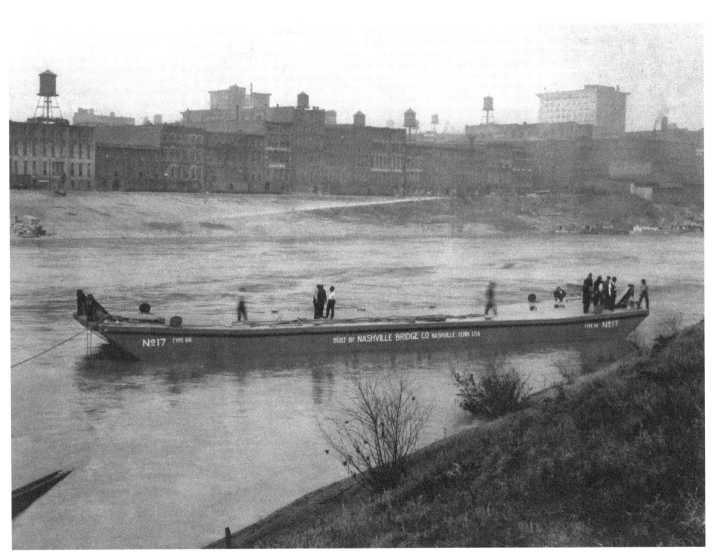

Steel barge on the Cumberland River, built by the Nashville Bridge Company, opposite First Avenue North.

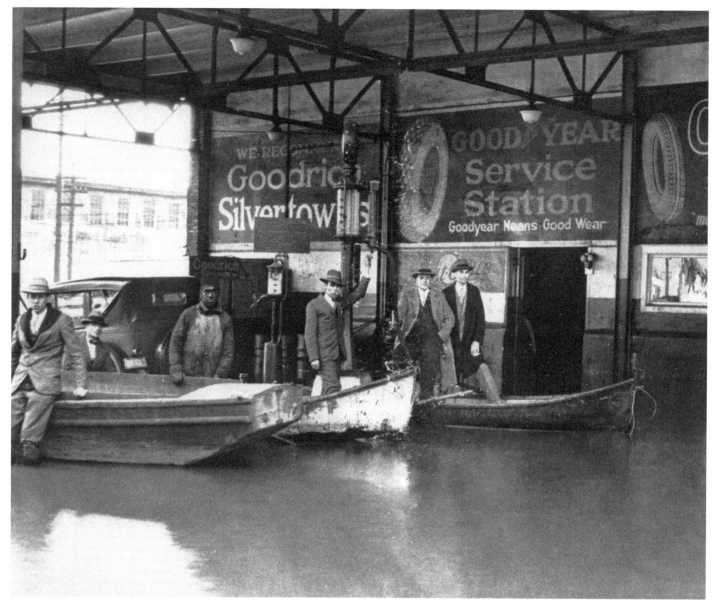

Merchants trade automobiles for boats during the December flood of 1926. It was the worst flood in the city's history up to that time.

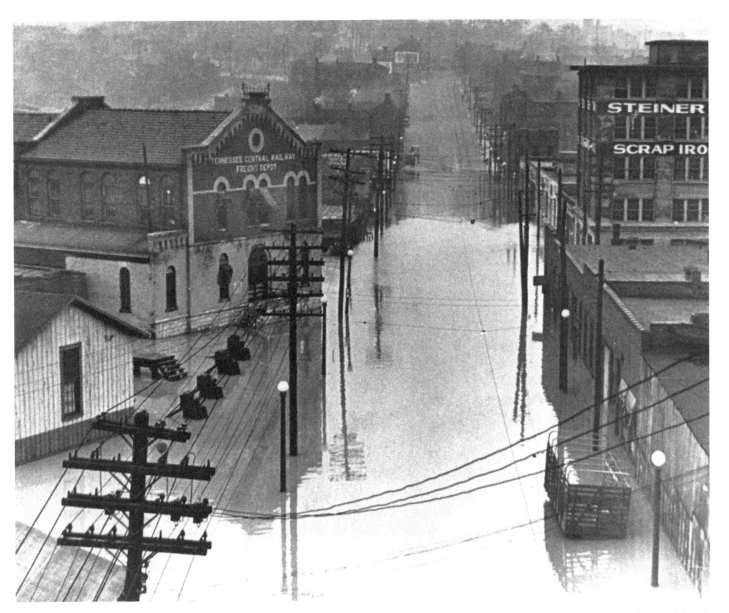

First Avenue South is under water during the 1926 flood.

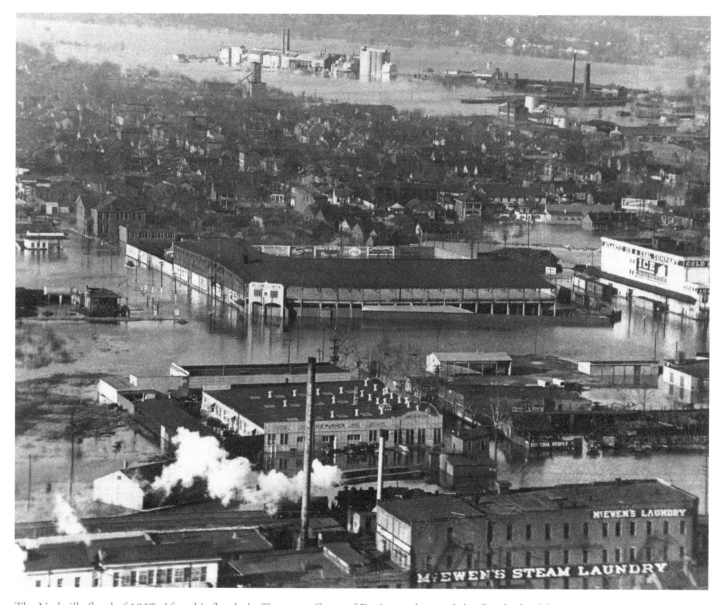

The Nashville flood of 1937. After this flood, the Tennessee Corps of Engineers dammed the Cumberland River to prevent future flooding.

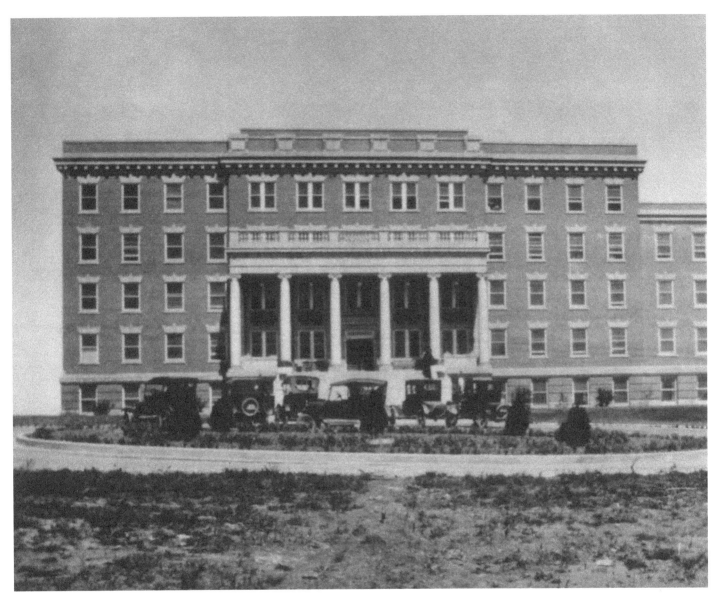

General Hospital on Hermitage Avenue, circa 1930.

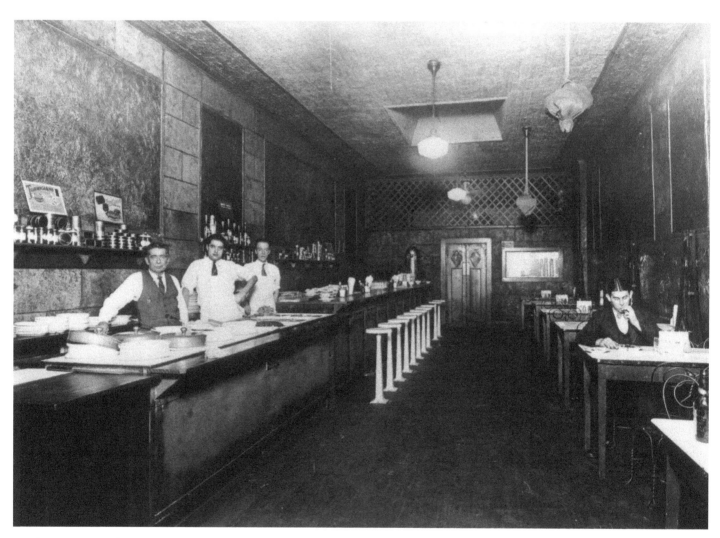

Frank Varallo poses for the camera inside his Chili Parlor, located at 811 Church Street, around 1930.

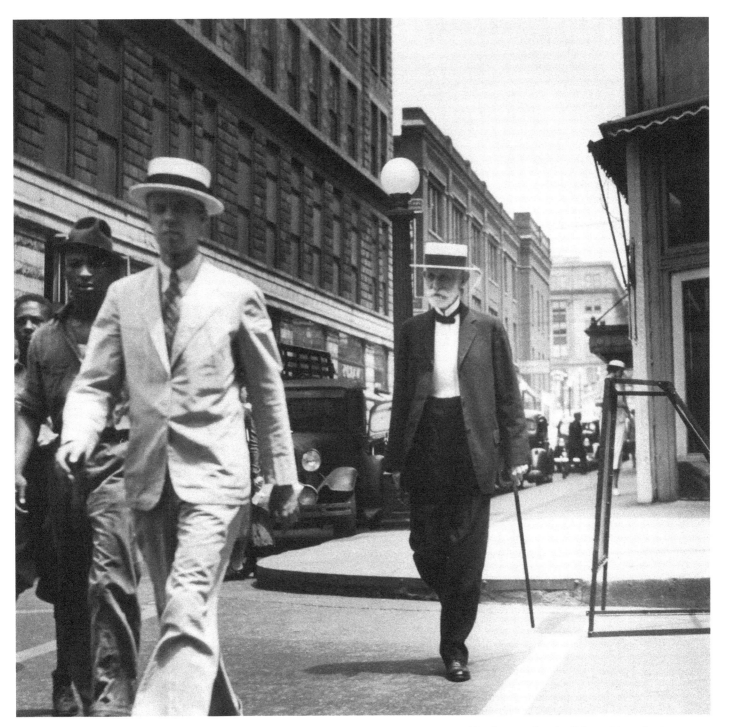

James Caldwell, one of Nashville's wealthiest businessmen.

Established by the Methodist Church as an institution to train women wishing to become missionaries, Scarritt College relocated to Nashville from Kansas City in 1924. The Nashville campus was located on 19th Avenue South and was for a time affiliated with Peabody College.

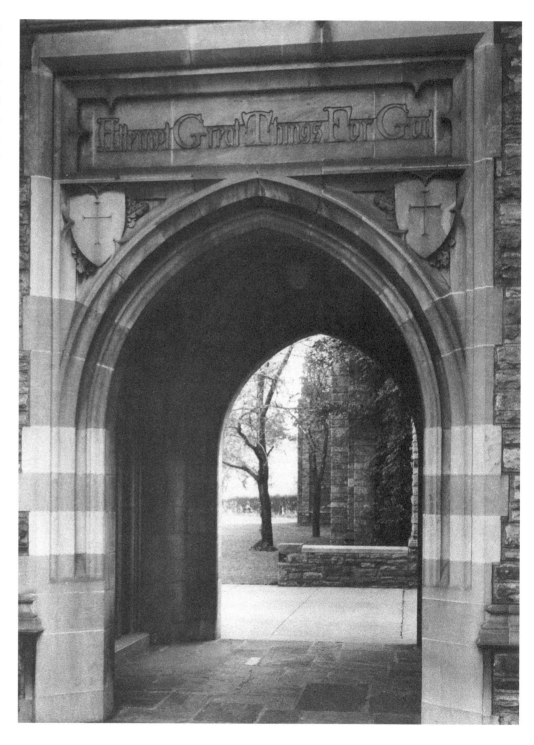

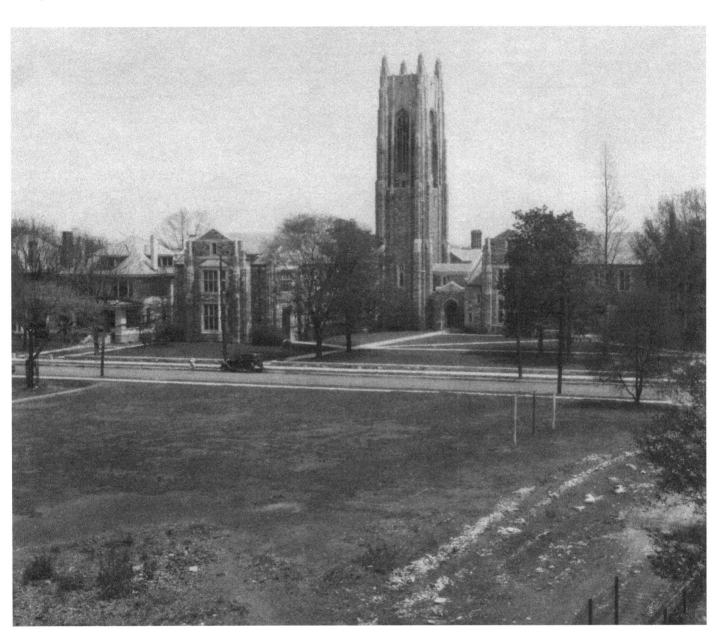

The Scarritt College Tower, designed by Henry C. Hibbs of Nashville, was completed in 1928.

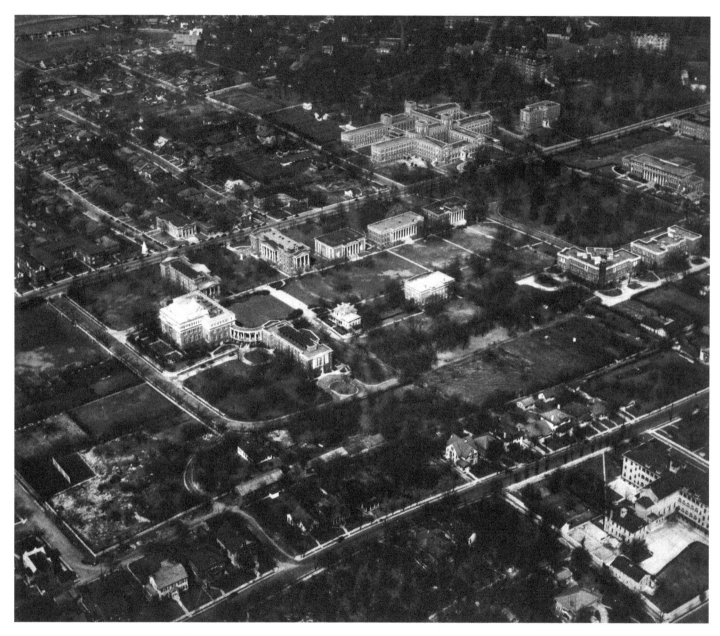

Aerial view of George Peabody College, late 1920s to early 1930s. Peabody College merged with Vanderbilt University in 1979.

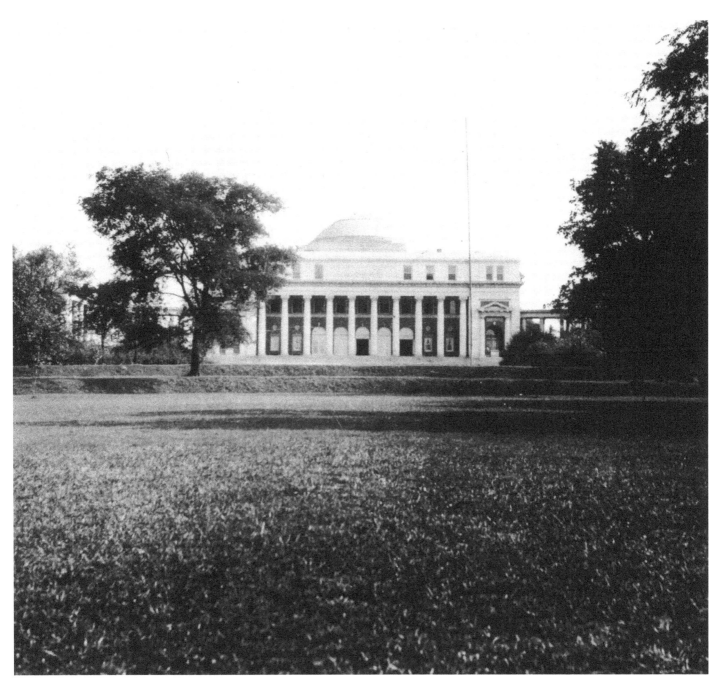

The Social Religious Building located on George Peabody Campus. Built in 1915, it was renamed the Faye and Joe Wyatt Center for Education on April 29, 2000.

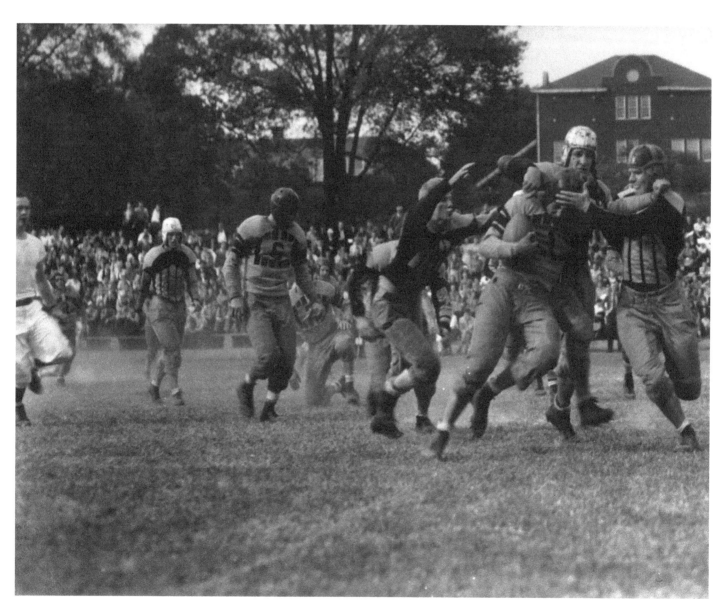

Nashville Central High football team is in action in the 1930s.

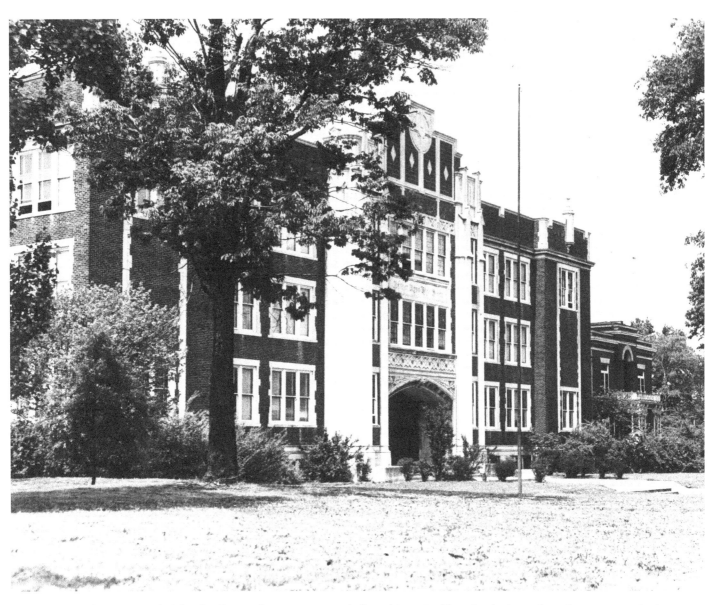

Father Ryan High School's Elliston Place campus was dedicated in 1929. The school relocated to a larger campus in the 1990s.

Vanderbilt's signature building, College Hall, circa 1925. Following the 1905 fire which gutted the original Main Building, reconstruction began almost immediately. The building was renamed Kirkland Hall in honor of Chancellor and Mrs. James H. Kirkland upon his retirement in 1937.

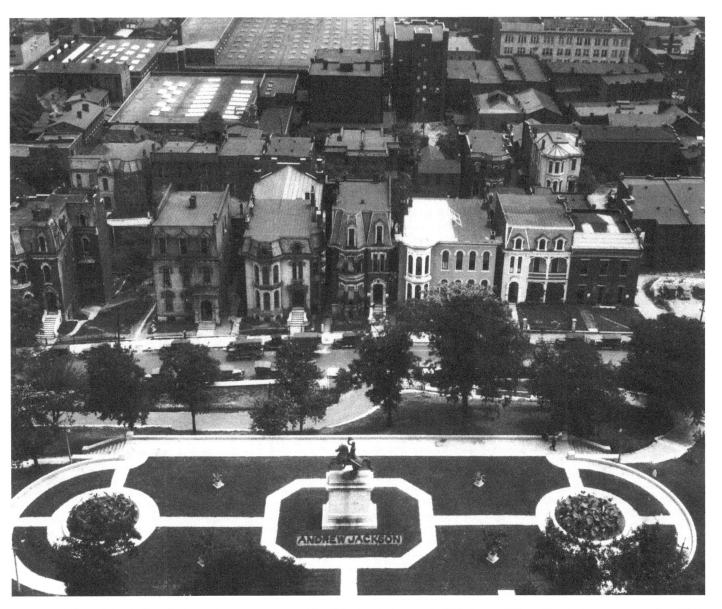

View of the Andrew Jackson Statue on the east side of the Capitol grounds. This is one of three identical statues created by Clark Mills. A second is in Washington, D.C., and the third is in New Orleans, Louisiana.

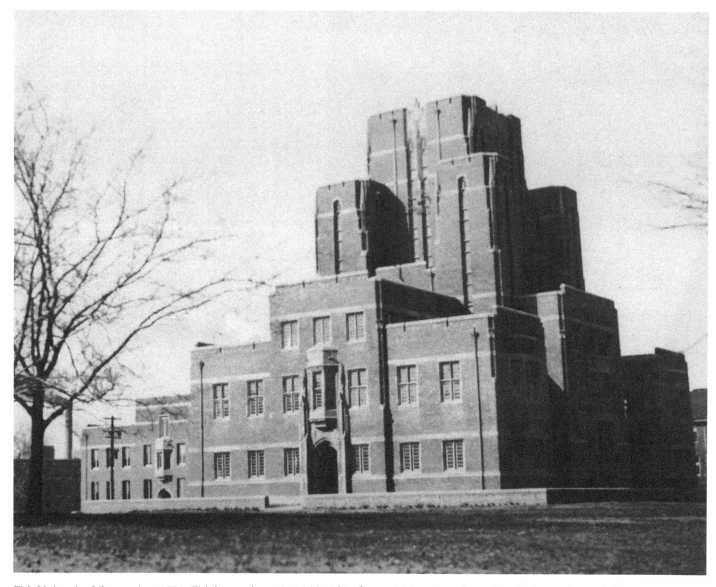

Fisk University Library, circa 1931. Fisk began classes in 1866 within former Union Army barracks, which were located close to the Union Station Hotel.

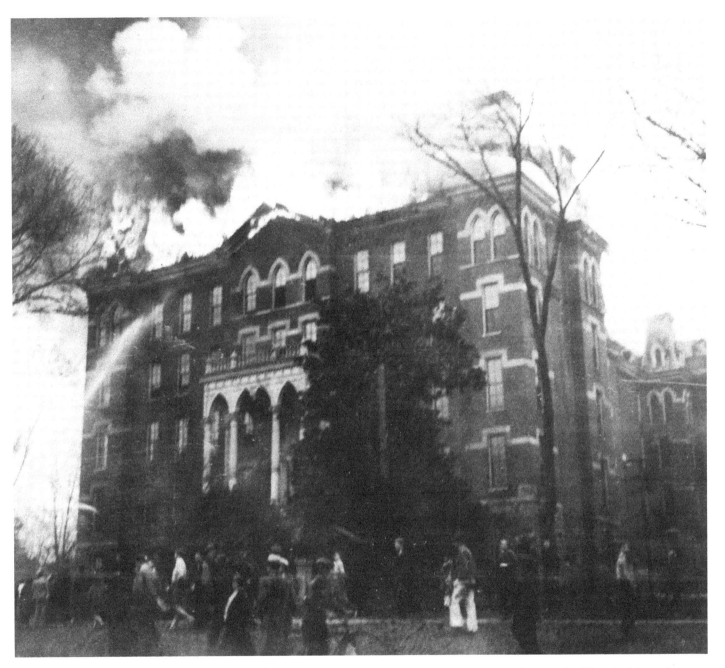

Vanderbilt University's Wesley Hall is engulfed in flames on February 19, 1932. This was the second of three buildings that were known as Wesley Hall. The first was replaced with the building in the photograph in 1880, and the third was the former YMCA Graduate College that Vanderbilt purchased and renamed in 1936. It was used by the Divinity School until 1959 and continued to be used by the university until it was razed in 1990.

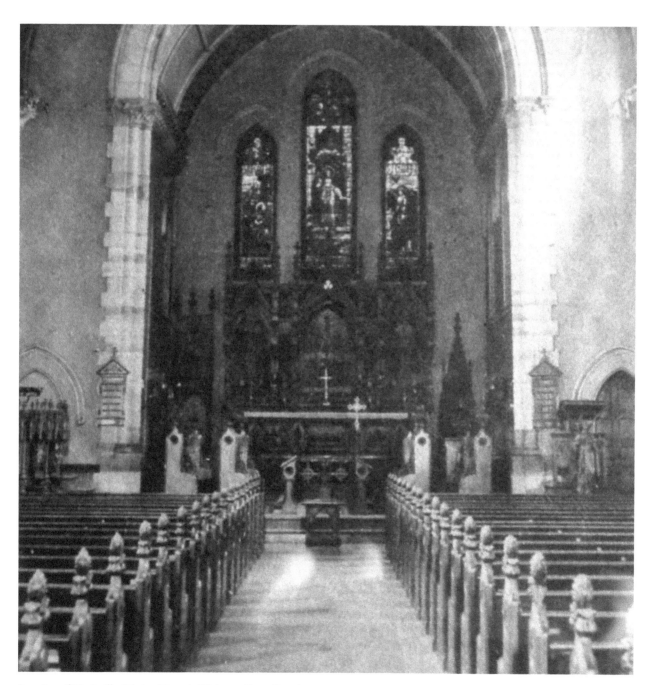

Interior of Nashville Christ Church (Episcopal) on Broadway.

184

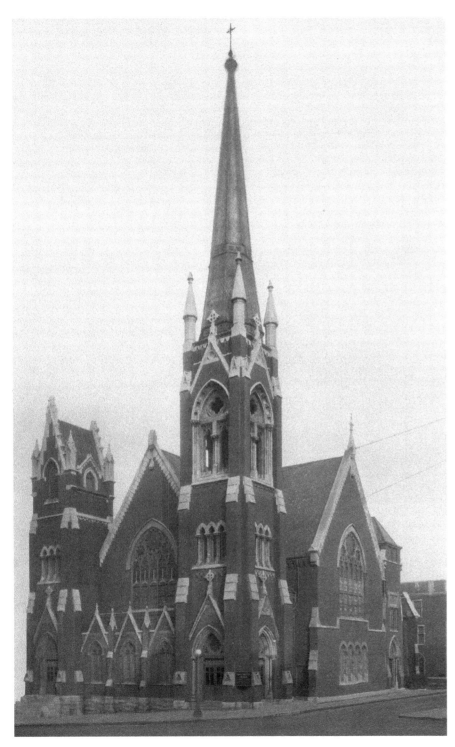

First Baptist Church on Broadway. A public outcry led to preservation of the bell tower and steeple when the church building was leveled and replaced with a new structure.

A parade on Sixth Avenue, celebrating a Vanderbilt Homecoming in the 1940s. The 1940 team was the first year of head coach Red Sanders. His coaching career was interrupted during World War II, when he became a lieutenant commander in the Navy. In 1996, he was elected to the College Football Hall of Fame for his coaching.

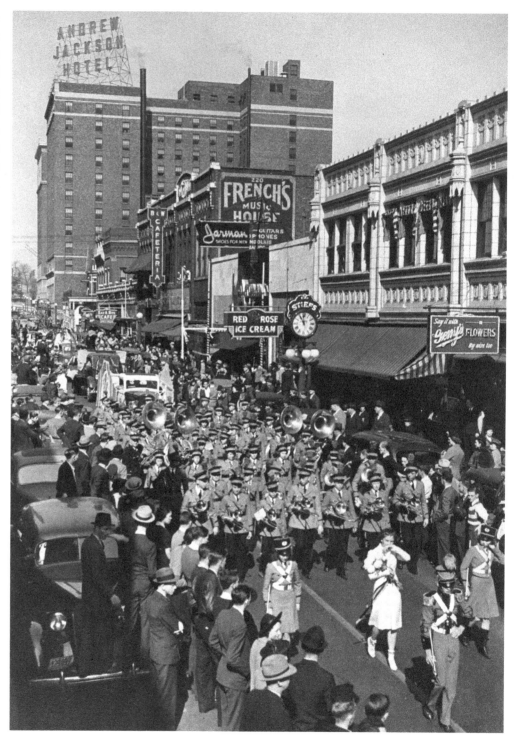

A MODERN CITY EMERGES

1940–1979

The manufacturing industry in Nashville boomed during World War II spurred by the completion of the Vultee Plant to build military aircraft. After the war, in 1945, a housing shortage erupted, resulting in conversion of many of the large homes to apartments and rooming houses. Banks, insurance companies, and other financial institutions emerged to lead in the building of the city's wealth.

In the 1950s, Nashville observed the Capitol Hill Redevelopment, the construction of the L & C Tower (the first modern skyscraper), and the opening of Belmont College. In 1954, segregation was declared illegal and Nashville began a school desegregation plan the following year. The Nashville Sit-In Movement in 1960 led to widespread desegregation of public facilities.

The country music industry became big business in the city. During this time, record labels, studios, and musicians all flocked to Nashville in search of fame and fortune. The term "Music City U.S.A." was coined during a 1950 WSM broadcast, and the Country Music Association was founded in 1958.

Nashville saw the formation of the Metropolitan Government in the 1960s, along with liquor by the drink, and the passing of the civil rights act. Hospitals and medical companies began forming, creating another great industry for the city.

In the 1970s, Nashville witnessed the return of professional baseball, the opening of Opryland, and a permanent home for the Grand Ole Opry with its transition from the Ryman Auditorium to Opryland in 1974.

During this era, transportation had also evolved. The old electric streetcars that once plied the streets were replaced with buses in the early 1940s. Tennessee's first interstate highway connecting Nashville to Memphis was constructed in 1962.

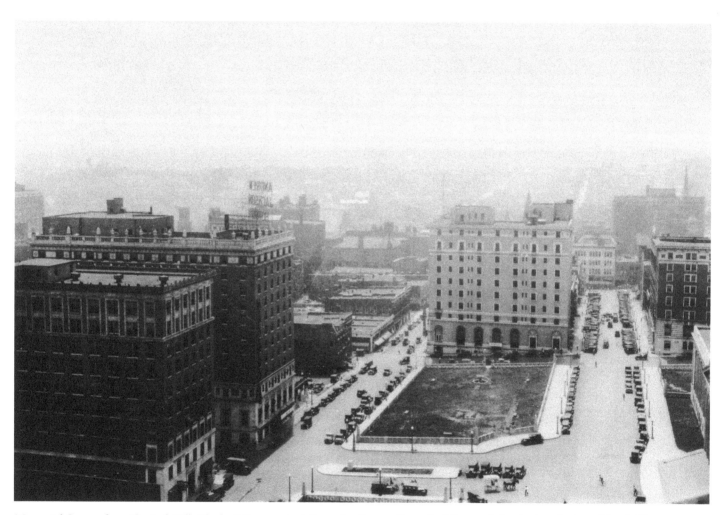

Memorial Square from Capitol Hill. The buildings to the left are the Cotton States Building and the Andrew Jackson Hotel. The Hermitage Hotel faces the State Capitol.

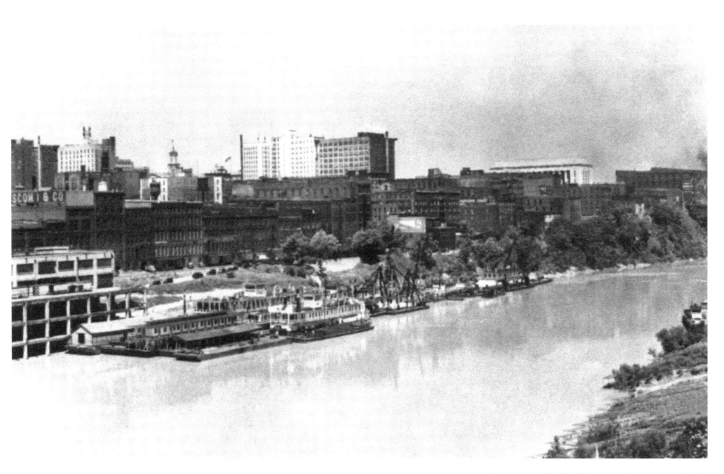

Downtown Nashville's riverfront, circa 1940.

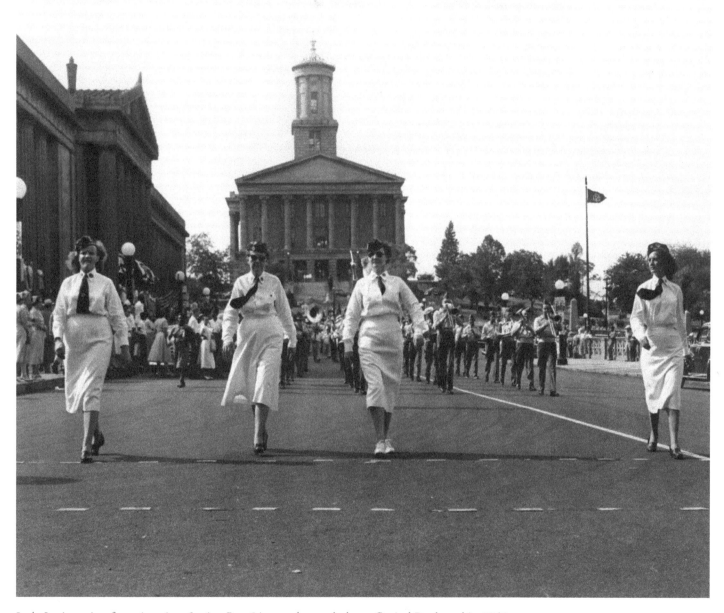

Lady Legionnaires from American Legion Post 5 in parade march down Capitol Boulevard in 1945.

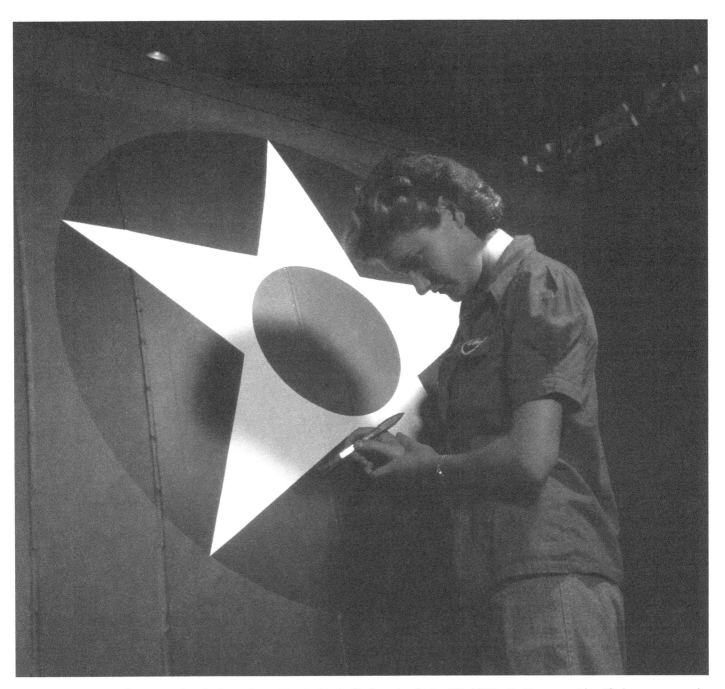

Rosie the Riveter played a key role working in Nashville factories during World War II. Here an unidentified woman puts the finishing touches on a military insigne on the fuselage of a Vengeance dive-bomber at the Vultee factory in Nashville.

The library at the Tennessee State Capitol.

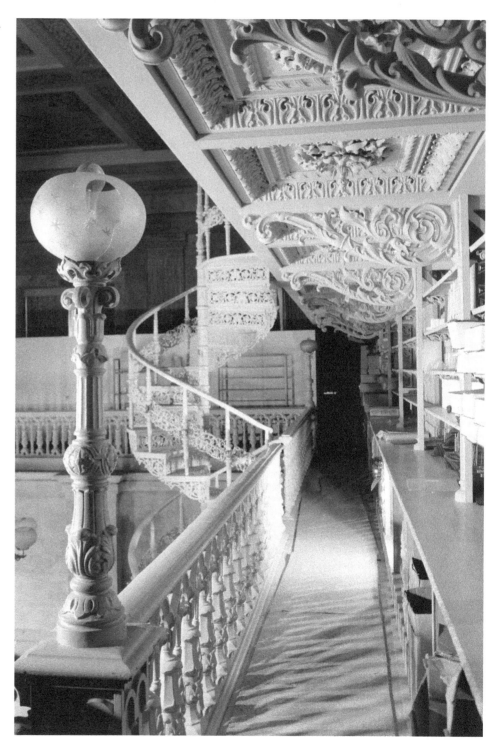

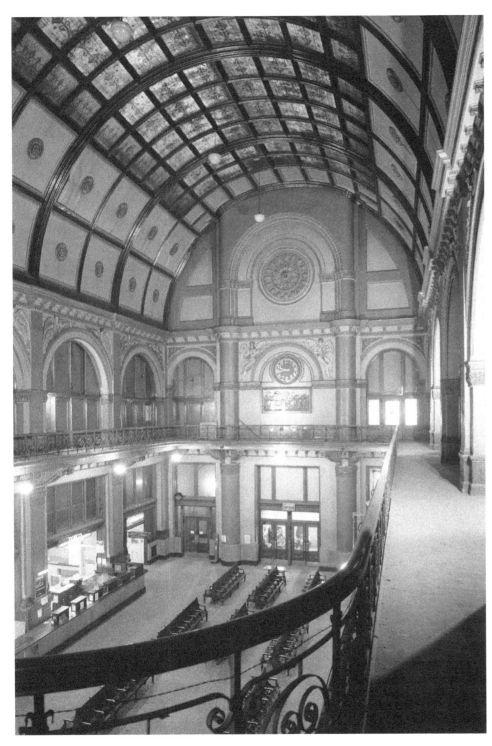

The interior of Union Station in the 1940s. Union Station stayed in business until the early 1970s. It sat dormant until it was converted into a hotel in the 1980s.

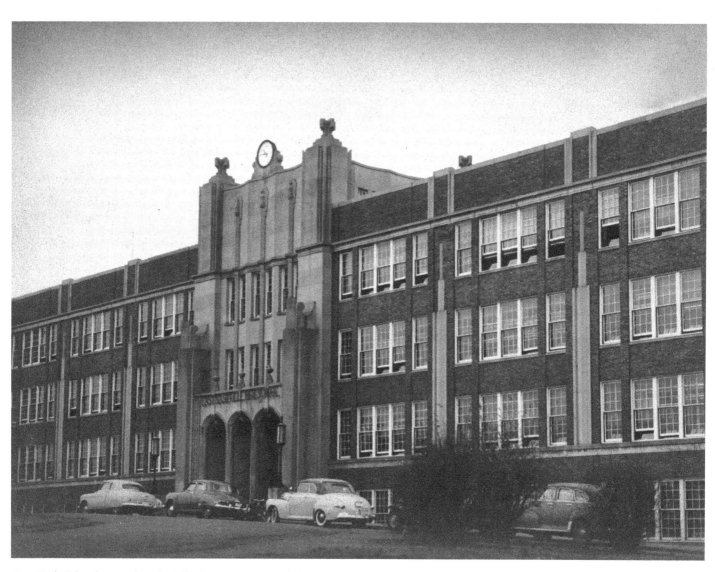

East High School opened in the fall of 1932 as a state-of-the-art institution featuring science laboratories, industrial arts shops, home economics, music, and art facilities.

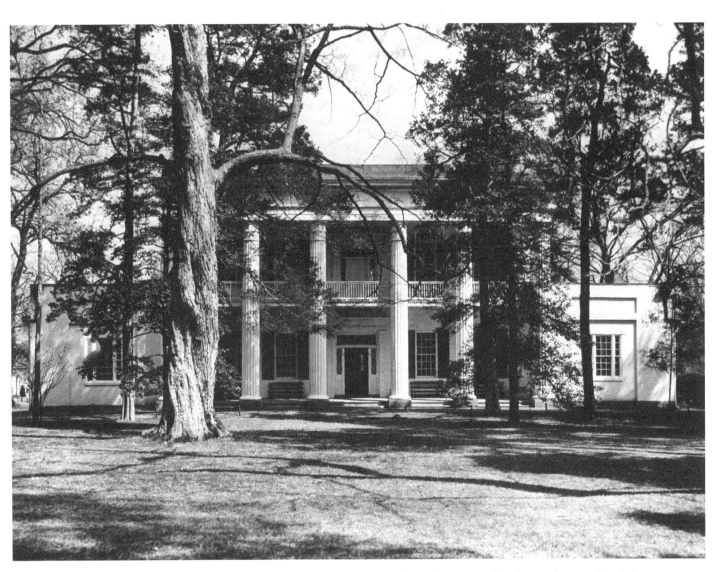

View of Andrew Jackson's home, the Hermitage, in 1941. The Jacksons moved to the Greek Revival–style home in 1821.

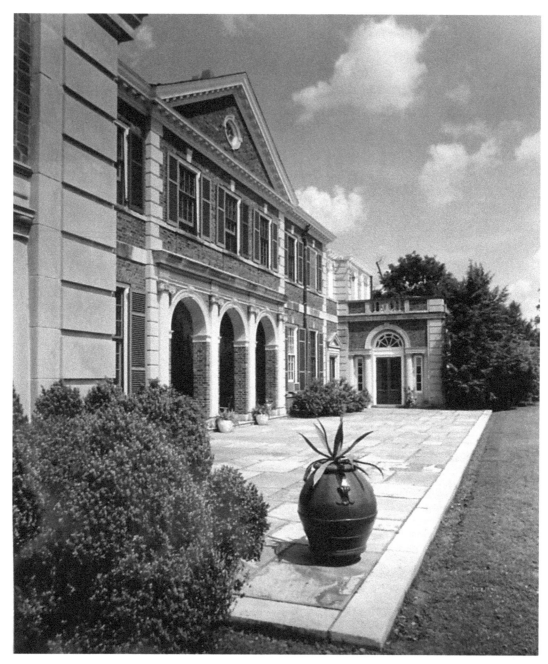

The rear of the Governor's Mansion was named "Far Hills" by its original owners, Mr. and Mrs. Ridley Wills.

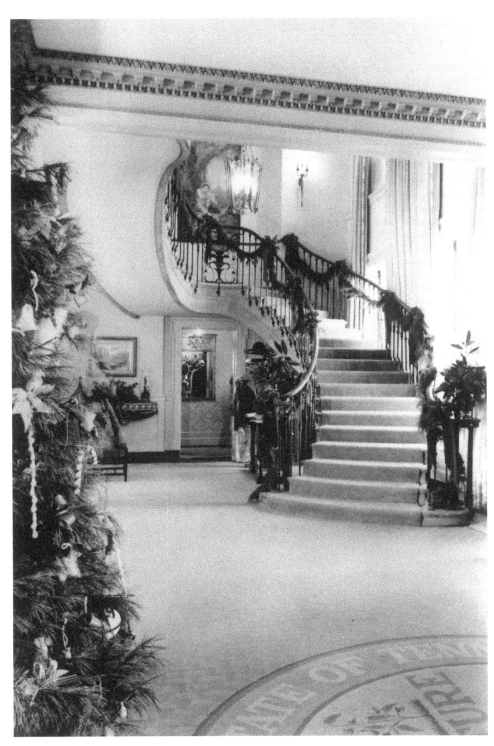

An interior view of the foyer of the Governor's Mansion decorated for Christmas, 1975.

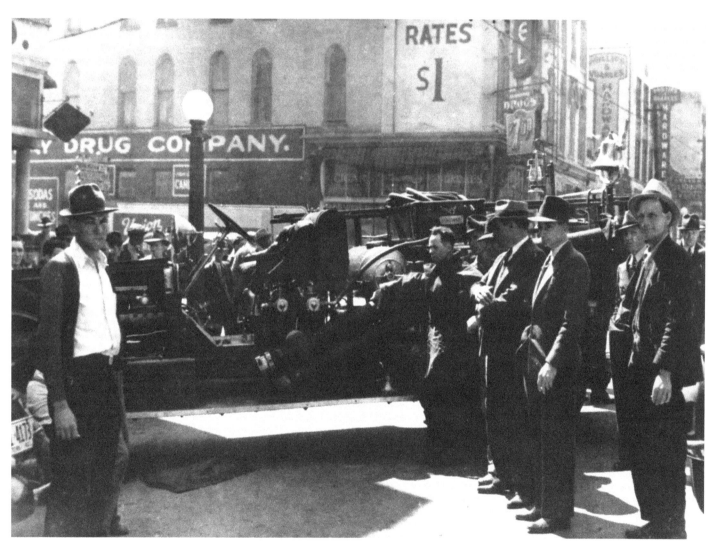

A firetruck is parked on Fourth and Broadway facing First Avenue with Phillip & Quarles Hardware (now the Hard Rock Café) in the background.

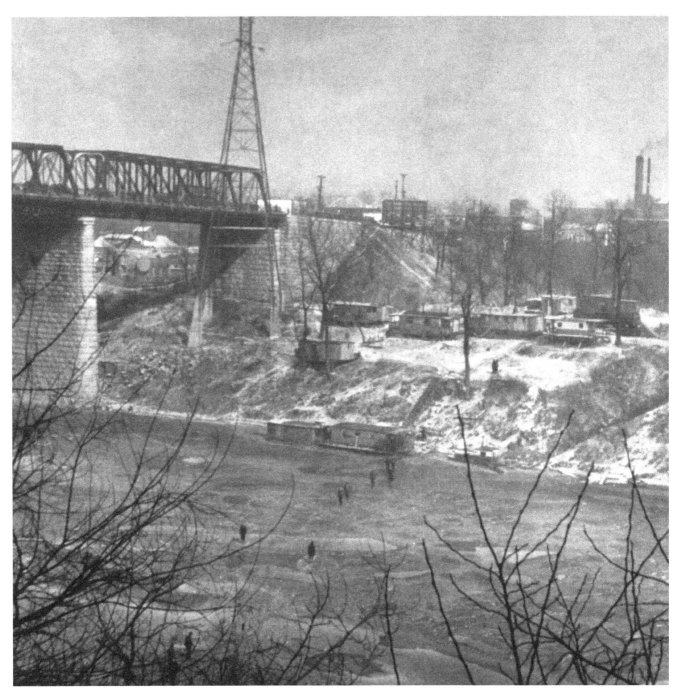

People walk across the rarely frozen Cumberland River during the ice storm of 1940. The river also froze in the great winter storm of 1952. A Model T Ford was driven across the river just below the Bordeaux Bridge.

The Belmont Water Tower.

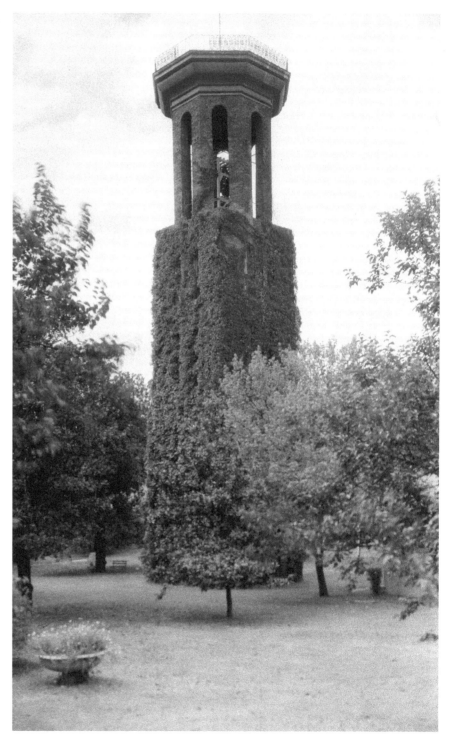

The Nashville Children's Museum, 1944 to 1973, was the former home of Peabody Normal College.

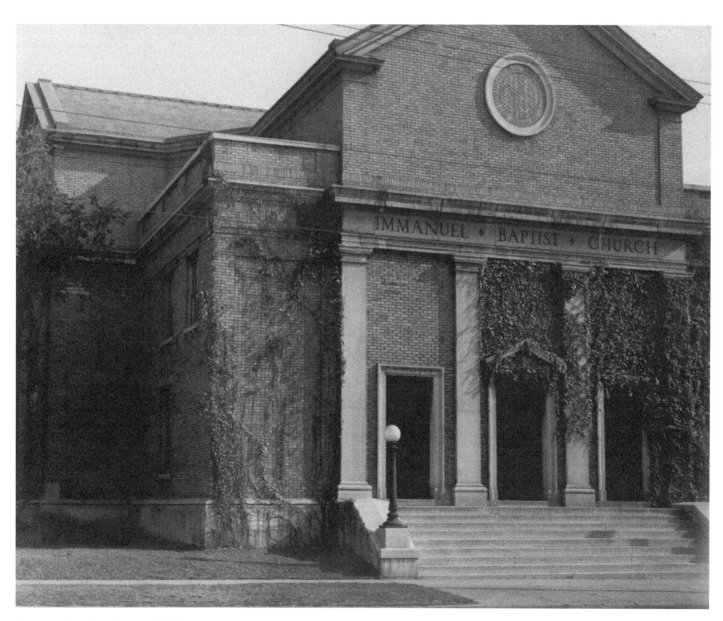

Immanuel Baptist Church, 1955.

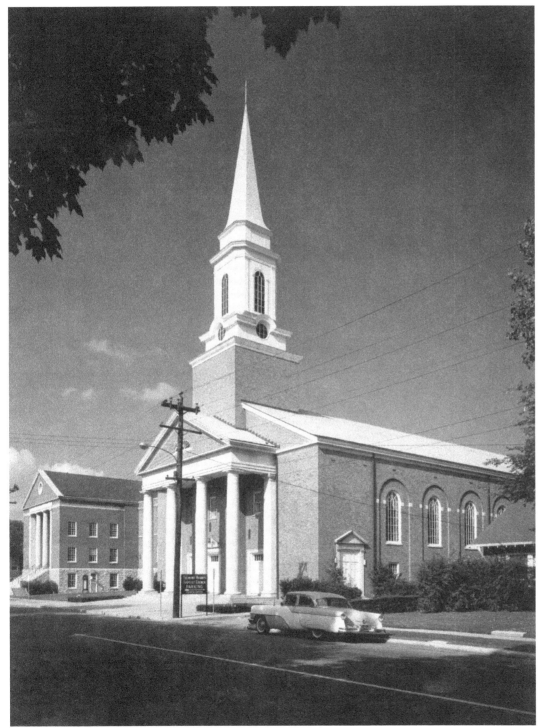

Belmont Heights Baptist Church, 1950.

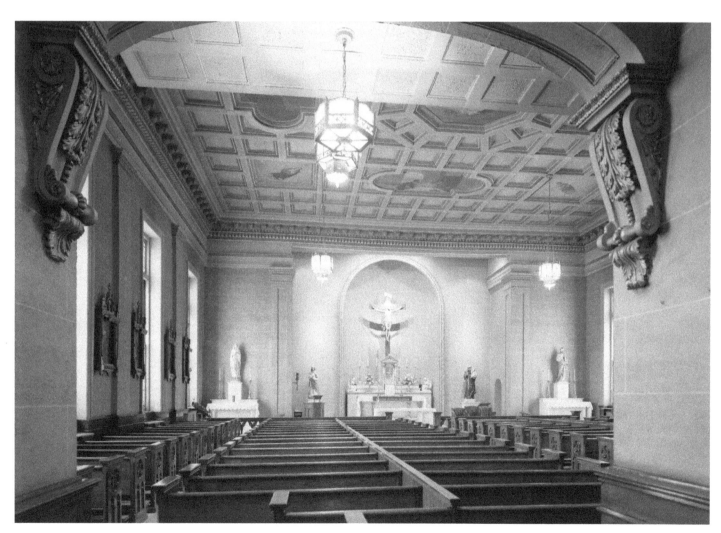

The interior of St. Mary's Cathedral on Fifth Avenue, circa 1960. Construction began in 1844 on the designs of Adolphus Heiman, Nashville's premier engineer-architect of that time.

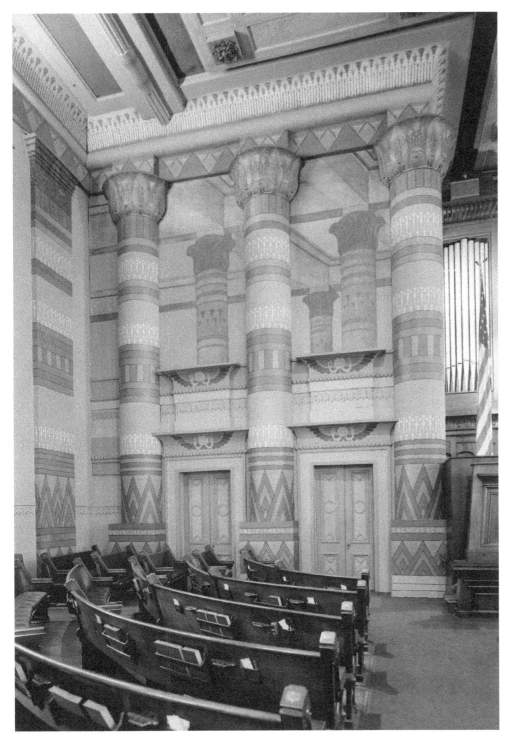

Interior view of the First Presbyterian Church located on Fifth Avenue North. The Egyptian motif was inspired by Napoleon discoveries of the day.

Home of the Grand Ole Opry, the
Ryman Auditorium, circa 1969.

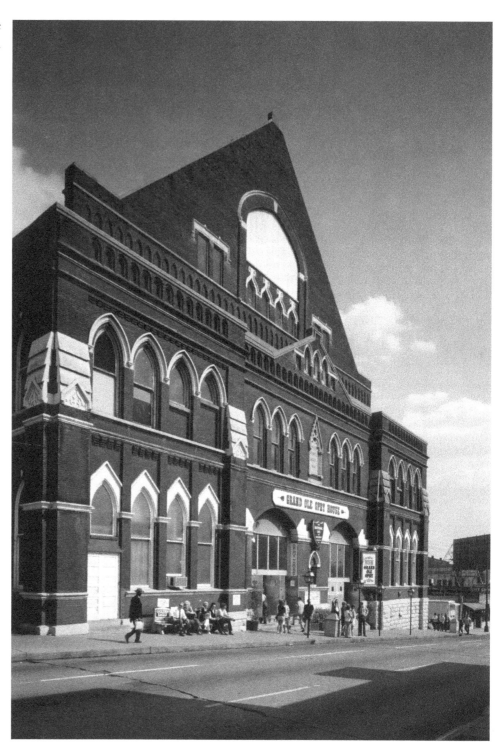

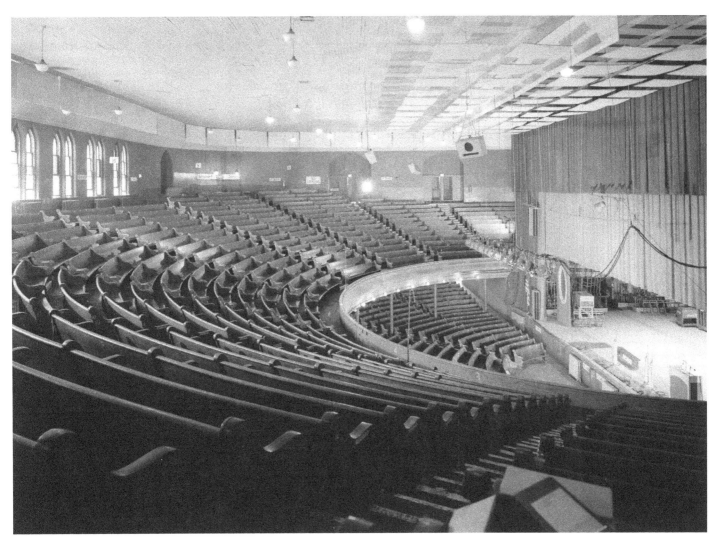

The Ryman Auditorium from the Confederate Gallery, constructed for the Reunion of Confederate Veterans held in June 1897.

Backstage at the Ryman Auditorium.

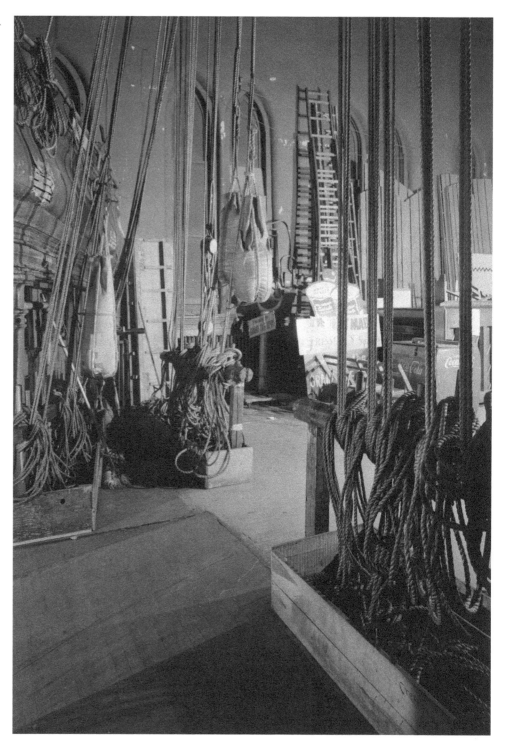

A look at the interior architecture of the
Ryman Auditorium.

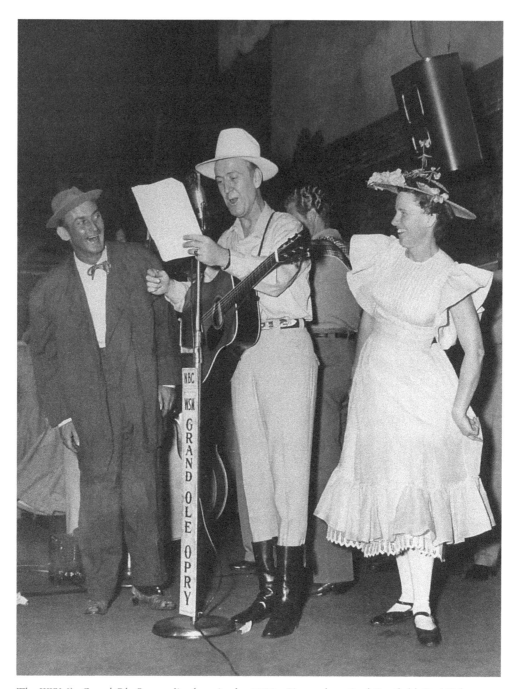

The WSM's *Grand Ole Opry* radio show in the 1950s. Pictured are Rod Brasfield, Red Foley, and Minnie Pearl. Roy Acuff is standing behind Red Foley.

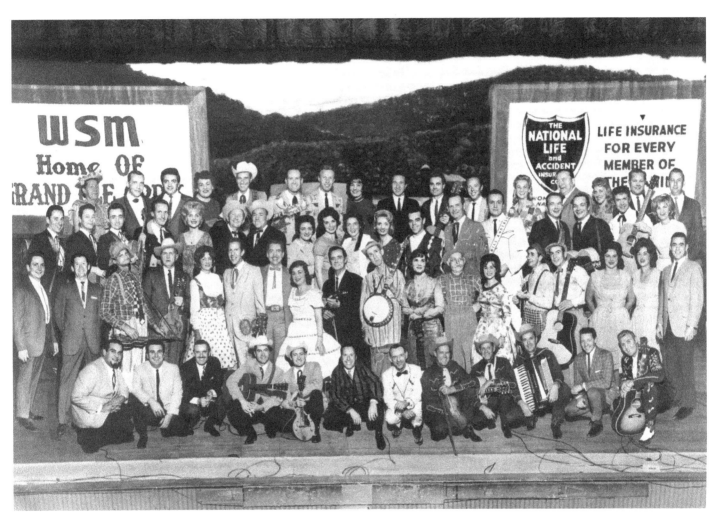

The Grand Ole Opry cast poses here in the mid 1960s.

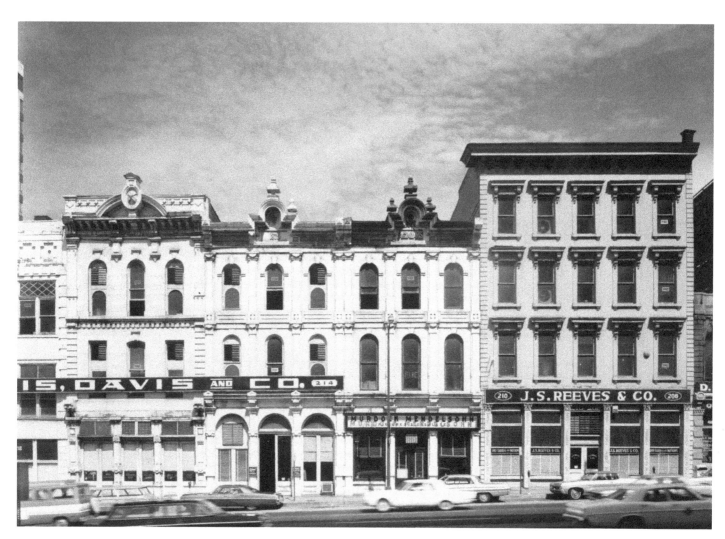

North side of the Nashville Public Square in the 1960s.

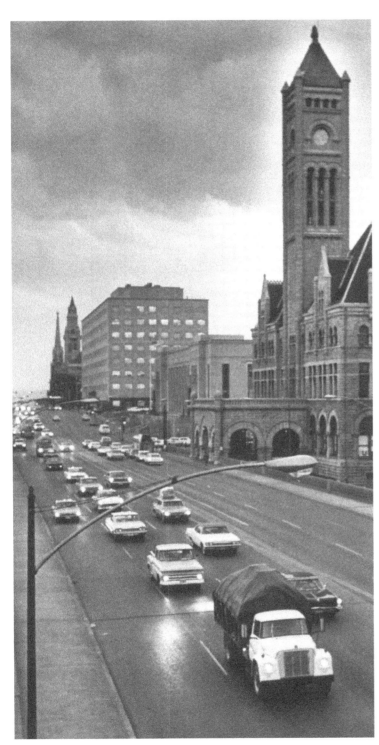

Broadway facing east toward Union Station, circa 1969. Buildings east of Union Station include the U.S. Post Office, Federal Courthouse, Customs House, and First Baptist Church.

The exterior architecture of the Tennessee State Penitentiary. The prison was featured in the film *The Green Mile.*

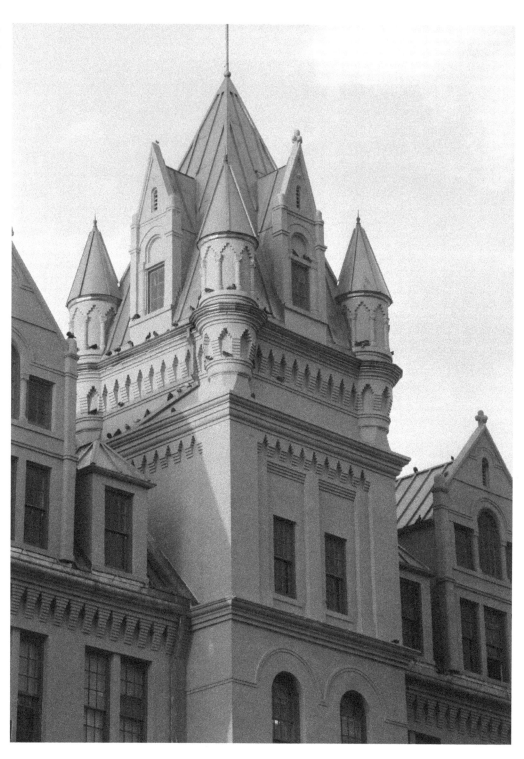

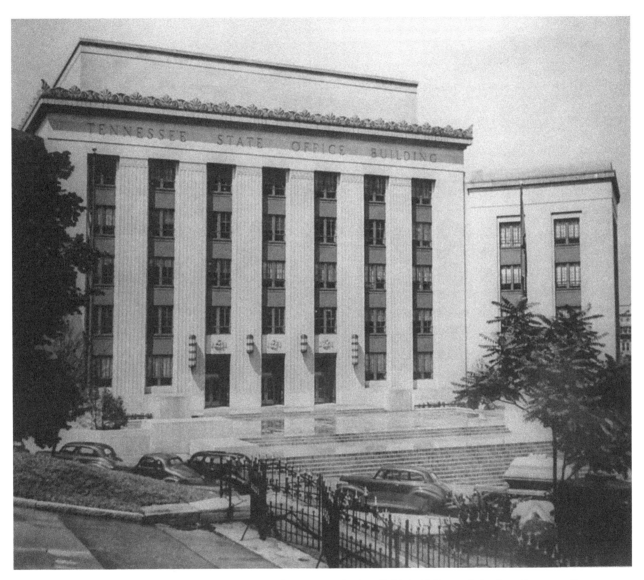

Tennessee State Office Building shortly after its completion in 1940. Until this building and the State Supreme Court Building (1937) were erected, the entire state government was housed in the Tennessee State Capitol and its annex.

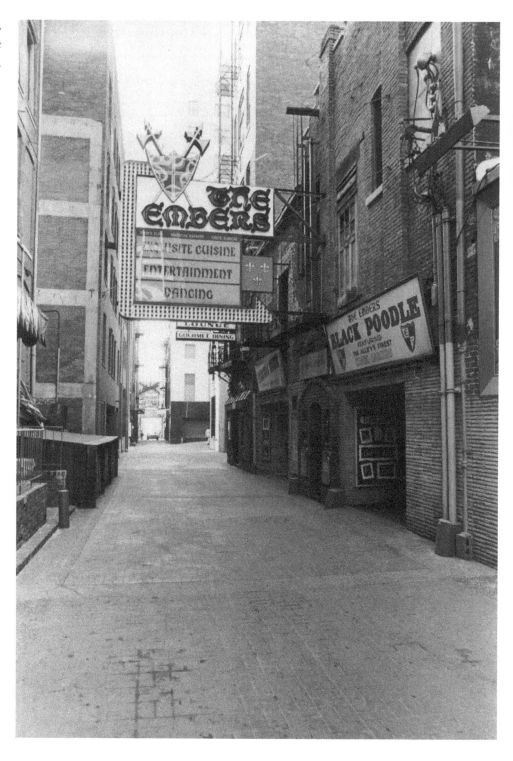

Printer's Alley in the mid 1970s, showing the Embers nightclub and the Black Poodle.

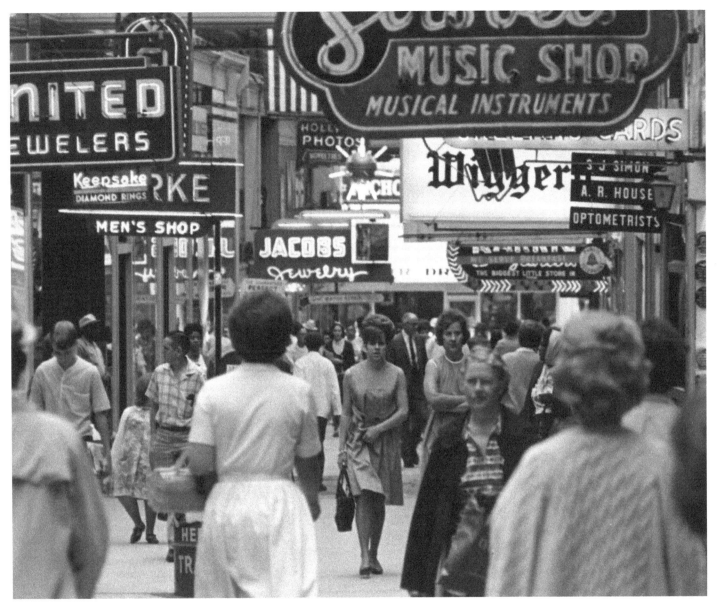

A crowd enjoys the downtown Arcade in the 1970s. Originally opened May 20, 1903, it was designed and built by Daniel C. Buntin. The Arcade also housed a pool hall that legendary pool hustler Minnesota Fats once called home. Fats was the model for the character Paul Newman played in the movie *The Hustler*.

Following Spread: An aerial view of downtown Nashville, circa 1968.

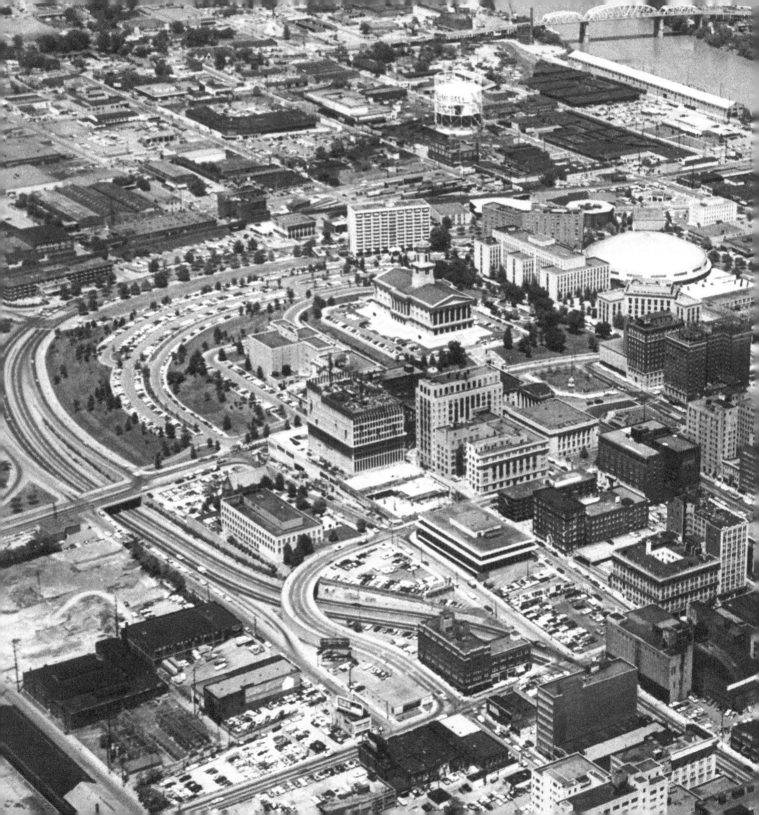

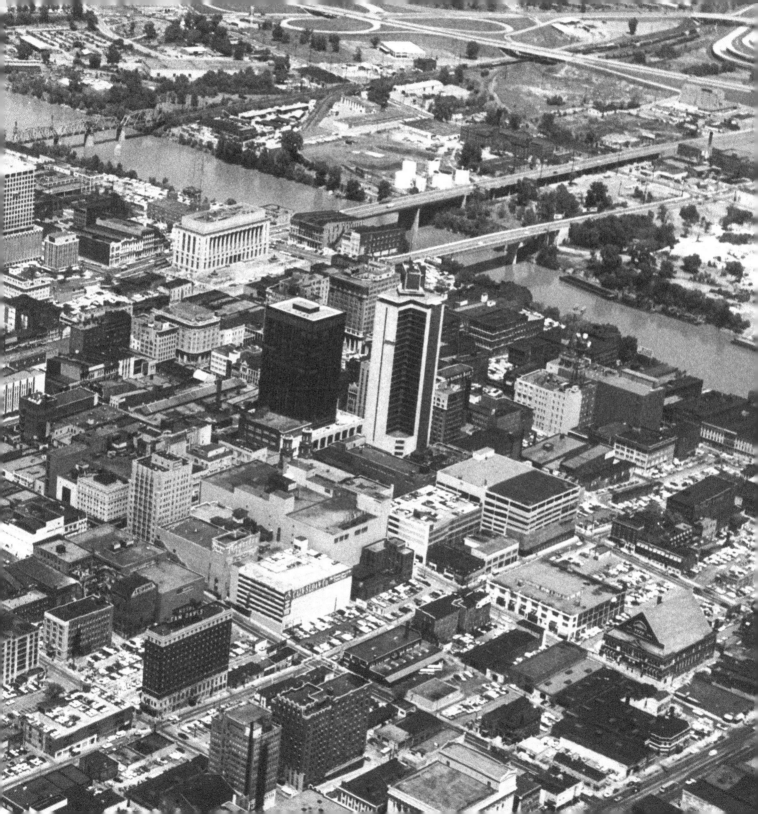

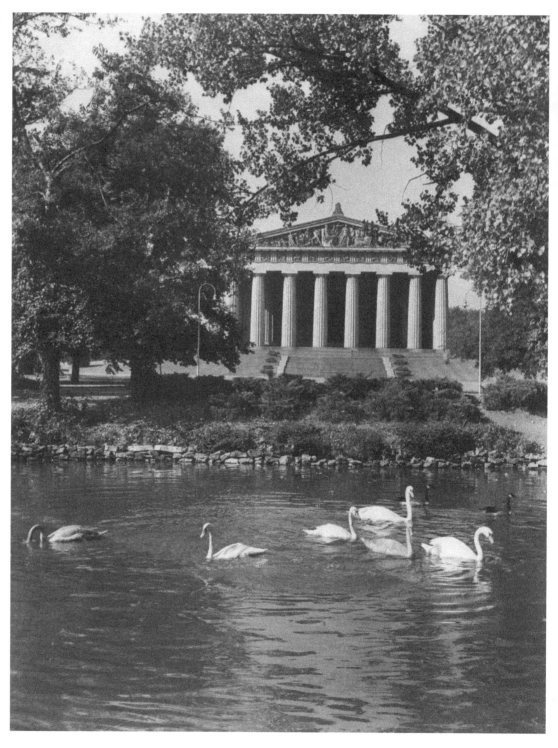

The Parthenon overlooks
Watauga Lake.

Notes on the Images

These notes, listed by page number, attempt to include all aspects known of the images. Each image is identified by the page number, photograph's or drawing's title or description, photographer or artist and collection, archive, and call or box number when applicable. Although every attempt was made to collect all data, in some cases complete data may have been unavailable due to the age and condition of some of the images and records.

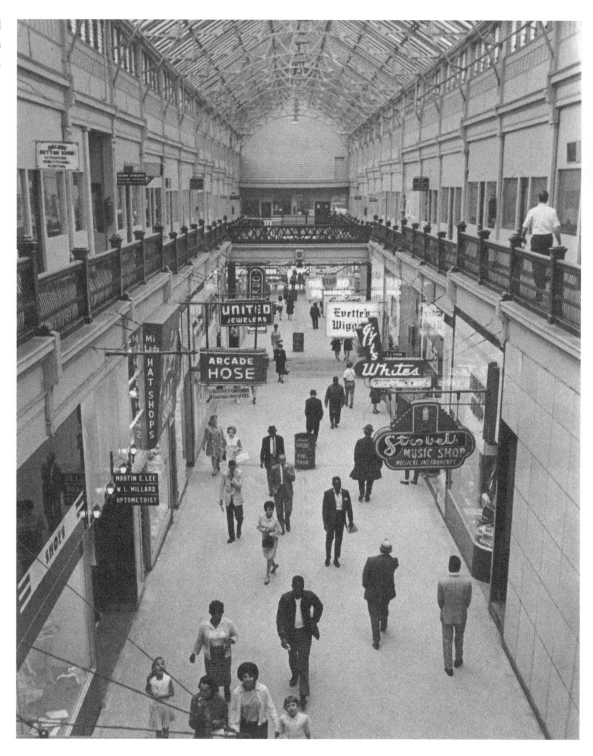

Shoppers stroll through the Arcade in the 1960s.

HISTORIC PHOTOS OF
NASHVILLE

By the mid-nineteenth century, the city of Nashville was a vibrant cultural center of the South. Through the Civil War, Reconstruction, two World Wars, and into the modern era, Nashville has continued to grow and prosper by overcoming adversity and maintaining the strong independent culture of its citizens.

This volume, *Historic Photos of Nashville*, captures this journey through still photography from the finest archives of city, state, and private collections. From the Civil War, to the Centennial Exposition and the building of a modern metropolis, *Historic Photos of Nashville* follows life, government, education, and events throughout Nashville's history. The book captures unique and rare scenes through the original lens of over 200 historic photographs. Published in striking black and white, these images communicate historic events and everyday life of two centuries of people building a unique and prosperous city.

Jan Duke has published numerous articles on Nashville. She is the editor of the award-winning Web site, nashville.about.com, and a lifetime member of the Cheatham County Historical Society, as well as the First Families of Tennessee, a project of the East Tennessee Historical Society that documents, honors, and identifies the state's first residents prior to Tennessee's statehood in 1796.

Jan has also written extensively for other publications, including *La Campana del Sur* (Nashville's Spanish newspaper), *Ireland's Own* magazine, and for the University of Regensburg, Germany.

Jan and her husband Phillip have two wonderful sons. They live in Cheatham County outside of Nashville.

WWW.TURNERPUBLISHING.COM

CPSIA information can be obtained
at www.ICGtesting.com
Printed in the USA
BVHW020818051219
565493BV00023B/125/P